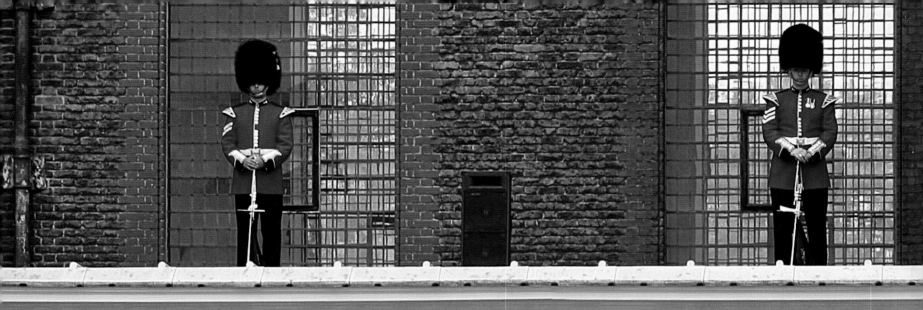

CONDIDIT CAROLUS SECUND

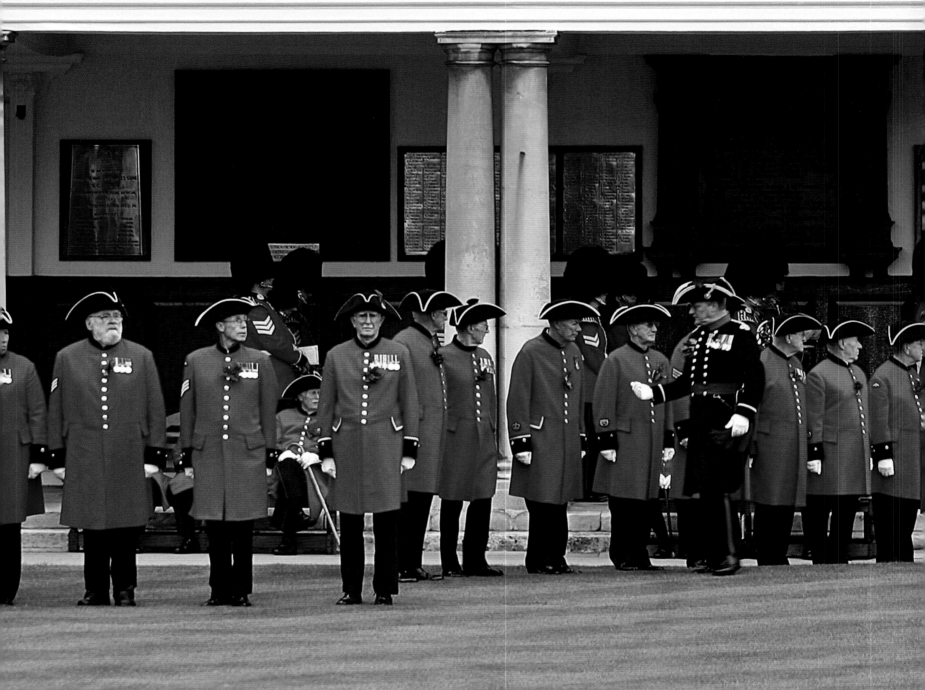

A YEAR IN PICTURES
THE ROYAL HOSPITAL CHELSEA

Patricia Rodwell

Introduction by Henry Russell

MERRELL
LONDON · NEW YORK

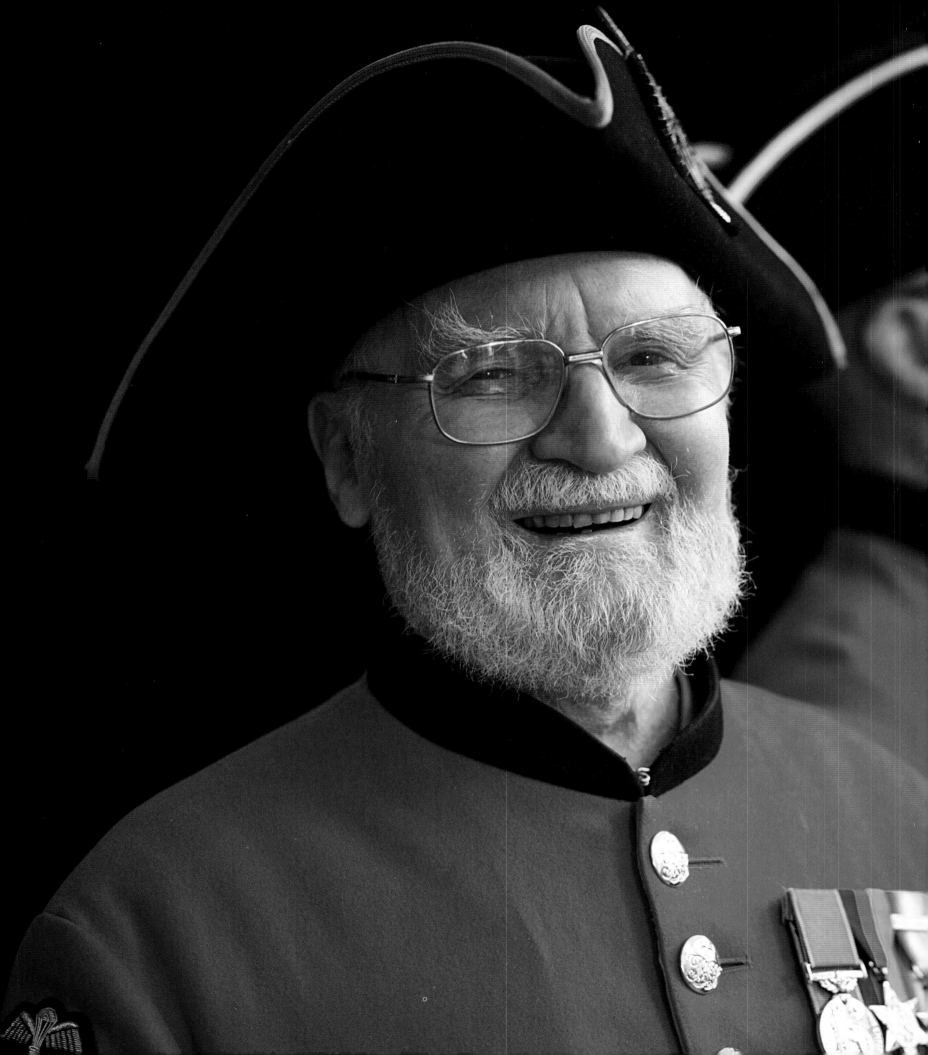

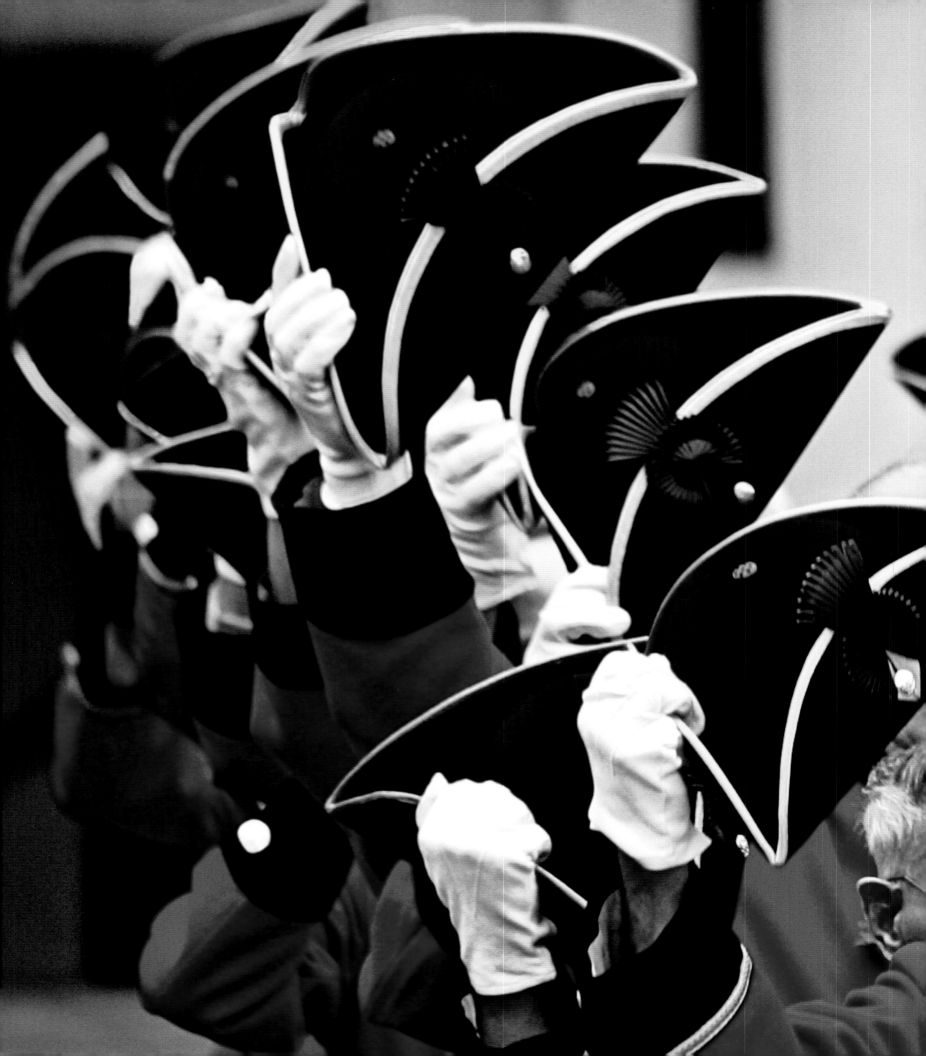

FOR THE SUCCOUR AND RELIEF
OF VETERANS BROKEN
BY AGE AND WAR
FOUNDED BY CHARLES II
ENLARGED BY JAMES II AND
COMPLETED BY WILLIAM AND MARY
IN THE YEAR OF OUR LORD 1692

During the reign of Charles II, the king realized the need
to make provision for his long-serving and injured troops.
He commissioned Sir Christopher Wren to build a
'hospital' – a place of refuge and shelter – for his soldiers.
The Royal Hospital Chelsea still serves that crucial need today.

Sadly, Wren's drawings and notes have since disappeared, but
a memo about his vision of the Hospital, written in 1682, survives.
It is said to have been written by the great man himself:

*The two sides of ye Court are double building in three stories and garrets,
both containing 16 galleries, in each of which are 24 cells divided off
with partitions of wanscot, and two larger Cells for corporals …
The upper end or front hath an Octagonall Vestibule in the middle
covered with a Cupolo and Lanthorne 130 fot high, and before it a
Portico of Dorick order … on each hand of which are lower Porticos
leading to each Wing. On each side of the Vestibule are assents to the
Hall on one hand and the Chappell on the other … On the corners of
the Building are 4 Pavilions … The lesser Porticoes and principal
doorways are Portland Stone. The rest of the Fabrick is brick, and
the whole pile well and durably built with good materials.*

Since the first group of ninety-nine 'Chelsea Pensioners' were
installed in Wren's elegant buildings in February 1692,
some 25,000 old soldiers have lived at the Royal Hospital.
This book celebrates this historic site and its residents.

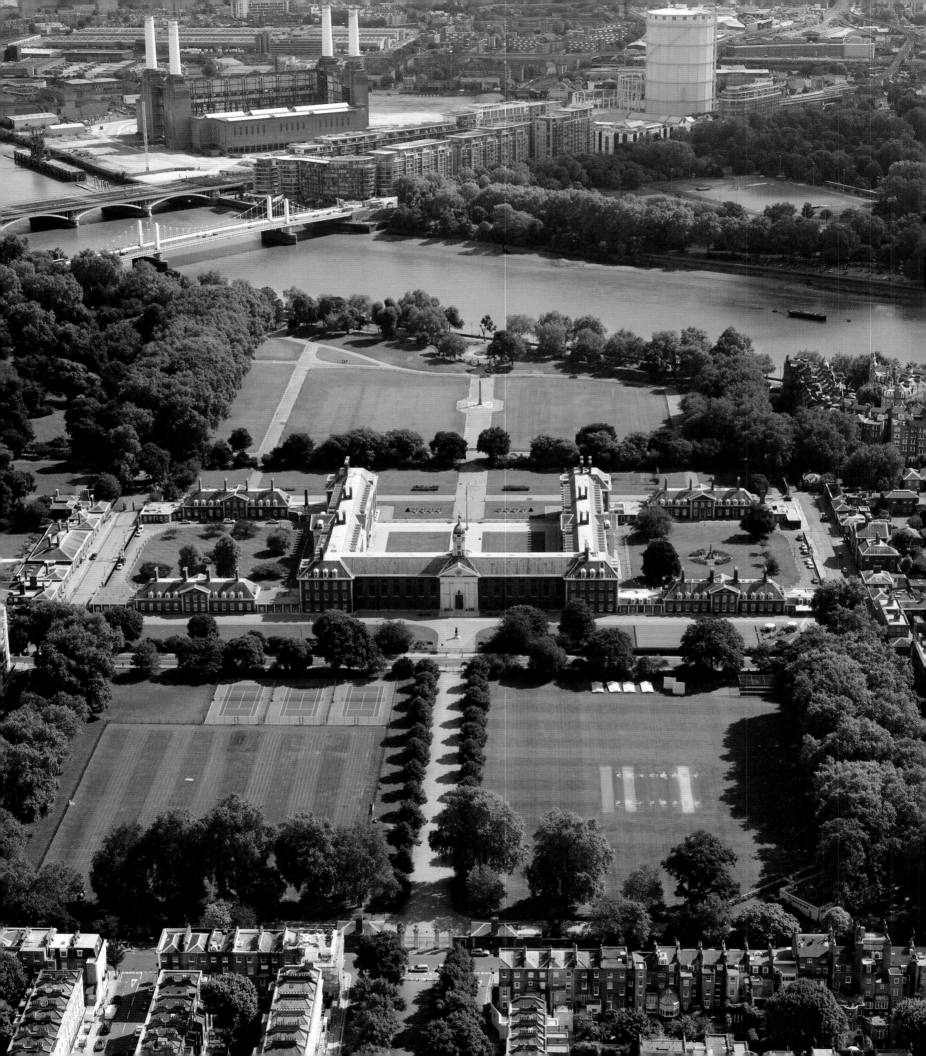

Introduction

It may seem perverse to describe one of London's finest landmarks as a hidden treasure, but the Royal Hospital Chelsea – which occupies 27 hectares (66 acres) in the heart of the British capital between Sloane Square and the north bank of the River Thames – is often overlooked by Londoners and tourists alike amid the bustle and attractions of the modern city. And that is no doubt what those who conceived and built it would have wished: the Royal Hospital is, after all, a retirement home for British soldiers and aims to provide tranquillity. Beneath the exterior calm lies a vibrant world, much of which had never been seen by outsiders before the Governor granted photographer Patricia Rodwell unique access to all areas and activities so that she could record with unprecedented intimacy a year in the life of this quintessentially British institution.

The Royal Hospital Chelsea (RHC) was founded by King Charles II, who on 22 December 1681 issued a royal warrant for its construction; it welcomed its first old soldiers (known as In-Pensioners) in February 1692. The king's decision to contribute to the welfare of military veterans was one of the late consequences of the English Civil War (1642–51), during which his father, Charles I, had been overthrown and executed. Previously the Crown had done little for old or injured army servicemen; the only provisions had been haphazardly distributed almshouses administered by the English counties. The republican Protectorate that ruled England under Oliver Cromwell, Lord Protector, from 1653 took greater and more systematic care of those who had borne arms in its service. When Charles II was invited back from exile in 1660, he resolved that the monarchy would henceforth follow this precedent and create an establishment dedicated to the 'succour and relief of veterans broken by age and war'.

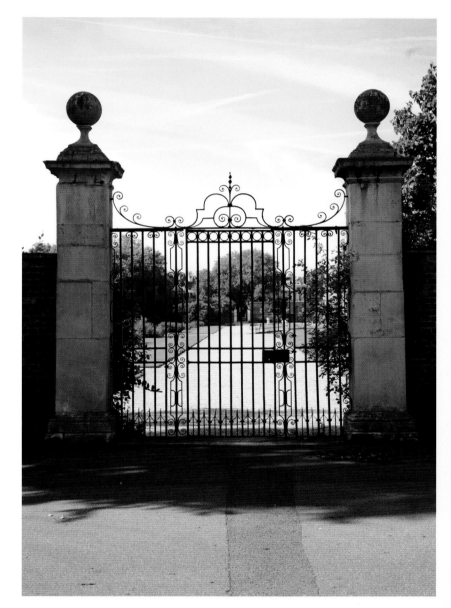

Aerial view of the Royal Hospital Chelsea and its grounds (opposite), seen from the north, with the River Thames and the chimneys of the disused Battersea Power Station in the background. The Royal Hospital's central quadrangle encompasses Figure Court; left (east) is Light Horse Court, right (west) is College Court.

An entrance gate allows a tantalizing peek into the Royal Hospital's South Grounds (above). To the south-east are the lush Ranelagh Gardens, once the private grounds of the 1st Earl of Ranelagh but now part of the Hospital's extensive grounds. Both the Hospital and its grounds are open to visitors.

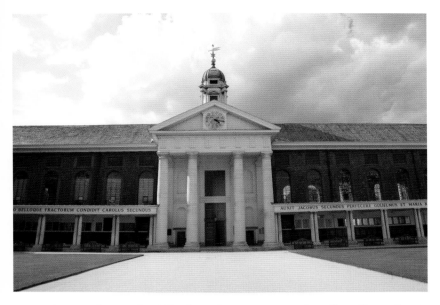
Sober elegance characterizes Wren's northern range, seen here from Figure Court.

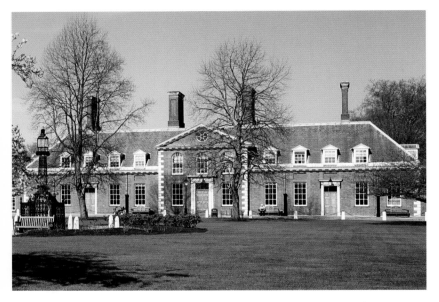
Light Horse Court was added to the original plans under James II's reign.

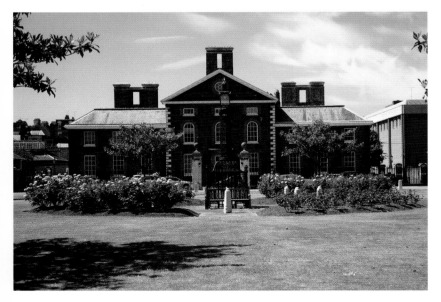
College Court is the third of Wren's quadrangles. The central well dates from 1722.

This was philanthropy, but philanthropy informed by pragmatism: one of the conditions of the Restoration was that Charles II should renounce the divine right of kings that had been arrogated since the reign of his grandfather, James I. No longer able to depend on this doctrine of absolutism, the new monarch felt vulnerable, so, to reassure him of his personal safety, Parliament allowed him to maintain a standing army. This was the first time in English history that the monarch had been so authorized; previously, all land forces other than the royal bodyguard had been mustered when needed and disbanded at the end of each emergency.

The new dispensation aroused anxiety, particularly among citizens of London, where the king maintained his principal residences, that there might one day be some attempt to turn the clock back by force to the time when the royal word was the whole of the law. The announcement that occupants of the proposed hospital were to be formed into four companies – a total of more than 400 non-commissioned officers and men – did nothing to allay fears that this new establishment would be a garrison by another name. On the face of it, these concerns were not unfounded: In-Pensioners regularly performed guard duties in the vicinity of the Hospital and remained on standby as reservists. They were last employed on active service in 1848 to prevent Chartist demonstrators from marching on central London.

Like many good ideas, the concept of the Royal Hospital Chelsea was not entirely original. It was inspired, at least in part, by a great new structure in Paris on which construction had begun in 1670 by order of the French king, Louis XIV: the Hôtel des Invalides, originally intended for the accommodation and care of 5000 French army veterans. In 1672 Charles's eldest illegitimate son, James Scott, 1st Duke of Monmouth, made two visits to the French capital, and each time he returned extolling the building work in progress by the banks of the River Seine. The father noted well what he was told.

Before long, a suitable site for development became available on the north bank of London's river. Chelsey College had been set up in 1609 by James I as a seat of

Protestant learning that would form a bulwark against Counter-Reformationists. But then the Civil War diverted attention from theological disputes between the churches of England and Rome; after the conflict, the Puritan Lord Protector, Oliver Cromwell, closed the College. At the Restoration the land was acquired by the Crown; the buildings were used first to house Dutch and Scottish prisoners of war. In 1666 the property was sold to the Royal Society, but the newly founded scholarly organization could find no use for it.

Encouraged by the success of a hospital opened in 1680 at Kilmainham in Phoenix Park, Dublin, for veterans of the Irish Army, Charles II now sought guidance from his counsellors about the possibility of creating a similar establishment in London. The king advanced about £7000 from the royal purse, but the Treasury was unable to contribute, so the balance of the required sum was raised partly through private donations (notably by Sir Stephen Fox, the Paymaster General from 1661 to 1679), and mainly by deductions from the pay of serving soldiers; indeed, this form of levy remained the principal source of finance for the RHC until the mid-nineteenth century.

In January 1682 the Crown bought back Chelsey College from the Royal Society and handed it over to the Surveyor General of the King's Works, Sir Christopher Wren. The existing, dilapidated buildings were quickly demolished and work on the present structure began in August of the same year.

Wren was at the height of his powers and basking in the glory of his new St Paul's Cathedral, then under construction, and more than fifty churches he had designed to replace those destroyed in the Great Fire of London of 1666. While his plans for the RHC were demonstrably influenced by Les Invalides, it could not fairly be asserted that they were derivative of the French building. Although there is a broad external similarity between the two complexes, there are numerous significant differences in detail. Wren eschewed Libéral Bruant's high-roofed pavilions and Jules Hardouin-Mansart's gold-plated church dome, and produced a design that was more vernacular than triumphalist.

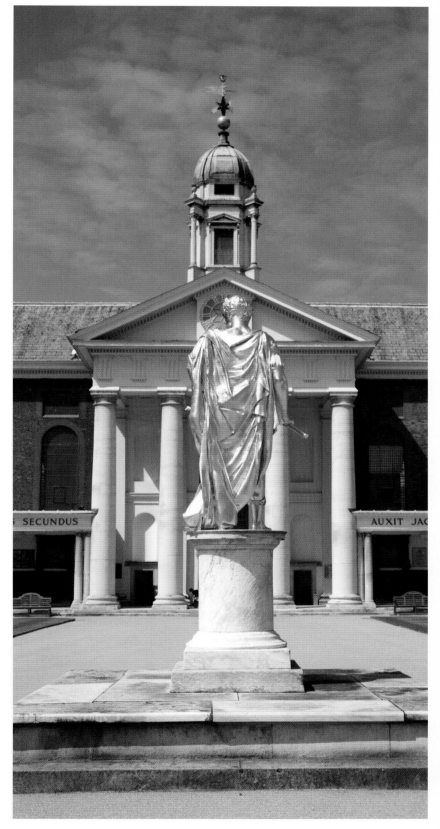

In Figure Court a statue of Hospital founder Charles II faces the Octagon.

Some regard this as emblematic of a more generalized difference between the architecture, and perhaps even the temperaments, of the two nations – English self-effacement in counterpoint to French ostentation. However that may be, Wren also made a virtue of economic and practical necessity: his buildings were constructed on the foundations of the pre-existent Chelsey College.

Work proceeded rapidly: on the death of Charles II in 1685 the Great Hall was ready and the Chapel was only two years from completion (it was consecrated in 1691). Among the first In-Pensioners to be admitted, in 1692, were soldiers wounded at the Battle of Sedgemoor (July 1685), in which the forces of the late king's brother, James II, put down a rebellion by the Duke of Monmouth, who wanted the throne for himself. The initial intake may also have included casualties from the Battle of the Boyne (July 1690), at which James, who had been deposed in 1688, tried unsuccessfully to wrest the crown back from his successor, William III.

The Royal Hospital Chelsea was officially opened in 1692 on the anniversary of Charles II's birth, 29 May, which was also the date in 1660 of the restoration of the monarchy. At about the same time, a great gilded statue of the founder – cast in copper alloy and standing 2.3 metres (7 ft 6 in.) tall – was transferred from its original location in the garden of Whitehall Palace and installed on a plinth in the grounds of the RHC's central three-sided edifice, which accordingly thereafter became known as Figure Court. Created in 1676 by Grinling Gibbons, the effigy depicts Charles II in the uniform of a Roman general.

By the end of 1692 the RHC was full beyond capacity, with 476 In-Pensioners. The accommodation was soon increased by the opening of two Wren-designed quadrangles, Light Horse Court and Infirmary Court; the latter was subsequently renamed College Court.

Between the buildings and the river were formal gardens flanked by paved walkways, beyond which were orchards and herb and vegetable patches; the whole was bounded by two artificial waterways that linked the

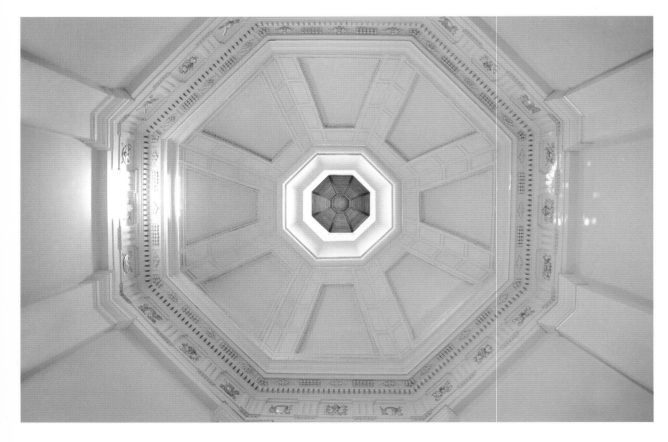

Interior view of the top-lit dome in the Octagon, which links the Great Hall and the Chapel. The plasterwork was completed in 1687 by John Grover, Master Plasterer to the Office of Works. The metopes display trophies of arms and the monogram 'JR' crowned (for James II, who succeeded Charles II to the throne in 1685), within a laurel wreath.

Light Hourse Court is named after the Light Horse, or old cavalrymen, who were housed in the south-east wing until that grade was abolished in 1850. The building was hit by enemy bombs during the First World War, and destroyed by a rocket in the Second World War. It was rebuilt in the mid-1960s as an exact reproduction of the original exterior. Today the building houses additional Long Wards accommodation for In-Pensioners.

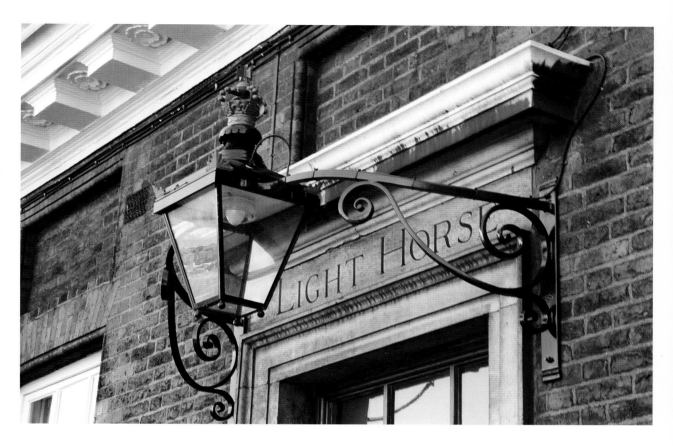

southern flank of the Hospital with the River Thames. Though conceived as an idyll for the delectation of In-Pensioners, the gardens were fraudulently appropriated by Richard Jones, 1st Earl of Ranelagh, who, having been appointed Paymaster General and Treasurer of the Royal Hospital, set about turning the grounds into his own private estate. By 1703, when Ranelagh was relieved of his offices, he had built for himself on the site a grandiose mansion and a rococo rotunda (the latter the subject of a painting by Canaletto); both were eventually demolished in 1805 and the land, which had in the intervening period become a public pleasure garden, was reincorporated into the Royal Hospital.

In the 1850s and 1860s this *rus in urbe* was again violated: first by the construction of a stone wall along the river's edge to protect the land from flooding, a precaution that necessitated the infilling of the canals; and then by further encroachment by a main road (Chelsea Embankment) along the north bank of the river. The gardens – which, though diminished since

Wren's time, remain magnificent – are now used as intended by In-Pensioners and visitors; they are also the venue for the Chelsea Flower Show, which is held annually for five days in May under the auspices of the Royal Horticultural Society.

Of the nineteenth-century improvements to the RHC, none was greater than those made by John Soane. Soane was appointed Clerk of Works to the Royal Hospital in 1807 and held the post for the next thirty years, during which British involvement in the Napoleonic Wars increased demand for places in the Hospital far beyond supply. Soane responded by designing a new Infirmary in Classical style to the west of the existing buildings, with space for eighty patients. Although sometimes overlooked by visitors, the summer house for In-Pensioners – completed around 1831, the year in which Soane was knighted by King William IV – is among the architect's outstanding triumphs and one of the Royal Hospital's finest structures.

In 1866 the Royal Hospital Chelsea Museum was opened in part of the Great Hall. Among the military

artefacts and memorabilia displayed are items associated with the Duke of Wellington, whose body lay in state here before his funeral in 1852.

The First World War caused such carnage in mainland Europe that direct attacks on Britain have been sparsely documented in all but the most detailed histories. In one raid on London on 16 February 1918, enemy aircraft flew by night up the moonlit Thames and dropped a 227-kilogram (500-lb) bomb on the Royal Hospital (the Germans maintained that, in spite of its name, the RHC was a legitimate target because the residents were still technically reservists). A captain and his wife, their two children and their niece were killed as the north-east wing of Light Horse Court was obliterated. At the end of the conflict, British military casualties were so great that the Royal Hospital was forced to introduce a minimum age for In-Pensioners: it no longer accepted anyone younger than forty-five.

During the Second World War, the RHC came under frequent attack as the Luftwaffe targeted London in the Blitz. The most devastating raid on the Hospital came on the night of 16 April 1941, when the east wing of Soane's Infirmary was destroyed, with the loss of thirteen lives. After the war the whole building was demolished, and in the 1960s it was replaced by the National Army Museum.

In the second half of the twentieth century the Hospital underwent gradual but momentous modernization. A new Infirmary opened in 1961; the Prince of Wales Hall, a social centre for In-Pensioners, was completed in 1985. From the 1980s the RHC's funds, which had been taken from the budget of the Ministry of Defence, were provided by grant-in-aid direct from central government. In 2009 the RHC let in women. Second World War veterans Dorothy Hughes (aged eighty-five) and Winifred Phillips (eighty-two) hit the headlines as the first female In-Pensioners, but at least two others – Christina Davis and Hannah Snell – had preceded them as Out-Pensioners (entitled to a pension but not residing in the Hospital) in the 1700s. While the twenty-first-century recruits entered the Chelsea Gate under their true colours, their Georgian antecedents had needed to pass themselves off as men.

Today the RHC continues to be run on semi-military lines (see p. 218). A board of commissioners (trustees), appointed by the monarch, is chaired by the Hospital's Governor. The board also includes the Lieutenant Governor, responsible for the day-to-day running of the Hospital and the development of policy. In-Pensioners are grouped into several companies, each of which has its Captain of Invalids; there are also a company Sergeant Major and Long Ward representatives from within the In-Pensioner community. At the time of writing, the RHC was home to some 300 male and three female In-Pensioners, with at least two more women set to move in. Candidates for residence must be ex-army widowers or widows, unmarried or divorced. They are normally no less than sixty-five years of age. The selection process involves a four-day 'look-see' and an interview. In-Pensioners are encouraged to make a contribution according to their abilities and interests, and many engage in paid work at the Hospital, typically as infirmary orderlies, tourist guides or clerical assistants.

Royal Hospital funding remains a constant challenge. The Chelsea Pensioners' Appeal, launched in 2004, has financed the building of the Margaret Thatcher Infirmary, opened in 2009, and the renovation of the Wren-designed North East Wing, completed in 2010. The remainder of the development programme, scheduled for completion in 2015, will see the transformation of the layout of the Long Wards in Wren's Figure Court, where on each storey thirty-six In-Pensioners currently share four lavatories and two showers, into accommodation composed entirely of en-suite study bedrooms.

The main annual event at the Royal Hospital is Founder's Day, which is held close to 29 May, the date of both Charles II's birth and the Restoration; the event also celebrates the future king's escape following defeat at the Battle of Worcester in 1651, when he hid in an oak tree to avoid capture by Parliamentary forces. It is in spring, in the build-up to what has become known in the outside world as Oak Apple Day, that we begin Patricia Rodwell's evocative and unique photographic record of a year at the Royal Hospital Chelsea.

The Royal Hospital year is here encapsulated in contrasting images: the pageantry of Founder's Day at the start of summer and a silent blanket of winter snow.

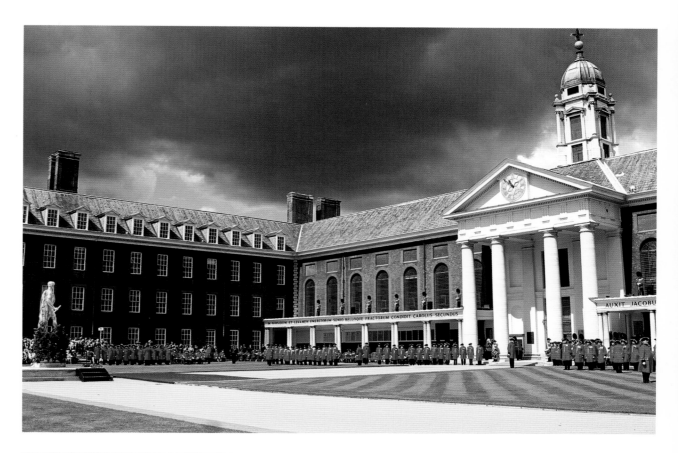

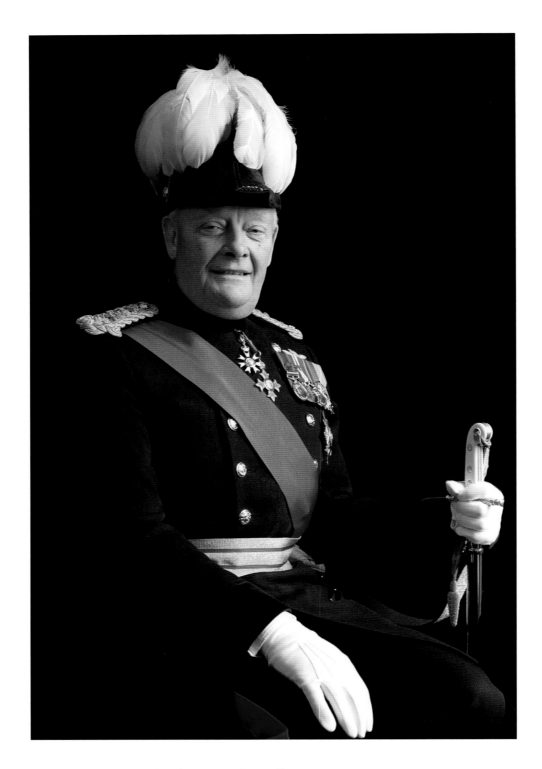

General The Lord Walker, GCB CMG CBE DL
Governor, 2006–2011

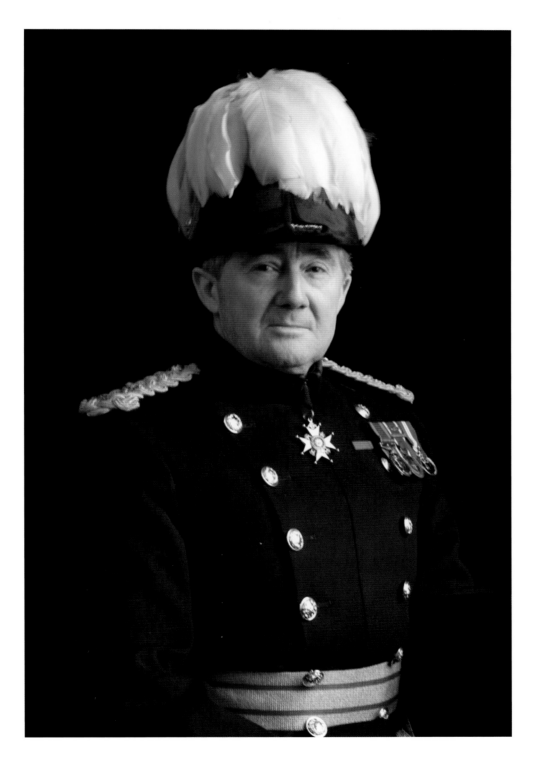

Major General Peter Currie, CB
Lieutenant Governor

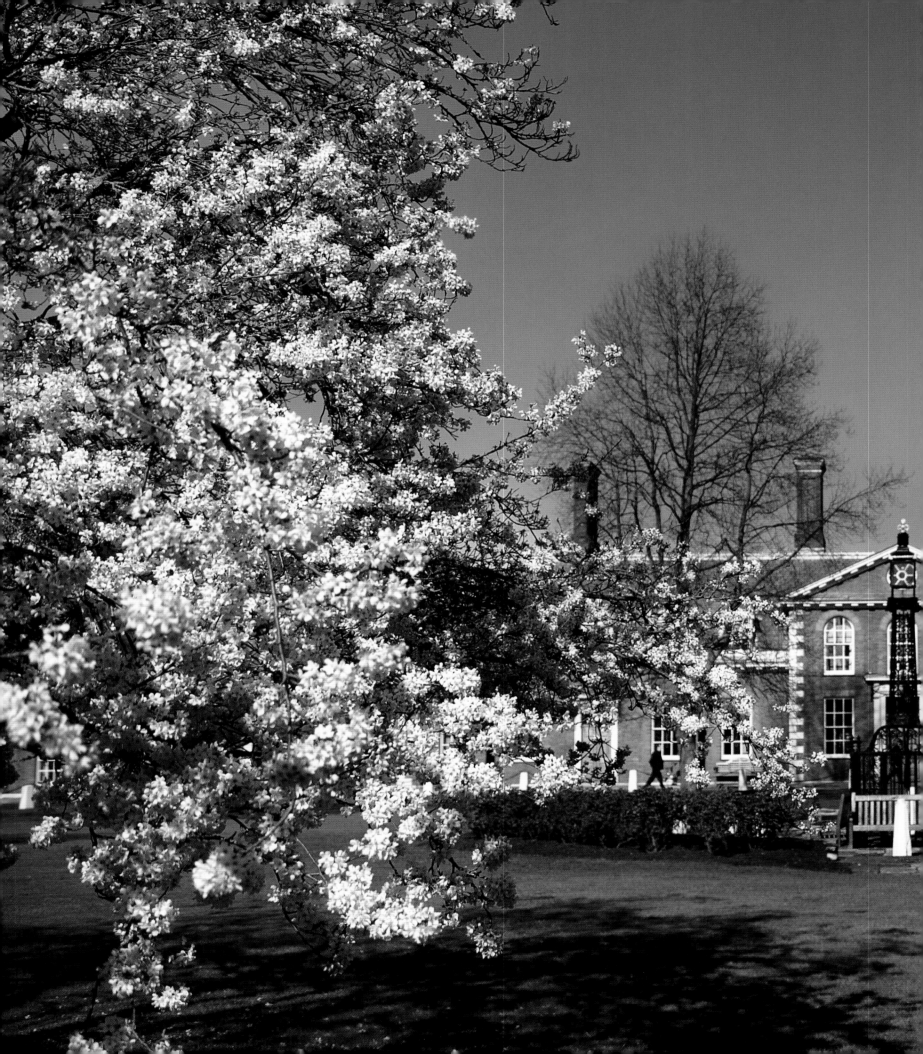

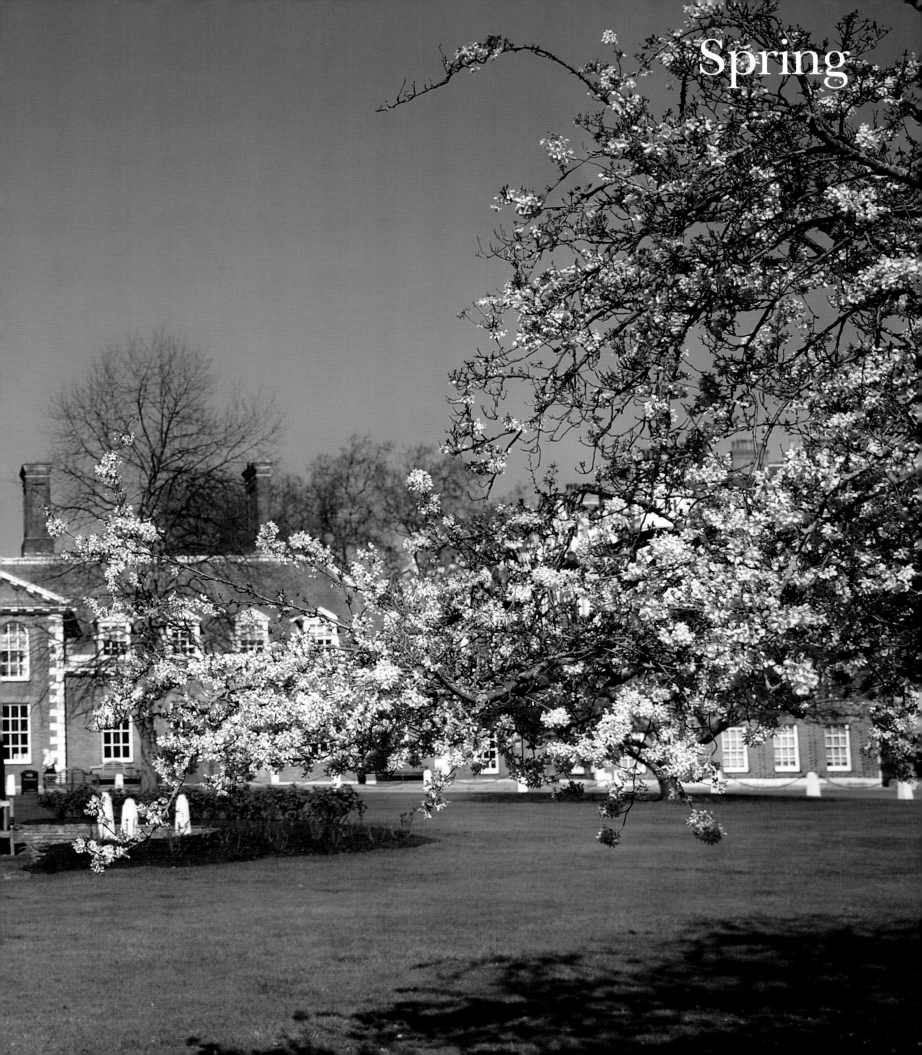

Spring

Anyone visiting the Royal Hospital Chelsea in late February or early March might be forgiven for thinking that winter had somehow passed by the foundation. When the earliest blossoms flaunt themselves on the boughs and the first daffodils sprinkle the lawns, if mud and leaves ever disfigured the grounds no trace of them remains; they have long been cleared away by assiduous staff. The captured cannon on the South Terrace have been de-grimed and made again as resplendent as they must have looked on the day they were accessioned into Napoleon's Grande Armée more than 200 years ago.

In the lengthening days the Royal Hospital devotes much of its attention to the universal preoccupations of spring – cleaning, rejuvenation. Freshly pressed dress uniforms get their first annual airings; buttons, though polished to the same degree year-round, now reward the effort most sparklingly. The Governor on walkabout satisfies himself that Grinling Gibbons's statue of Hospital founder Charles II still glisters as it has glistered every year since it was regilded for Queen Elizabeth II's Golden Jubilee in 2002.

All nature seems at work, but the efforts of In-Pensioners and auxiliary staff are not routine seasonal ends in themselves: they are contributions to a greater common objective, that of ensuring that the Royal Hospital is next season displayed to its best advantage on Founder's Day, the focal event of the year.

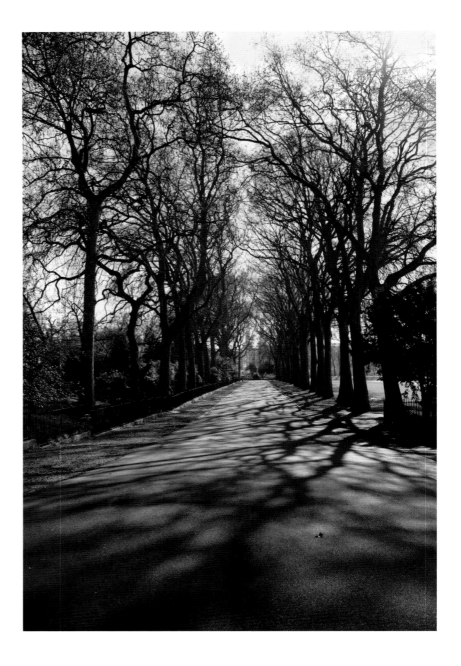

Previous pages:
Spring blossom on still-bare branches in Light Horse Court.

Clockwise from above:
Avenue in the South Grounds, leading to the River Thames; Bullring Gate on Chelsea Embankment, South Grounds; view of the Chillianwala Obelisk and the main quadrangle around Figure Court, from the South Grounds; early colour in Light Horse Court.

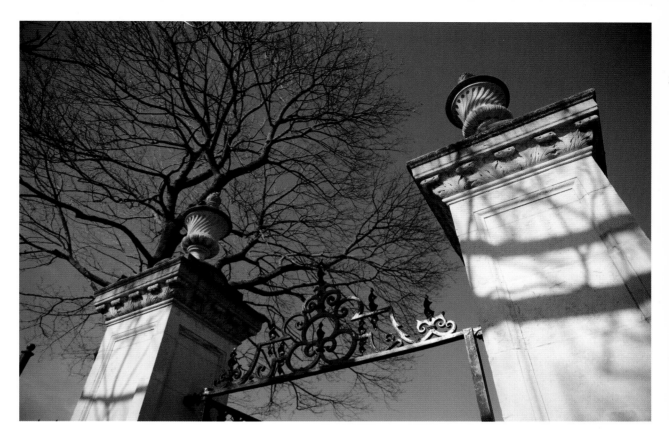

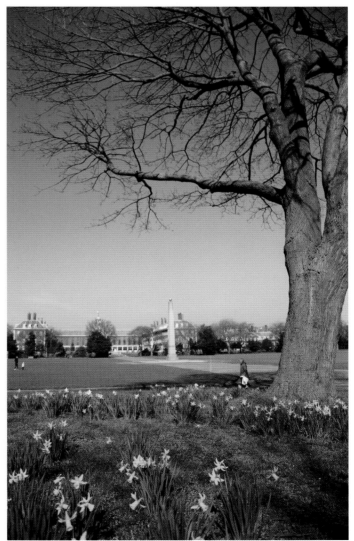

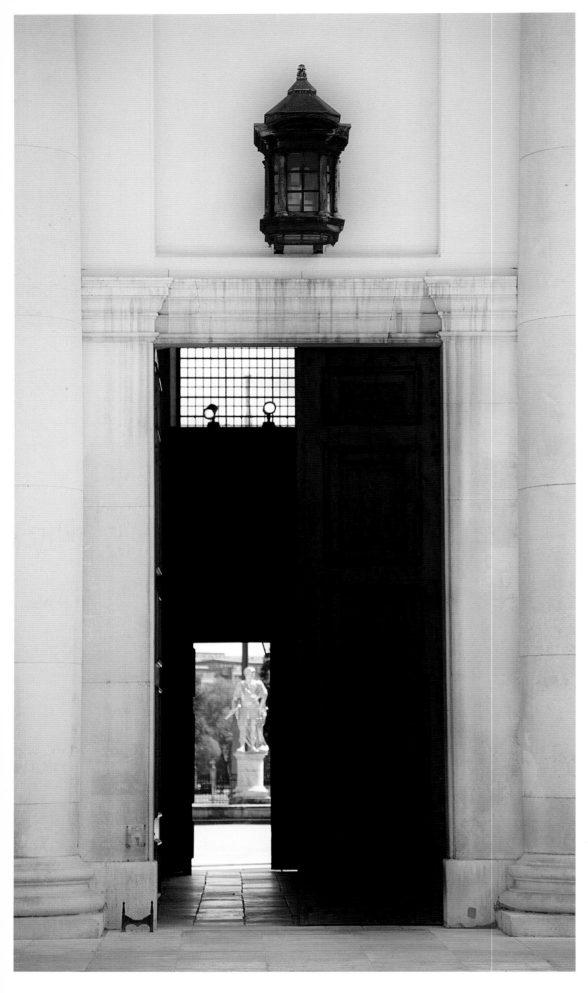

THE OCTAGON

The Octagon porch, topped by the Royal Hospital Chelsea's distinctive cupola, seen from the Chapel Gate entrance on Royal Hospital Road to the north of the building. The Octagon (named after its internal plan) and its vestibule are the centrepoint of the northern range of the Royal Hospital buildings, and link the Great Hall and the Chapel. Together, they form the oldest part of the Royal Hospital, and were designed by Sir Christopher Wren and completed in about 1690. The Octagon's large double doors – still the originals, built in 1687 – were constructed to allow the passage of mounted troops making their way through to and from Figure Court (glimpsed through the open doors, left) and the River Thames.

Opposite, a group of visitors on a tour of the Royal Hospital stands next to a statue of a Chelsea Pensioner by Philip Jackson, which was unveiled in 2000. Its base is inscribed with the soldier's prayer, based on that said by Sir Jacob Astley before the Battle of Edgehill (1642), the first pitched battle of the English Civil War: 'O Lord you know how occupied I shall be this day. If I forget thee do not forget me.'

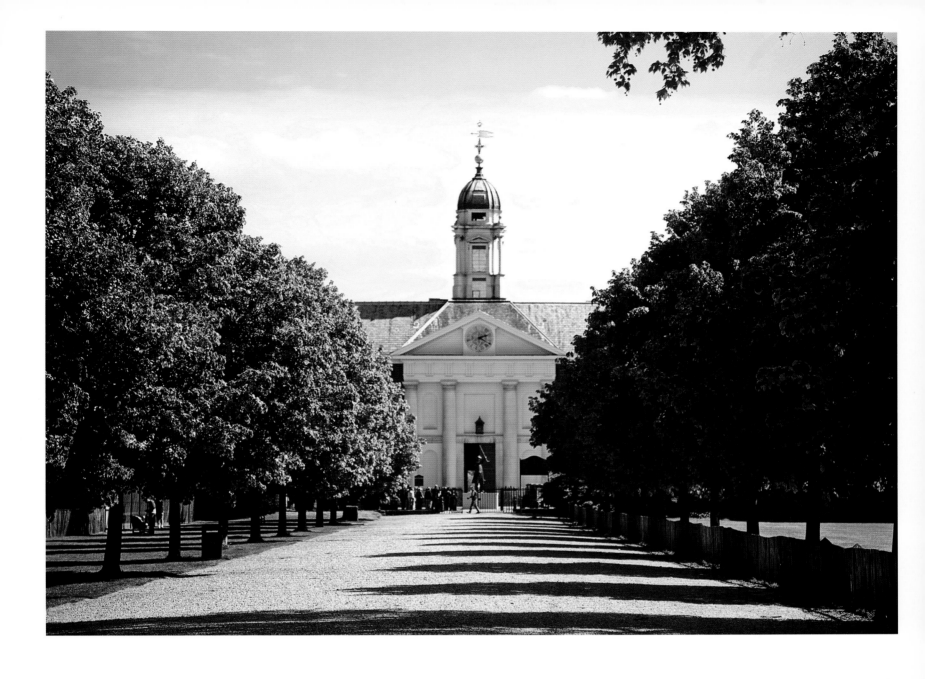

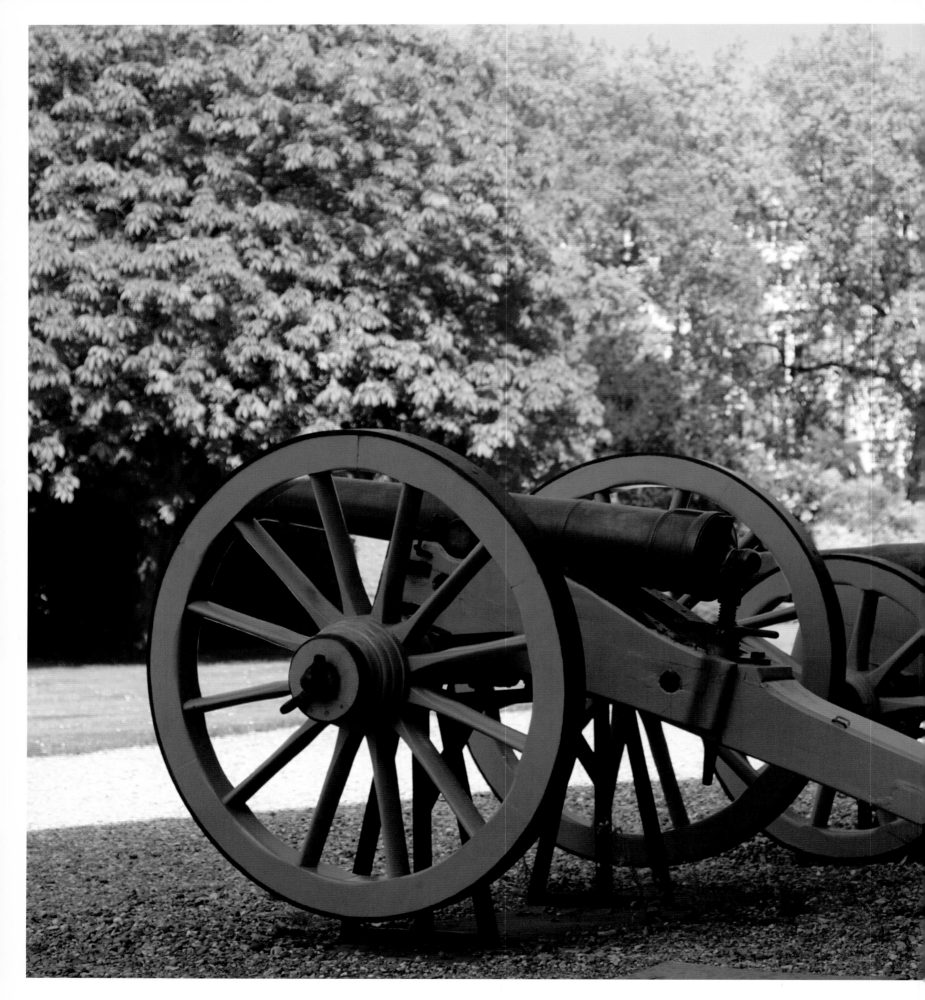

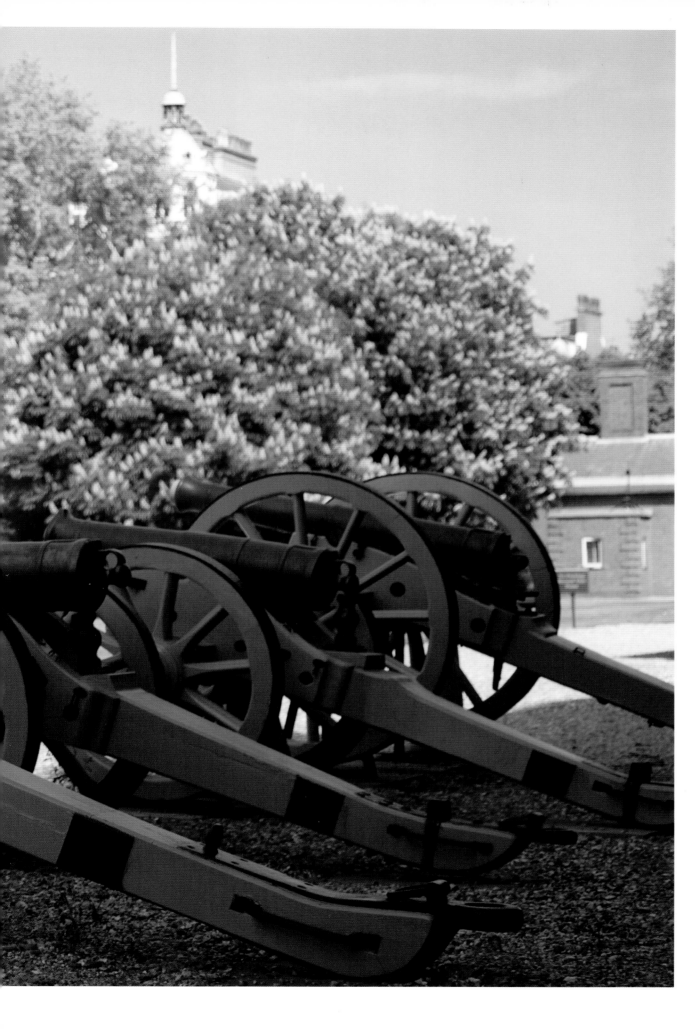

Four French cannon captured at the Battle of Waterloo in 1815 sit in the Royal Hospital's grounds, reminders of the establishment's military history. Near by sit two cannon taken from the Sikhs at the Battle of Chillianwala (1849; see also pp. 154–57), a Chinese piece from about 1680 and a Dutch cannon dated 1623.

THE QUARTERMASTER'S CLOTHING STORES

In-Pensioner (I.P.) Don Matthews working at the Stores and (opposite, top) helping a Store assistant to kit out a new 'recruit'. In-Pensioners make a great contribution to the running of the Royal Hospital, with some 100 I.P.s acting as, among other things, volunteer guides, chapel and museum attendants, and clerical and shop staff.

In-Pensioners may wear civilian clothes when going out, but all I.P.s are issued with the Royal Hospital's famous scarlet frock coat, used for formal occasions, and 'blues' for everyday wear in the Hospital grounds and within 2 kilometres (1.24 miles). Along with their uniforms, I.P.s receive various items of headdress: the tricorne (opposite, top; see also p. 32); the shako (opposite, top shelf; see also p. 33); and the lounge cap (opposite, bottom shelf), which may not be worn outside the Royal Hospital grounds and is the only one I.P.s may adorn with the cap badge of the regiment or corps in which they served.

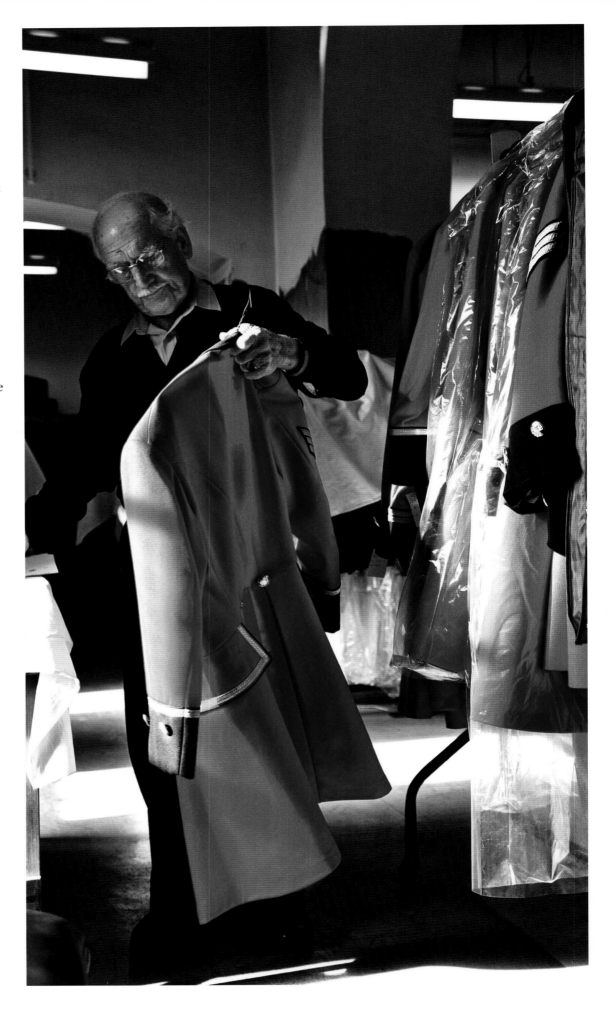

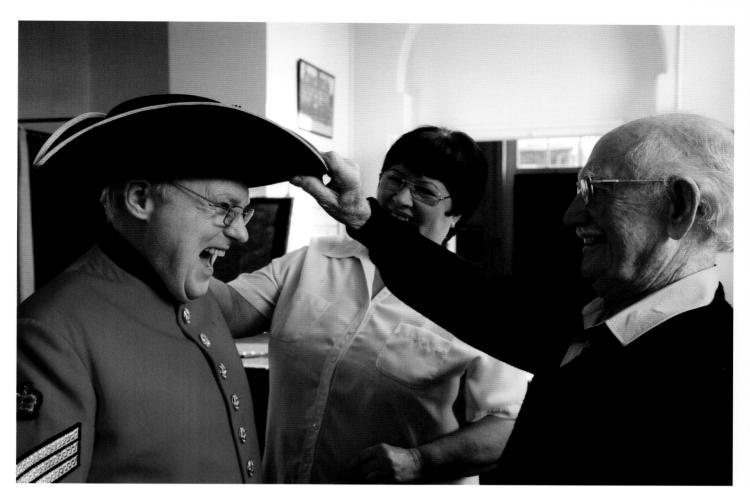

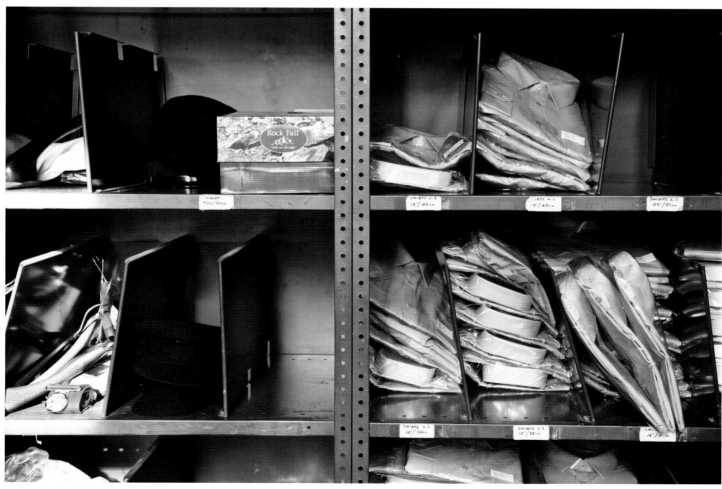

An assortment of medal ribbons and various ranks (below) in the seamstresses' room, waiting to be sewn on to new I.P.s' coats. The ribbons' colours represent specific medals or awards, to be worn on 'scarlet' only. For each individual I.P., his or her relevant ribbons are put together as a bar on to which the corresponding medal or award can be pinned on formal occasions (see p. 92).

(see p. 92)

A dust jacket protects sets of the In-Pensioners' frock coats (below, right). To ensure perfect fit, the 'scarlets' are adjusted by a seamstress (opposite, bottom) before finally being issued to new In-Pensioners.

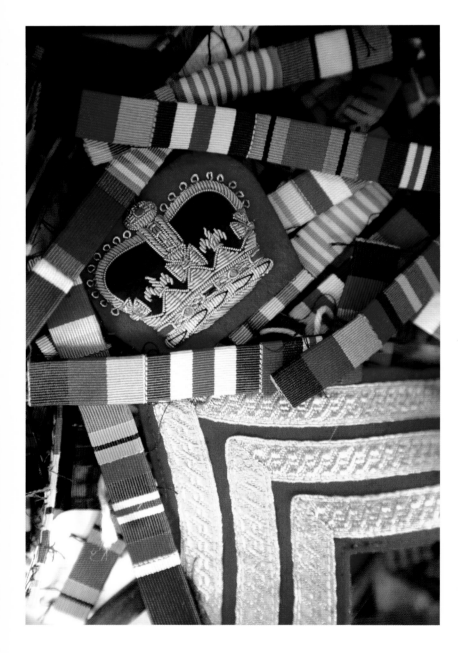

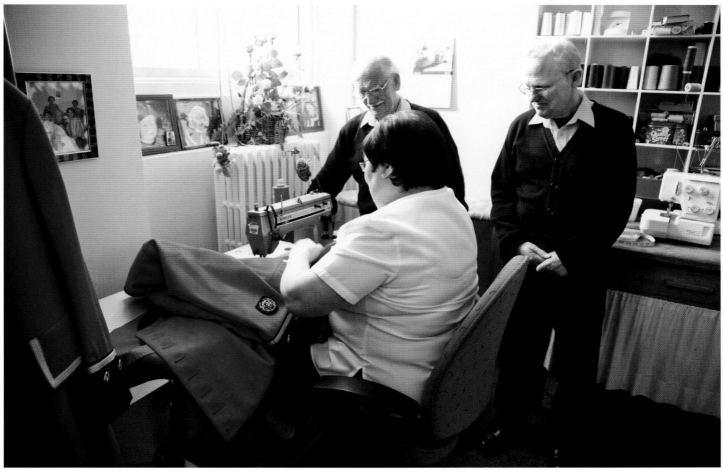

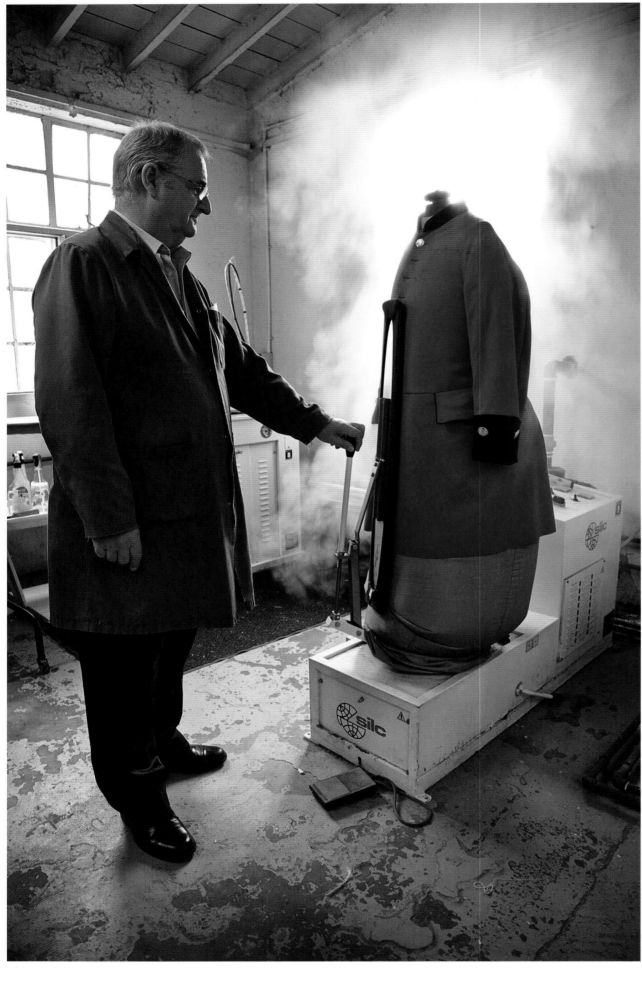

An In-Pensioner's scarlet is steam-pressed. When set on a hefty frame, slightly too-tight scarlets can also be stretched by steaming so that they will fit more comfortably.

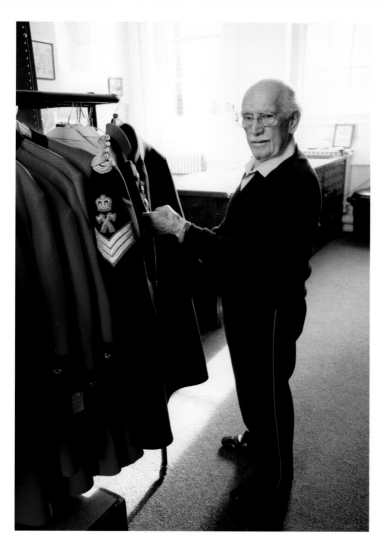

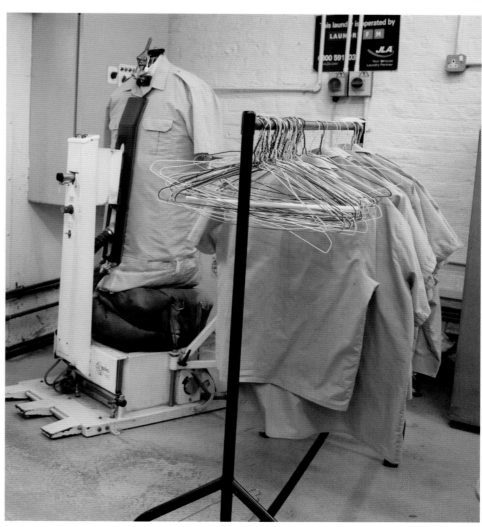

I.P. Don Matthews carefully checks out a uniform before it is stored away (above, left). Staff at the Royal Hospital's laundry and dry-cleaning room (above and left) help to ensure that the In-Pensioners are impeccably turned out at all times.

The tricorne hat and its cockade adornment (opposite) have been part of In-Pensioners' attire since the Royal Hospital opened in 1692. Style details have changed over the years, but the basic shape has remained the same. The headdress is worn only in the presence of royalty or on church parades.

The shako (right), adapted from a French design, has been worn as an In-Pensioner's 'undress' item of head gear since about 1800.

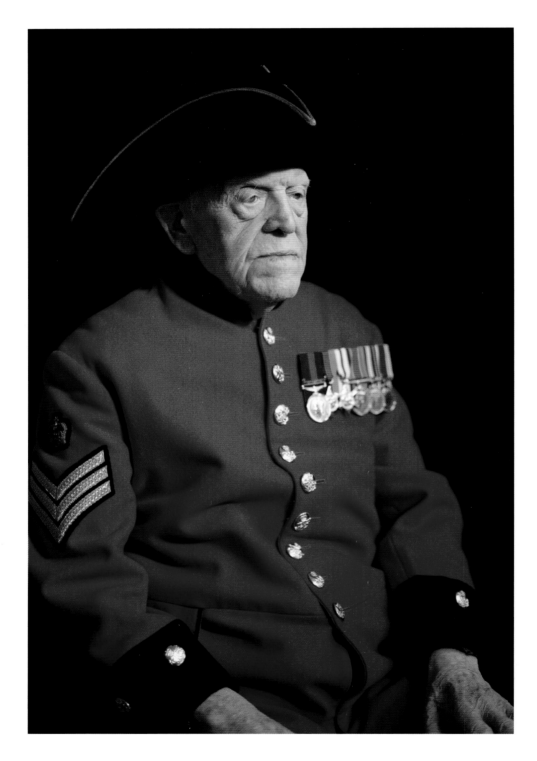

I.P. Patrick Brady

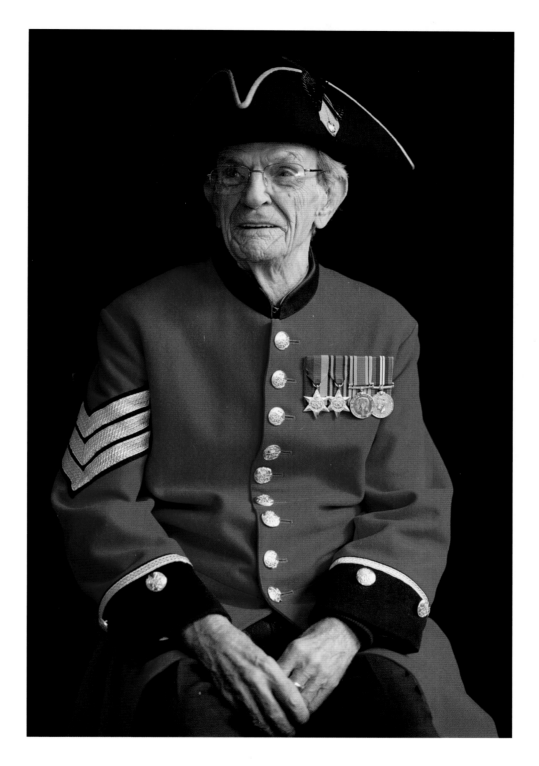

I.P. Sid Sanderson

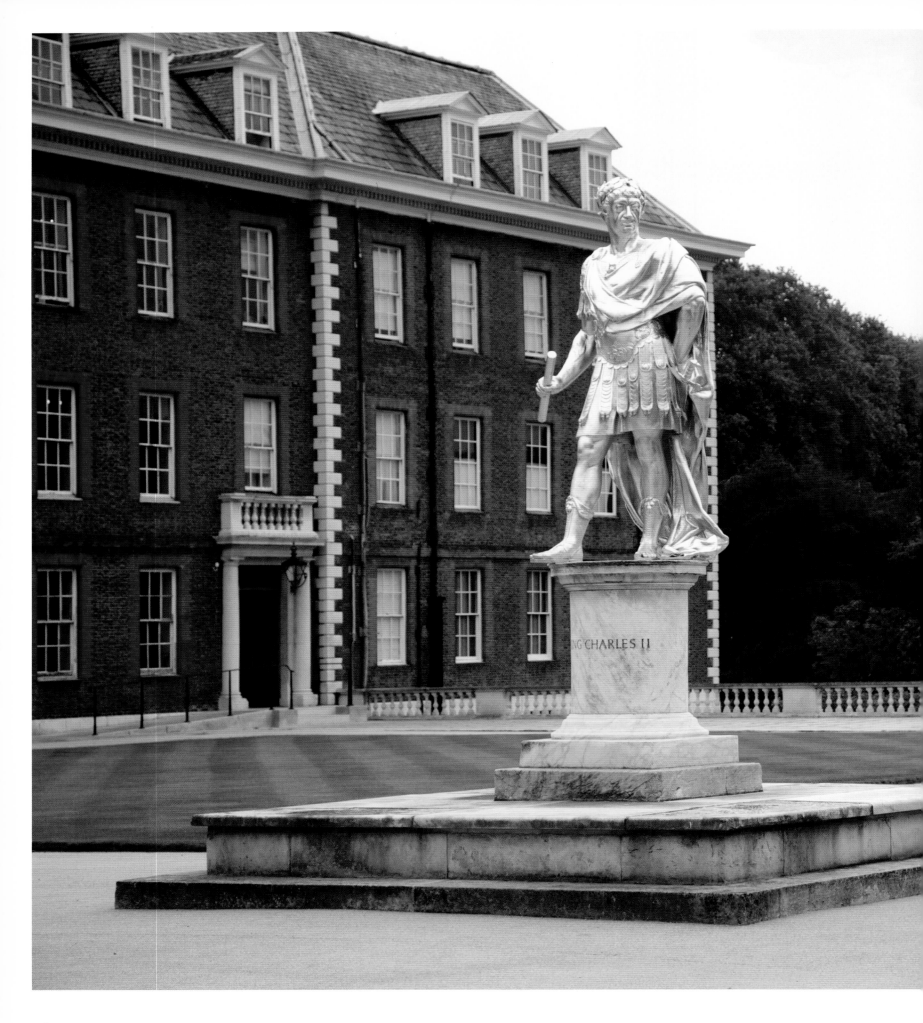

THE GOVERNOR'S PARADE

The Lieutenant Governor, Major General Peter Currie (far left), and the Duty Officer, Captain of Invalids Lieutenant Colonel Rupert Lucas, perambulating Figure Court before taking the weekly Governor's Parade, held every Sunday before chapel. During the ceremony, which is open to the public, a detail of men is inspected, and they are sometimes joined by various visiting regimental associations, such as the Royal Signals Association (overleaf), which took part on 5 September 2010.

Figure Court, where the parade is held, is named after the gilded statue of Royal Hospital founder Charles II (see p. 69).

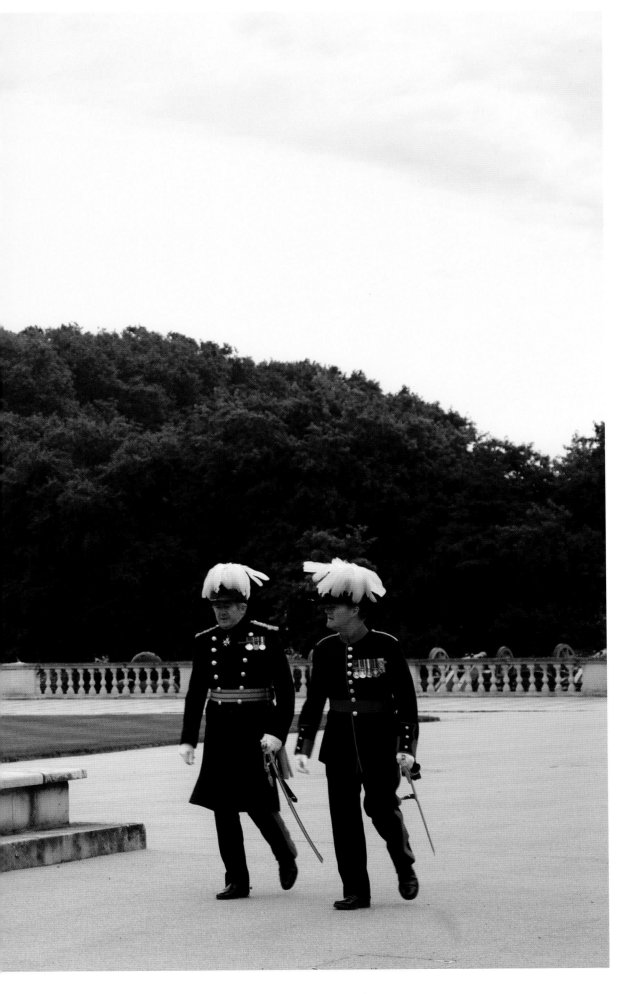

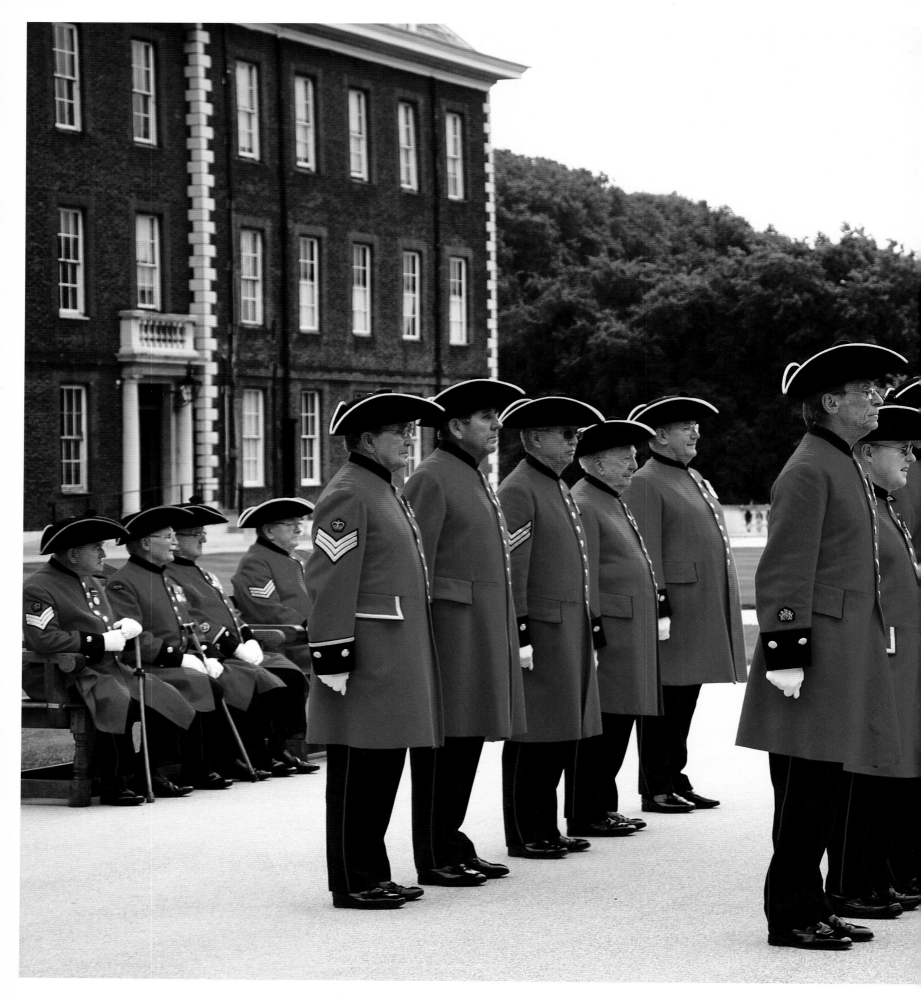

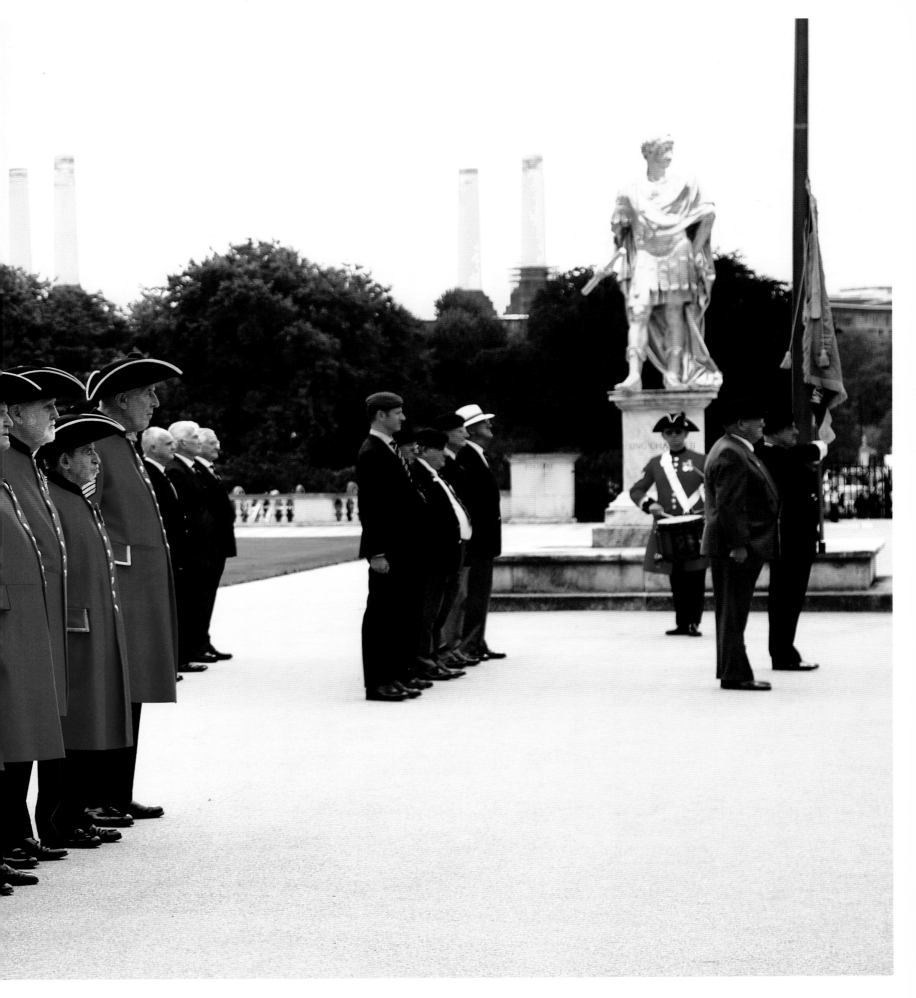

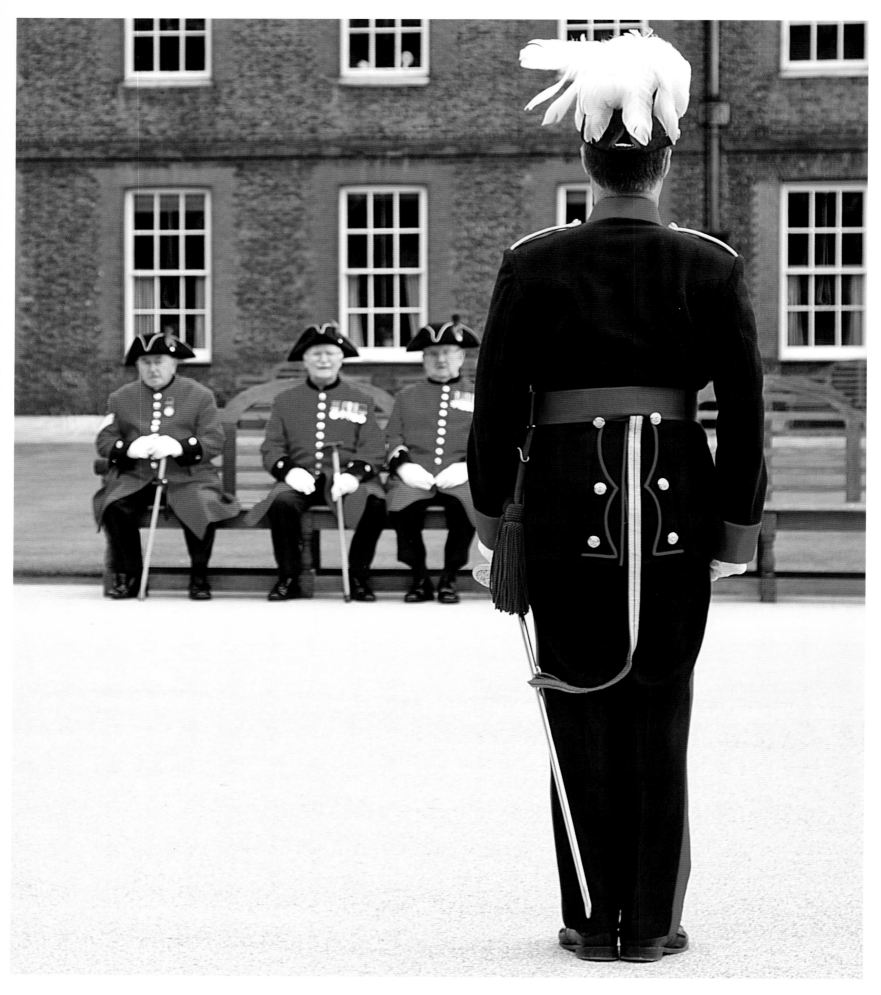

The Duty Governor at the Governor's Parade ceremonially inpects all the I.P.s present, including those too frail to stand (opposite).

Duty drummer I.P. Tom Metcalfe (right), beating the officers on parade. Before the advent of radio communications, all battlefield orders were issued by either the drum, the bugle or the trumpet. At the Royal Hospital a drum is used to call officers on parade.

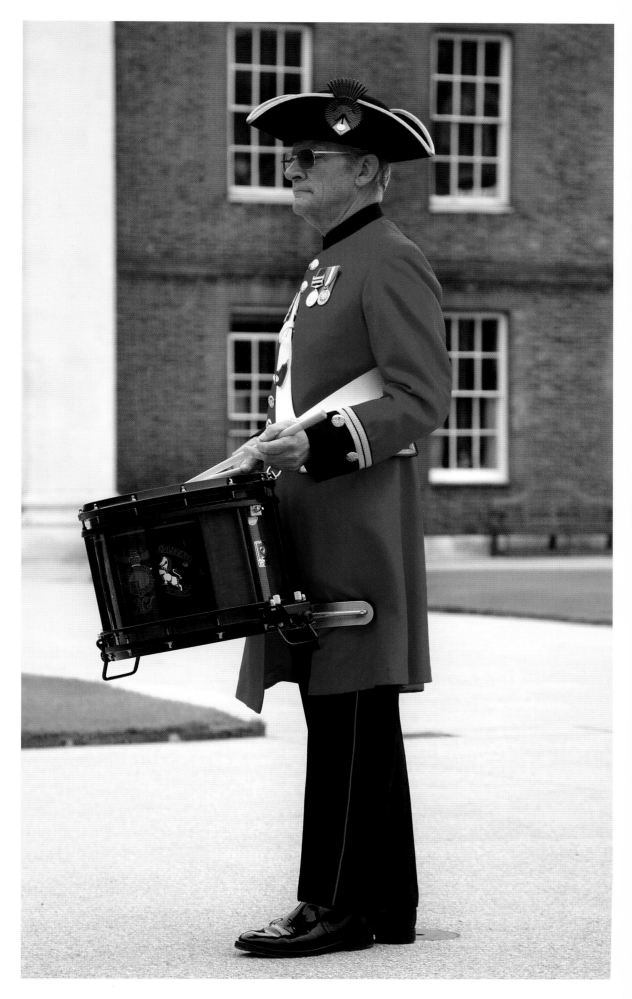

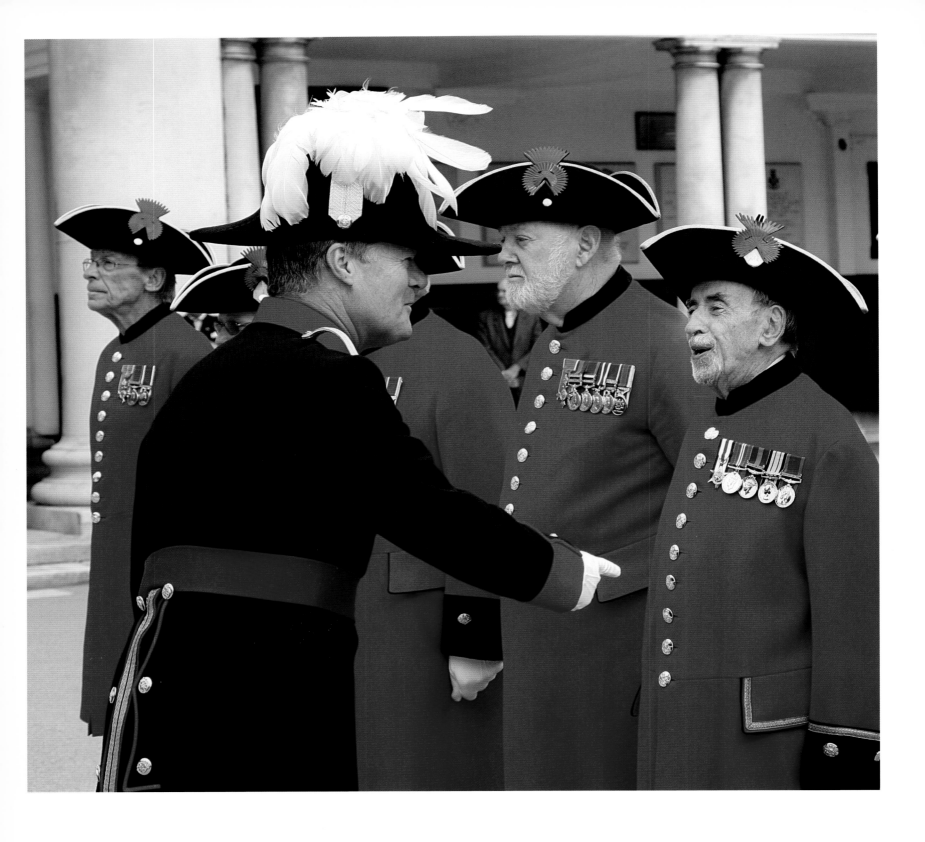

The Duty Governor inspecting the front ranks during the Governor's Parade (opposite), and In-Pensioners retiring to chapel at the conclusion of the ceremony (right).

The officers' ceremonial uniforms – with their blue frock coat, bright sash and sword belt – are based on the ones worn at the Battle of Waterloo in 1815. The style of their flamboyant swan-feathered bicorne hats dates from about 1870.

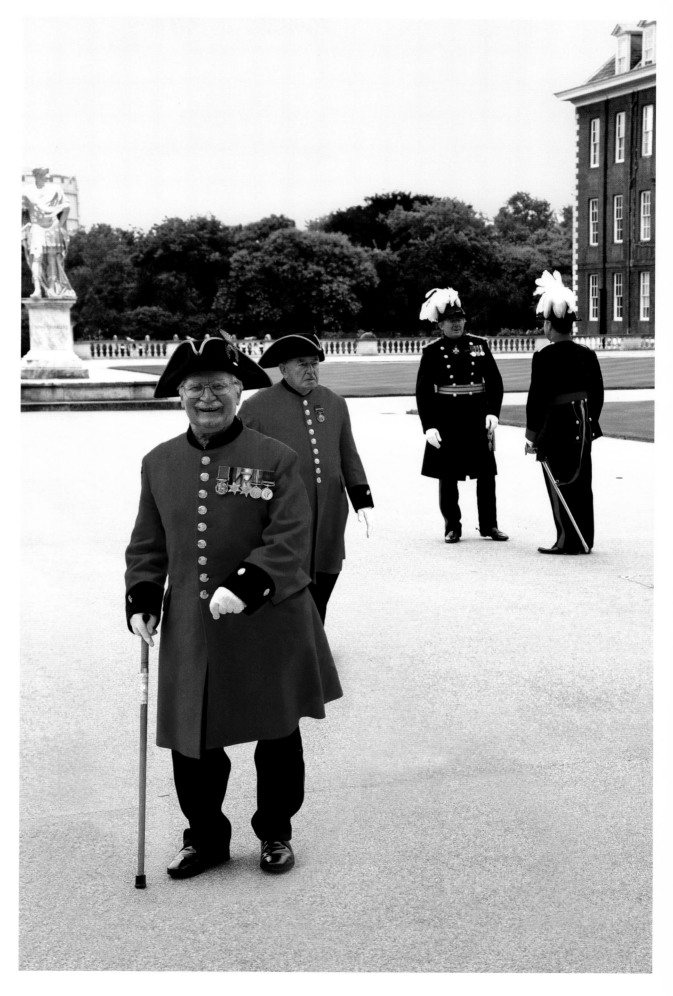

I.P.s Nick Clark, David Robertson and Chris Melia (foreground, left to right) and the other In-Pensioners leaving the Governor's Parade mingle with visitors in the Colonnade before the start of the Sunday service at the Royal Hospital Chapel.

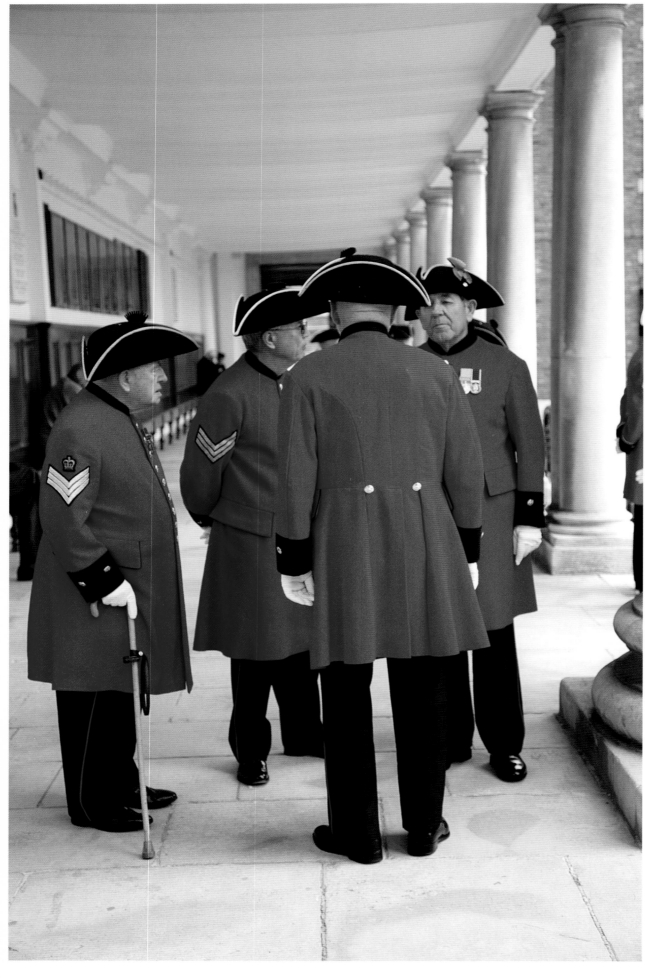

The Colonnade's cloister-like construction makes it a practical and sheltered gathering place as well as an elegant passageway linking the Royal Hospital's three courts: College Court to the west, Figure Court in the centre (along the north side of which the Colonnade runs) and Light Horse Court to the east.

The Latin inscription on the frieze announces to all that the Royal Hospital Chelsea was established 'for the succour and relief of veterans broken by age and war, founded by Charles II, enlarged by James II [Charles II's brother] and completed by William and Mary [James II's daughter] in the year of Our Lord 1692'.

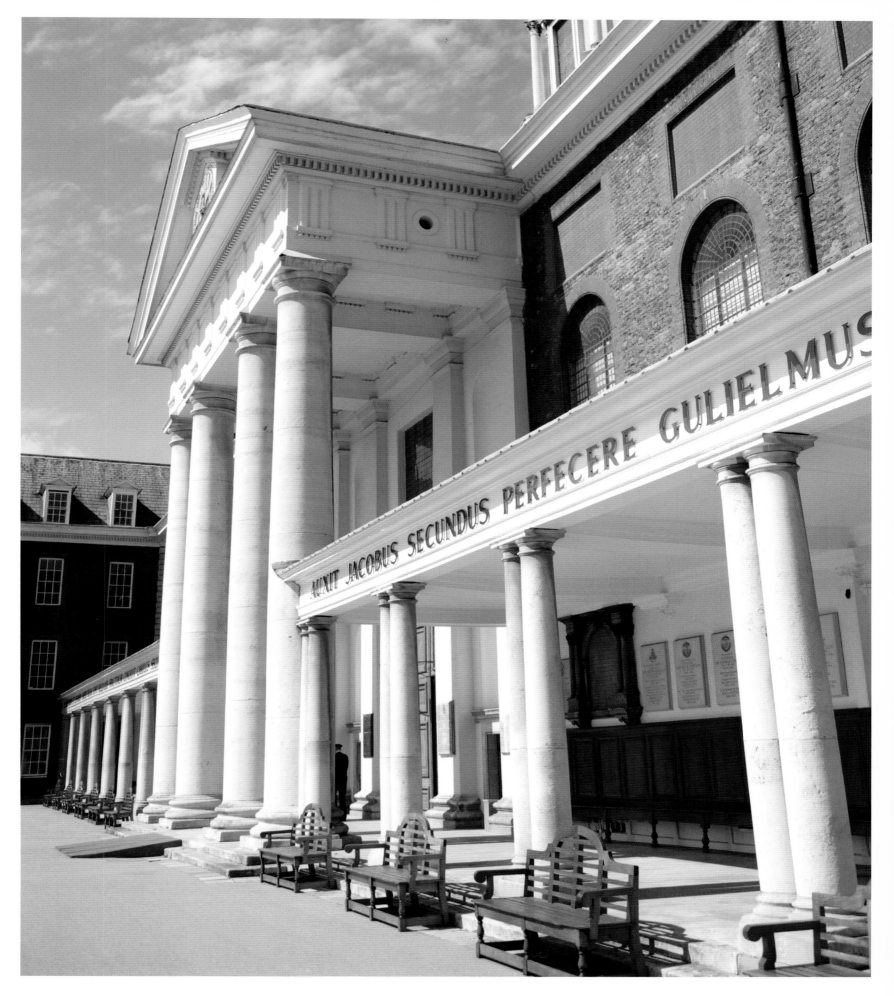

The Chapel, designed by Wren with seven windows of plain glass on each side to allow God's clear light to flood in, is the jewel in the crown of the Royal Hospital. Its decorative simplicity – there are no pictures, icons or colour to distract the eye, the heart or the soul – and collegiate style of seating (facing the central aisle rather than the altar) make it an inspiring place for worship. The chapel was consecrated in 1691, the year before In-Pensioners first took up residence in the Hospital, and is now a parish chapel; its services (opposite) are open to local residents and visitors. A choir, placed in the centre of the Chapel, attends each service.

The Chapel's beautiful carvings (visible opposite, for example in the bosses at the top of the wainscoting and in the domed pediment resting on its Corinthian columns) are by notable wood carvers of the late seventeenth century, including Grinling Gibbons and William Emmett, and the plasterwork was done by Henry Margetts. The floor is of black and white marble paving. The large mural of the Resurrection behind the altar, painted by Sebastiano Ricci in 1715, depicts the stillborn children of Charles II's wife, Catherine of Braganza; she bore him no surviving children.

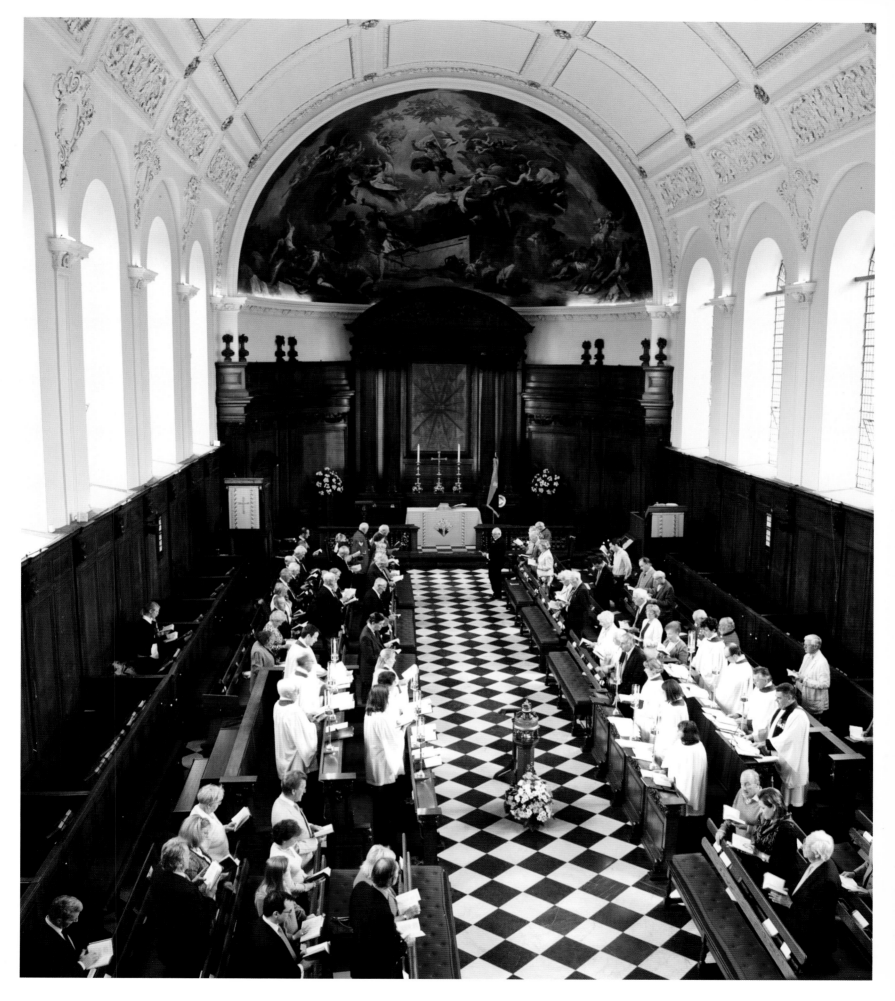

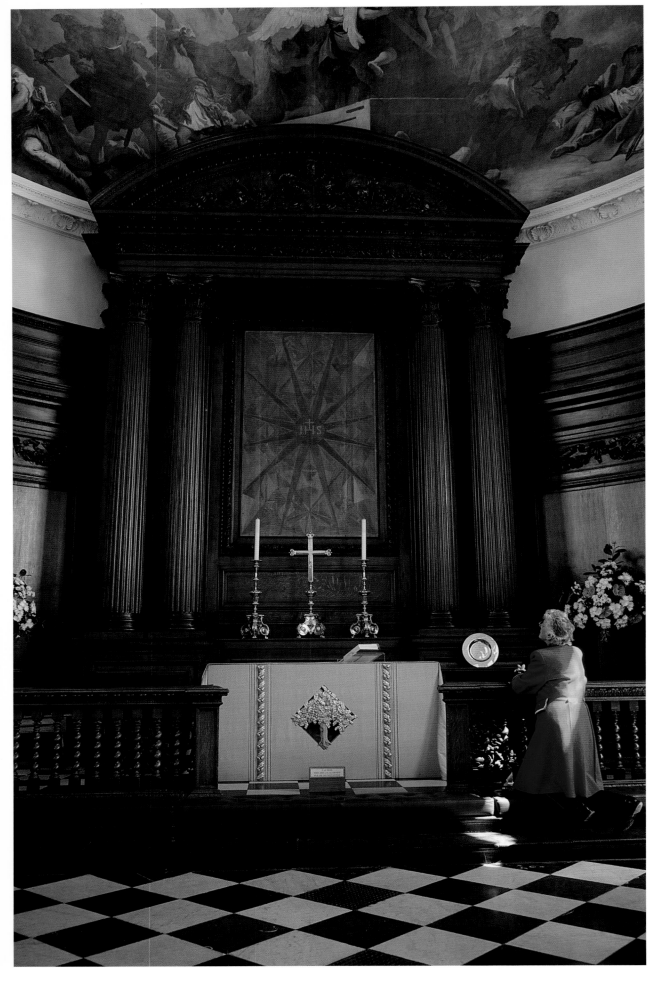

I.P. Marjorie Cole reflects by the Chapel's altar. The pulpit is covered in a cloth featuring a central lozenge embroidered with an oak in full leaf in reference to Charles II. The marquetry panel between the columns is thought to have been taken from a church in London before the Great Fire of 1666, thus saving it from destruction.

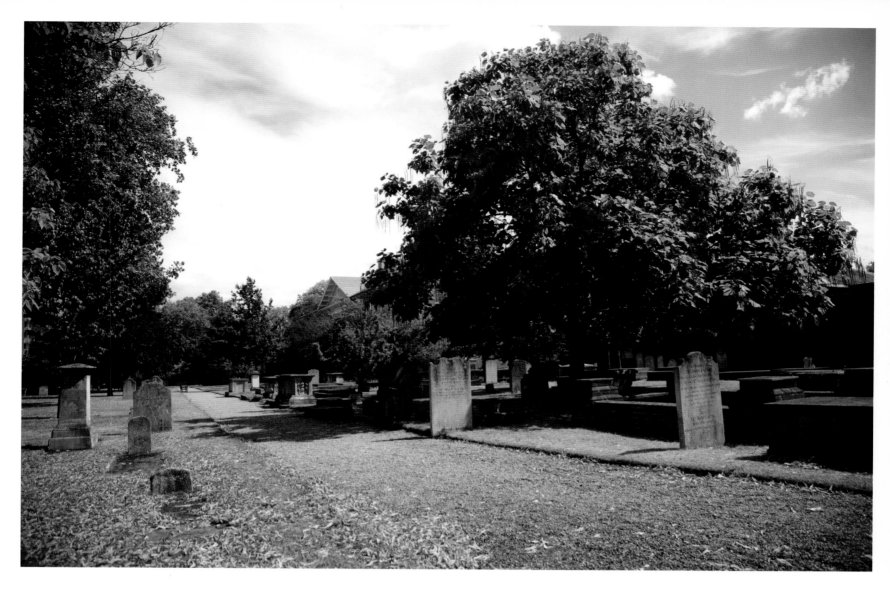

THE BURIAL GROUND

Between its consecration in 1691 and its closure in 1855, the Royal Hospital Chelsea burial ground became the final resting place of more than 10,000 pensioners and others connected with the establishment, such as William Cheselden, the pioneer of modern surgery (died 1752), and architect and engineer Samuel Wyatt (died 1807). After its closure, for nearly forty years burials took place at nearby Brompton Cemetery, until the Royal Hospital purchased its own burial grounds in Brookwood Cemetery near Woking, Surrey, in 1893. However, the burial ground at the Royal Hospital has now reopened for the scattering of cremated remains. The names of all deceased In-Pensioners are recorded in books of remembrance kept in the Infirmary chapel.

Martin Bell

*Former BBC foreign affairs correspondent
and former Member of Parliament*

For me, the Royal Hospital Chelsea is living history. It is more than 300 years old, yet the idea of an institution founded for the 'succour and relief of veterans broken by age and war' is as up to date as today's news from Afghanistan.

Our armed forces are engaged in that country – by no means for the first time – in their most intensive armed combat since the Korean War. In due course some of those veterans will join the proud ranks of the Chelsea Pensioners. Let us not forget that, because of the remarkable front-line care in the field hospital at Camp Bastion [the main British military base in Afghanistan], soldiers are now surviving injuries that in any other war would have killed them. Let us not forget also that some of the most lasting injuries are those to the mind, in what is now known as post-traumatic stress disorder (PTSD). We have never owed more to our men and women in uniform. And I hope that we no longer take our debt to them for granted.

There are those who argue that the care of veterans is entirely a matter for the government. Of course the politicians have their part to play – not least because it is as a result of their decisions that our soldiers' lives are on the line in Afghanistan and elsewhere. The casualties are brought home to us as never before. But we the people also have a part to play. We have played it in our response to the Royal Hospital's fundraising appeal [see p. 220]. We play it in our remarkable support for other military charities, such as Help for Heroes. And we play it in our support on the streets for the homecoming parades of battalions and regiments back from hazardous tours of duty in foreign lands.

I believe that something remarkable is going on, which is very much in the tradition of the Royal Hospital. It is a breaking down of the barriers that used to separate the armed forces from civil society, and a decoupling of our respect for the serving men and women from the particular causes for which they were sent to war.

Like many people I know, I had the gravest reservations about the decision to go to war in Iraq; and yet I had no reservations about presenting campaign medals to reservists of the Royal Anglian Regiment who had served there. (And let it be remembered in that regiment's honour that General The Lord Walker, the former Governor of the Royal Hospital Chelsea, was one of the first officers commissioned into it.)

The Royal Hospital, past and present, is the very best of British. I know of no more moving ceremony in the calendar of public events than its early-summer Founder's Day parade. The Guards band strikes up 'The Boys of the Old Brigade', and with stately discipline lines of scarlet march – or wheel – past the sovereign's representative, who takes the salute. Yet in a very real sense it is the In-Pensioners themselves who are being saluted, as they should be.

It has taken a while, after a period of (in my view) disgraceful neglect, for the service and sacrifice of those who have worn the Queen's uniform to be properly appreciated by the rest of us, who live easier and safer lives as a result of their protection.

The Royal Hospital Chelsea reminds us of that military covenant – what our soldiers have done for us, and what in return we know we should do for them. It is part of the bond between us. Long may it flourish.

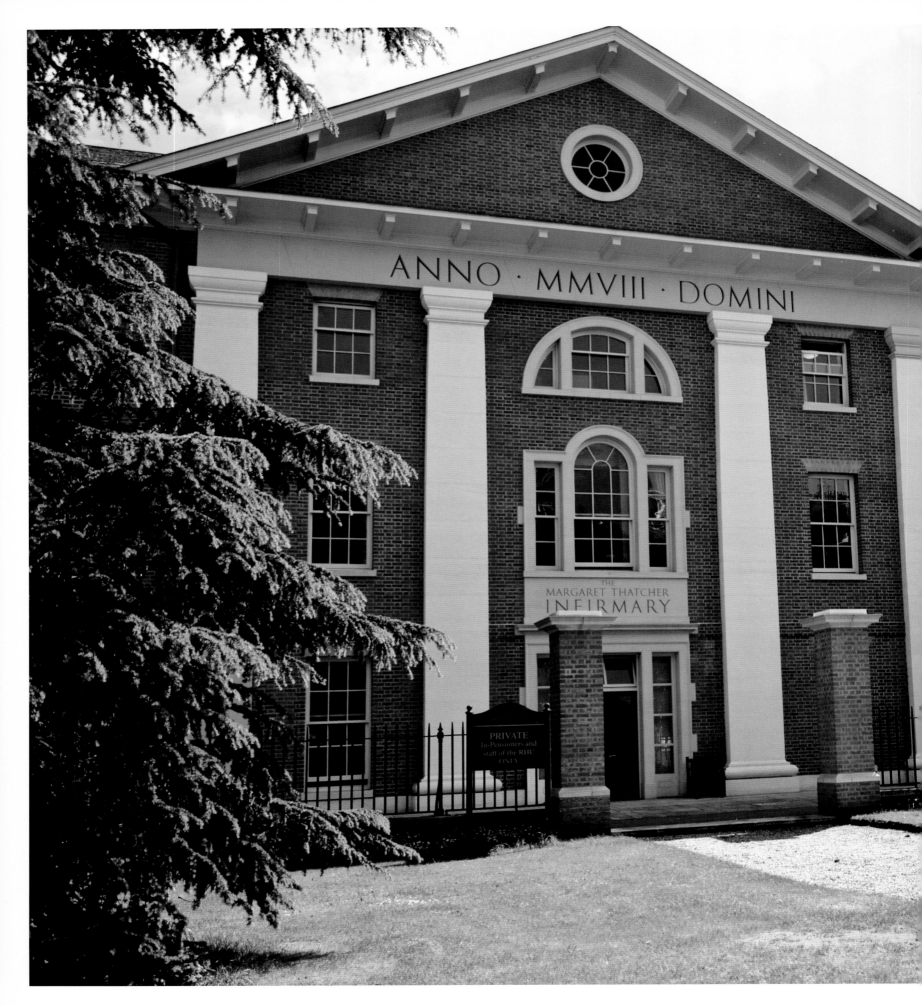

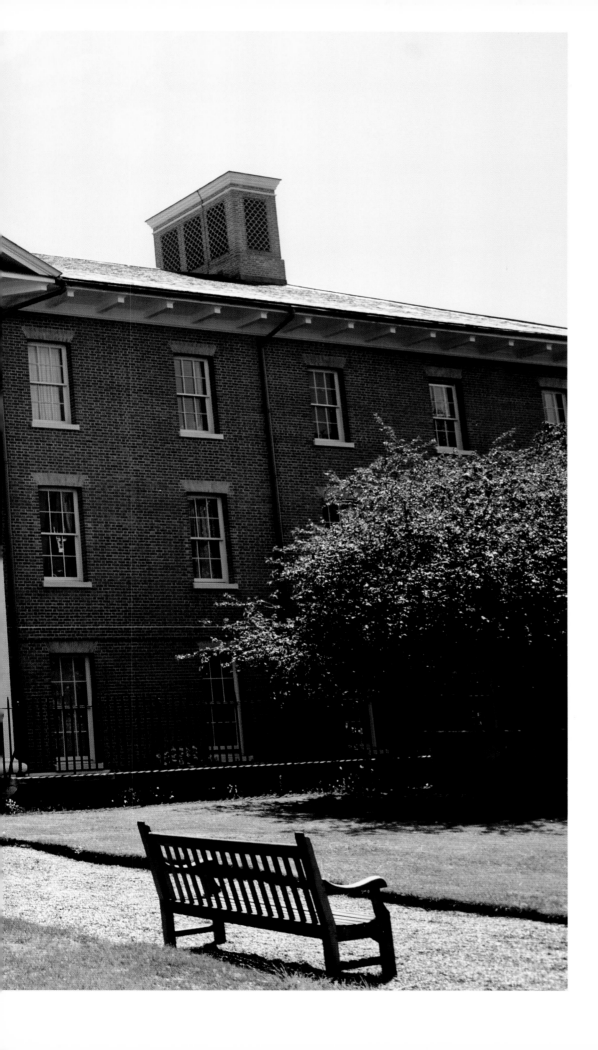

THE INFIRMARY

The Royal Hospital's Margaret Thatcher Infirmary, designed by Quinlan Terry and opened by HRH Prince Charles, Prince of Wales, and former prime minister Margaret Thatcher in 2009, can accommodate up to 125 In-Pensioners who are either ill or no longer able to look after themselves and need round-the-clock care. The Infirmary is a sympathetic building, offering patients their own room with en-suite bathroom and the very best of medical supervision. Surgery and more complicated medical matters are attended to at local hospitals.

Within the Infirmary building is a dispensary, a physiotherapy centre and hydrotherapy pool, barbers, a room for arts and crafts, a thriving coffee shop (open to the public) and a chapel, smaller and more intimate than Wren's Chapel in the northern range of the buildings. Concerts and various entertainments are provided regularly by volunteer musicians, theatre groups and others.

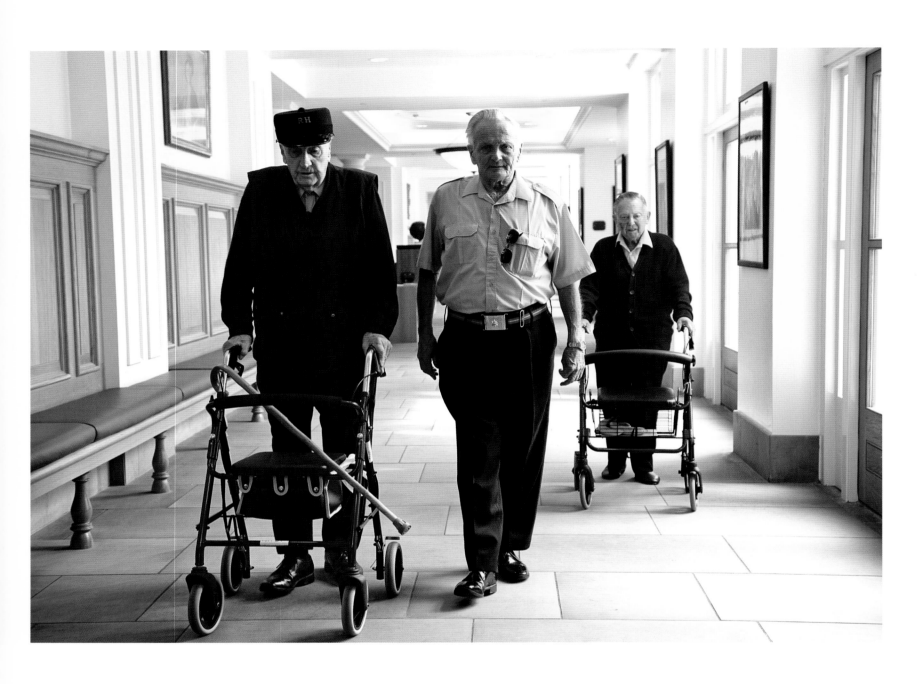

The Infirmary building is designed to be bright and inviting, and to be part of all In-Pensioners' lives: it is where volunteer musicians, such as Esther Parshkov (right), put on lively entertainment, and it also houses the Royal Hospital's popular café, which provides both indoor, rainy-day seating (below) and outdoor garden tables.

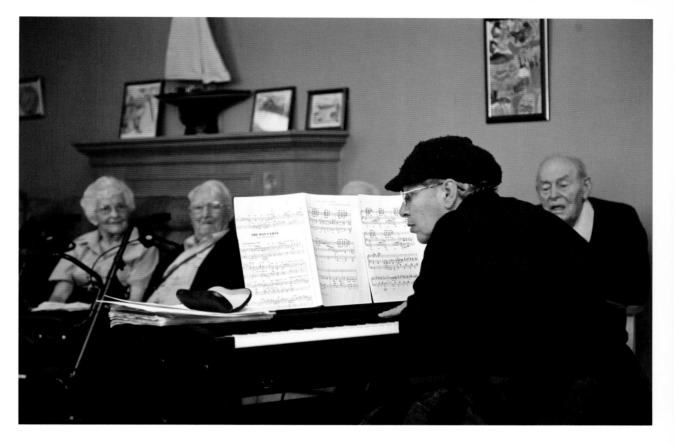

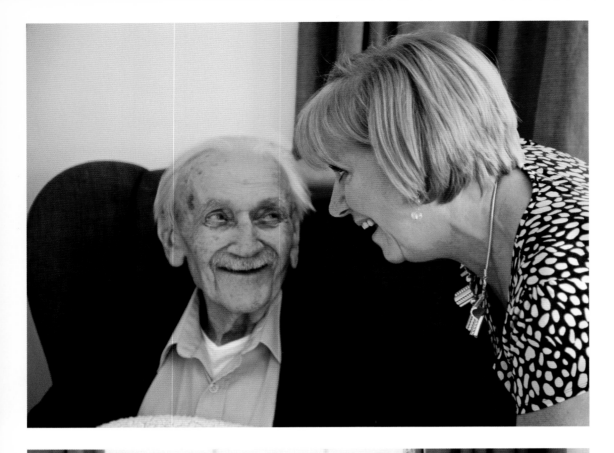

Royal Hospital Chelsea Activities Coordinator Theresa Ayeche (left, with I.P. Bill Ellis) and Senior Staff Nurse Shanaz Din (below, with I.P. John Griffiths) develop close ties with their patients.

Rooms in the Infirmary overlook peaceful and secluded Salisbury Court (opposite). The fountain was donated to the Royal Hospital by Wates Construction in 2011.

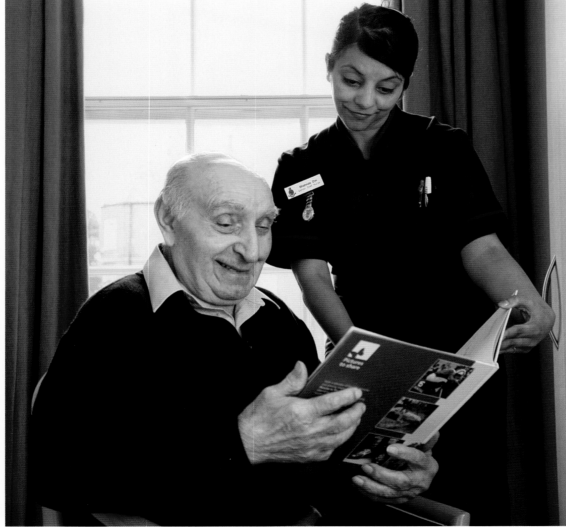

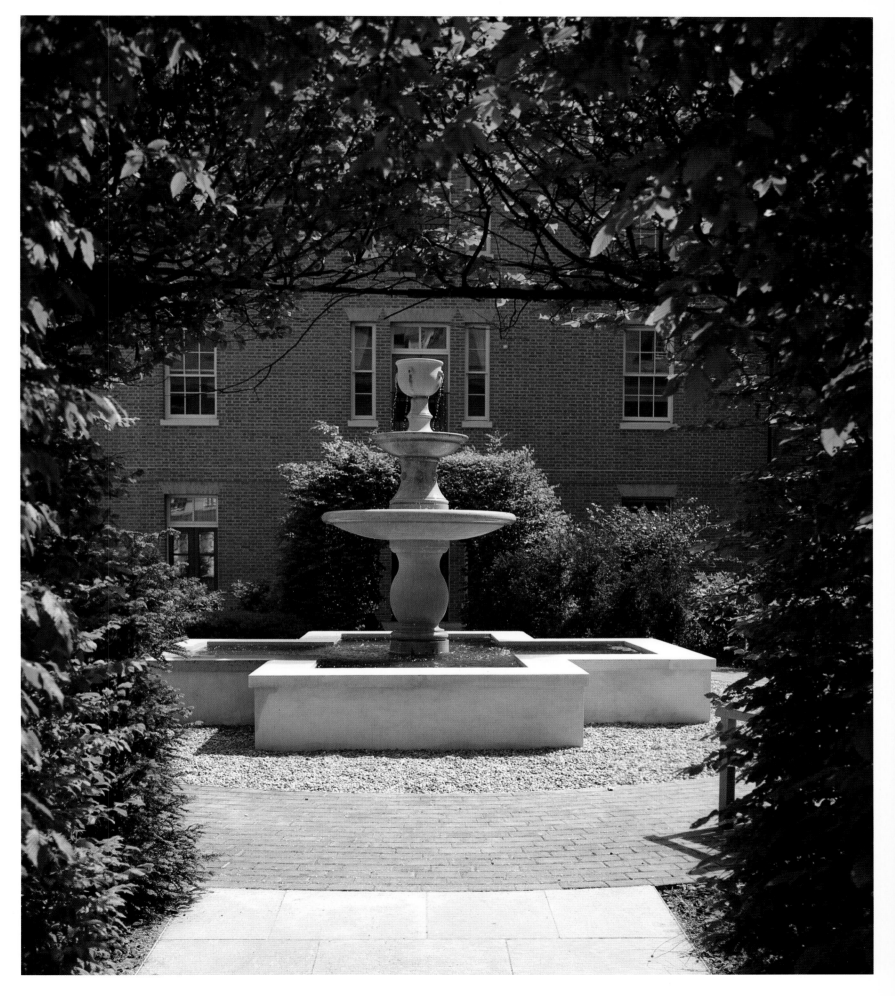

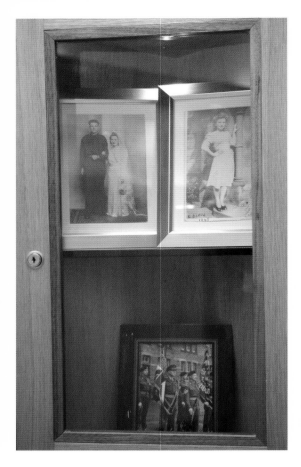

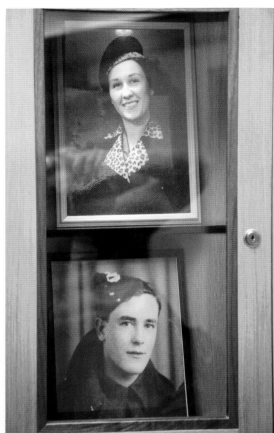

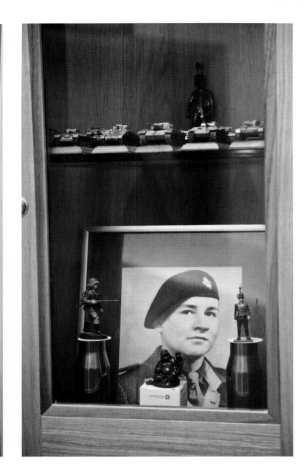

Outside each patient's room in the Infirmary are glass-faced cabinets in which he or she can display personal mementos.

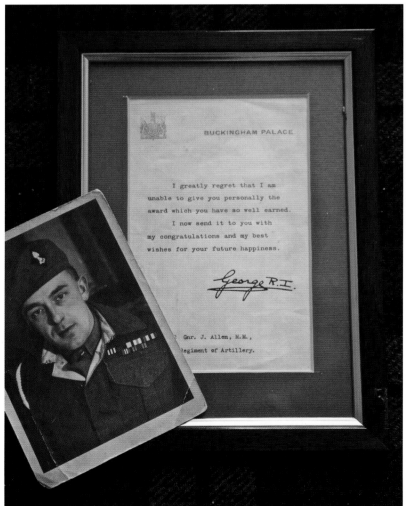

7th Hussars 18th Hussars QMO 3rd Dragoon Guards 4th Dragoon Guard 6th Dragoon Guards 6th Inniskilling

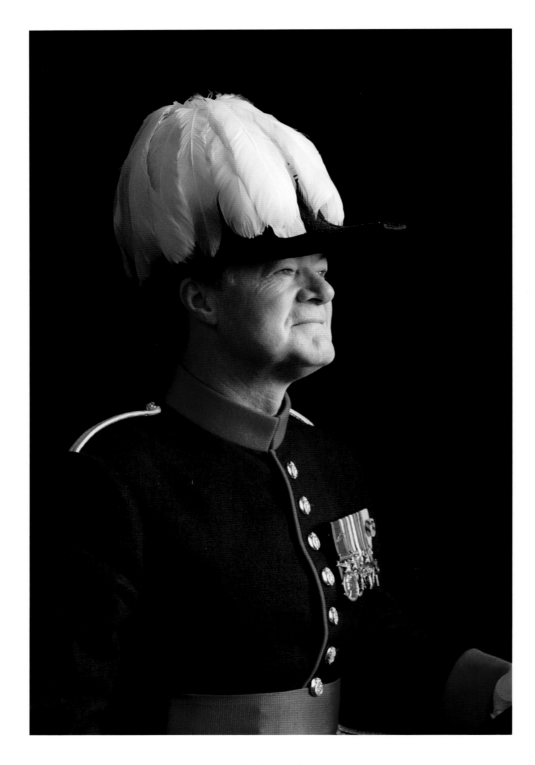

Lieutenant Colonel Rupert Lucas
Captain of Invalids

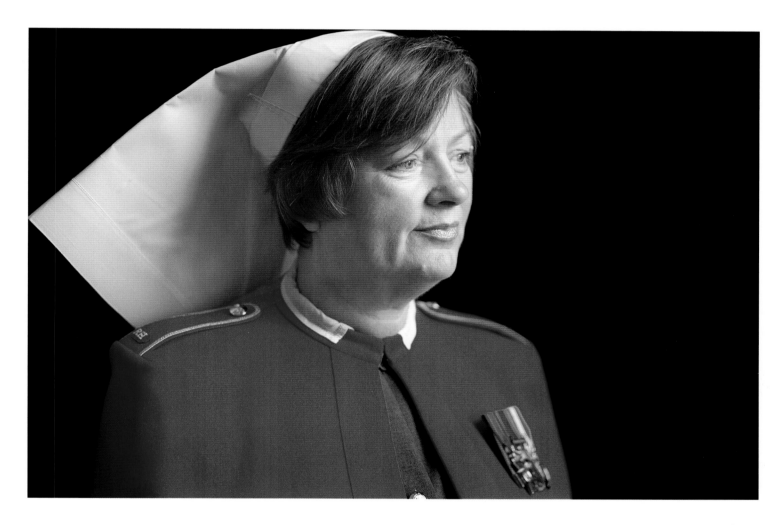

Colonel Laura Bale, RRC
Matron

Summer

On Founder's Day the Chelsea Pensioners commemorate both the birthday of their first benefactor, King Charles II (29 May 1630), and the anniversary of his triumphal return from exile abroad to London – the same day in 1660, which formally marks the restoration of the English monarchy. Because the date conflicts with the staging of the Chelsea Flower Show, which takes place at the Royal Hospital grounds in late May each year, the Founder's Day event is held on the first Tuesday in June.

Charles II's birthday, 29 May, is otherwise known as Oak Apple Day, after the time the future king hid in an oak tree as the Roundhead army pursued him from the field of the Battle of Worcester on 3 September 1651 – the final battle of the English Civil War. It is in reference to this escape that In-Pensioners and guests at the great parade wear sprigs of oak in their buttonholes and that the statue of Charles II is festooned with cuttings from the same tree.

It is on this day that the In-Pensioners, as military men and women, are reviewed by a distinguished visitor; in 2011 the guest of honour was HRH Prince Harry. At the conclusion of the ceremony, In-Pensioners raise their tricorne hats and give three sets of three cheers: the first for 'Our pious founder', the second for the reviewing officer, and the last for the reigning monarch. If the monarch were to take the parade, there would be just two sets of cheers.

Here Patricia Rodwell records this moving and impressive ceremony. She then turns her camera on some of the day-to-day activities that take place during the remainder of the summer; these include a bowls tournament on the immaculate green just inside the Chelsea Gate, a hotly contested laser-rifle shooting contest, and gentler – but one suspects perhaps no less competitive – allotment-tending.

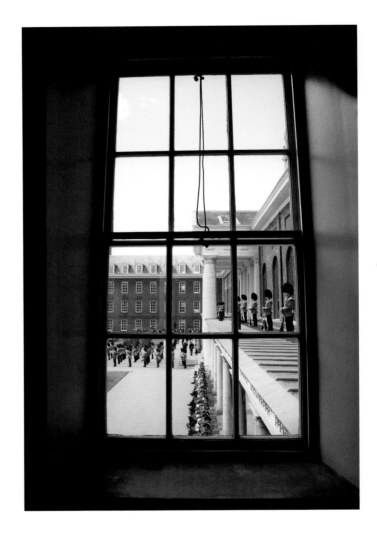

Previous pages:
Summer roses in the Royal Hospital Chelsea grounds.

Clockwise from above:
View from a window overlooking the Colonnade roof during the Founder's Day parade; the bowling green; I.P. William Titchmarsh visiting the annual Chelsea Flower Show, held in the Royal Hospital's grounds; and the north range's statue of a Chelsea Pensioner (see p. 22).

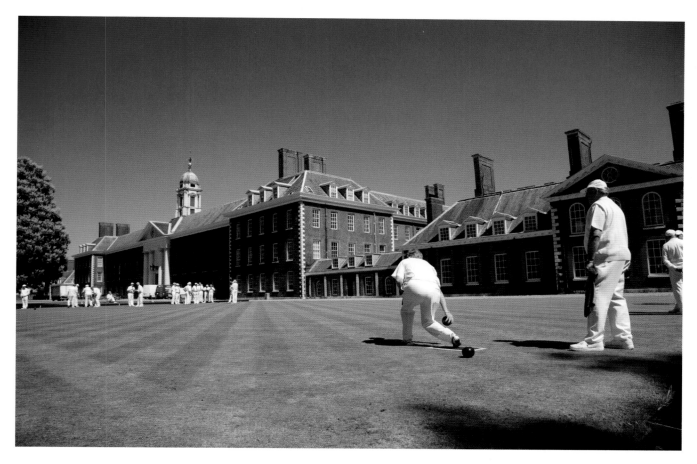

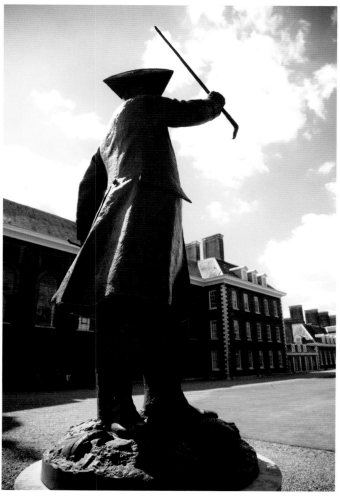

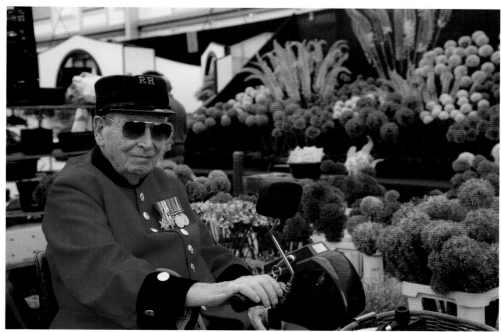

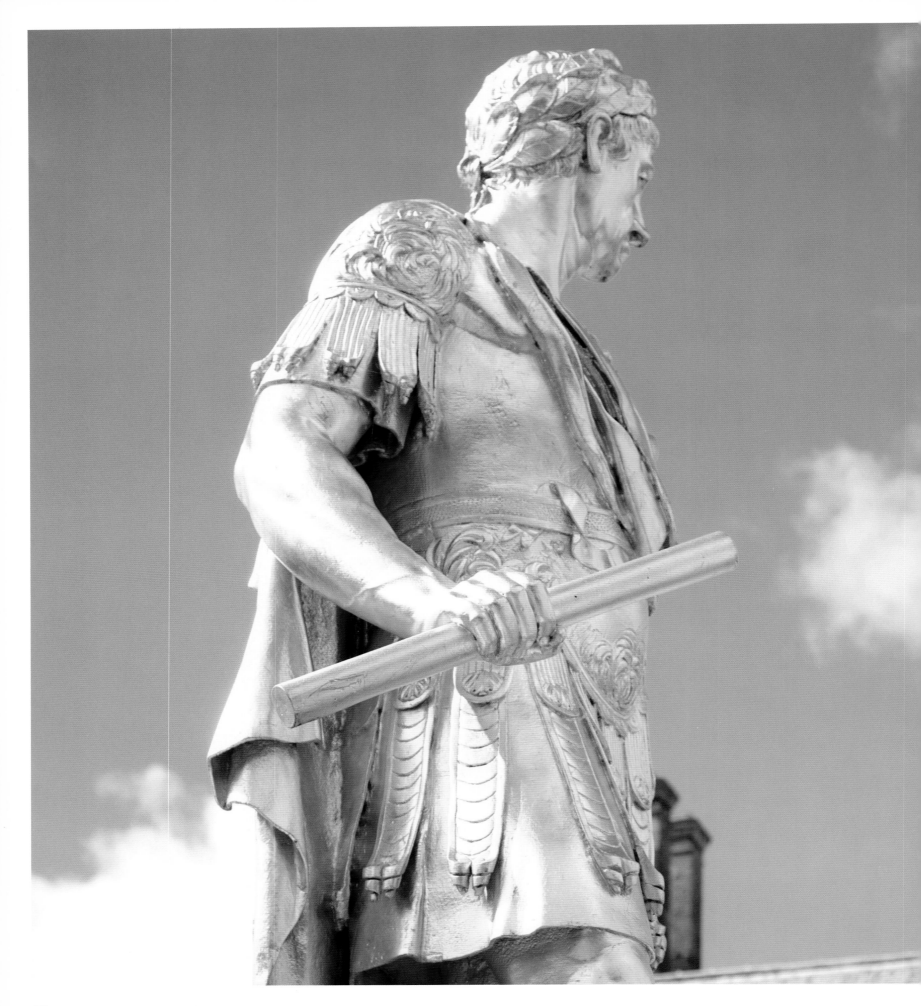

THE STATUE OF CHARLES II

The centrepiece of Figure Court (the Royal Hospital Chelsea's central court) is the gilded statue of the Hospital's founder, Charles II, dressed as a Roman general and holding a baton as a sign of his authority. The work of Grinling Gibbons in 1676, the effigy measures 2.3 metres (7 ft 6 in.) in height. Among the reasons why the sculptor dressed Charles II in Roman attire is the fact that the French king Louis XIV was portrayed in a similar way in the old soldiers' hospital he had founded in Paris a few years earlier, the Hôtel des Invalides. (Les Invalides still houses a military hospital, but is not a retirement home in the way the Royal Hospital is.)

The statue was presented to Charles II in 1682 and initially stood in the grounds of Whitehall Palace; it was moved to the Royal Hospital after the king's death in 1685. Originally cast in copper alloy and gilded, the effigy was bronzed in 1787. It was regilded in 2002.

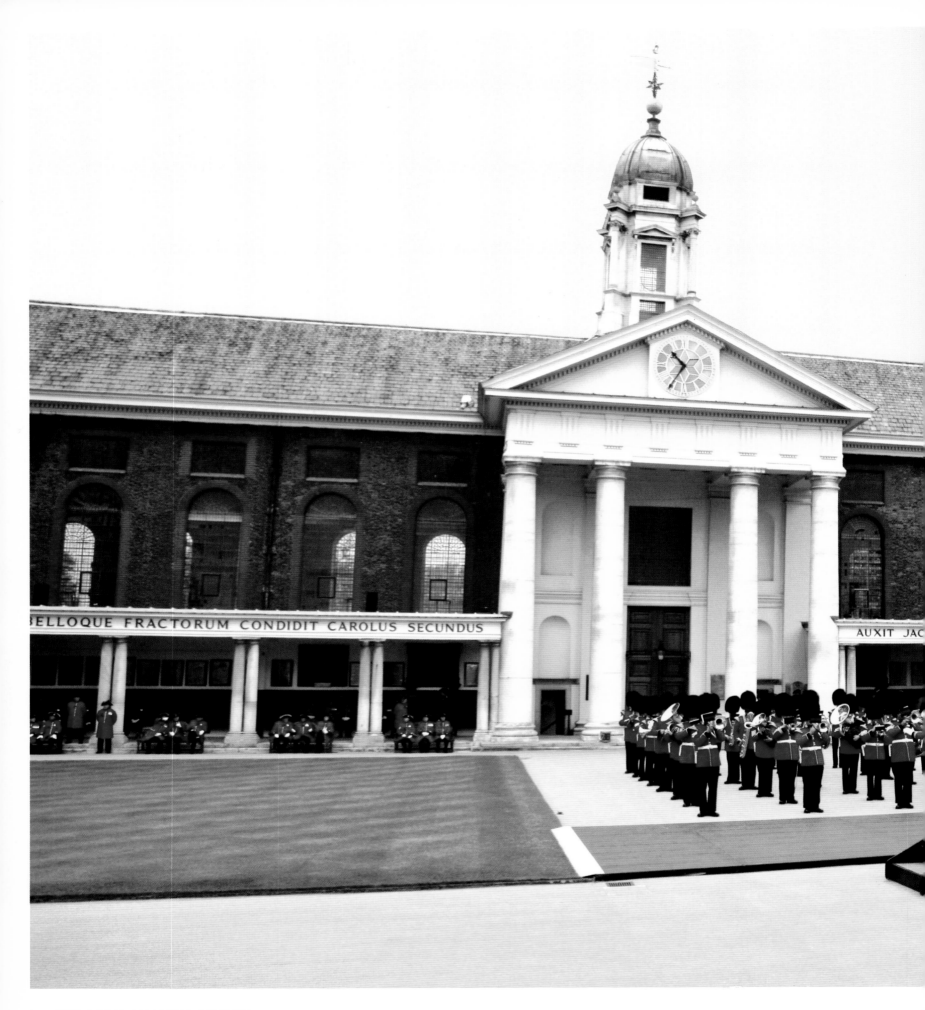

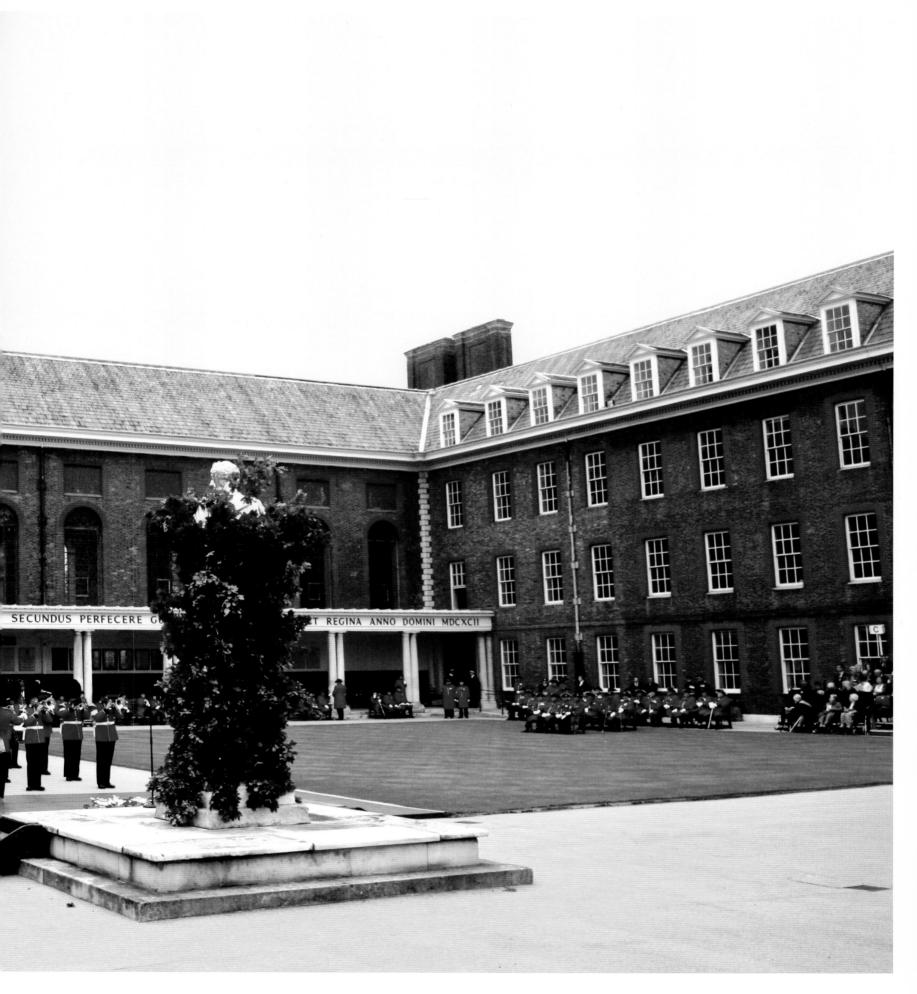

FOUNDER'S DAY

Founder's Day, the biggest day in the Royal Hospital's calendar – and the only day of the year on which In-Pensioners must be present – is held around 29 May, Charles II's birthday and the date of his restoration to the throne in 1660. In the presence of some 3000 invited guests (sitting on tiered stands at the edge of the parade ground, just visible on the right in the photograph on pp. 70–71), the In-Pensioners are ceremonially reviewed, usually by a member of the Royal Family; in the picture below, taken in 2011, the Royal Standard is visible, indicating the presence of British royalty. The gilded statue of Charles II in Figure Court is covered from top to bottom in oak leaves, commemorating the future king's escape after his defeat at the Battle of Worcester in 1651 (see p. 66). It has become customary for all In-Pensioners, Royal Hospital staff and visitors to wear a sprig of oak on this day.

I.P. Alf Humphries on Founder's
Day in 2011.

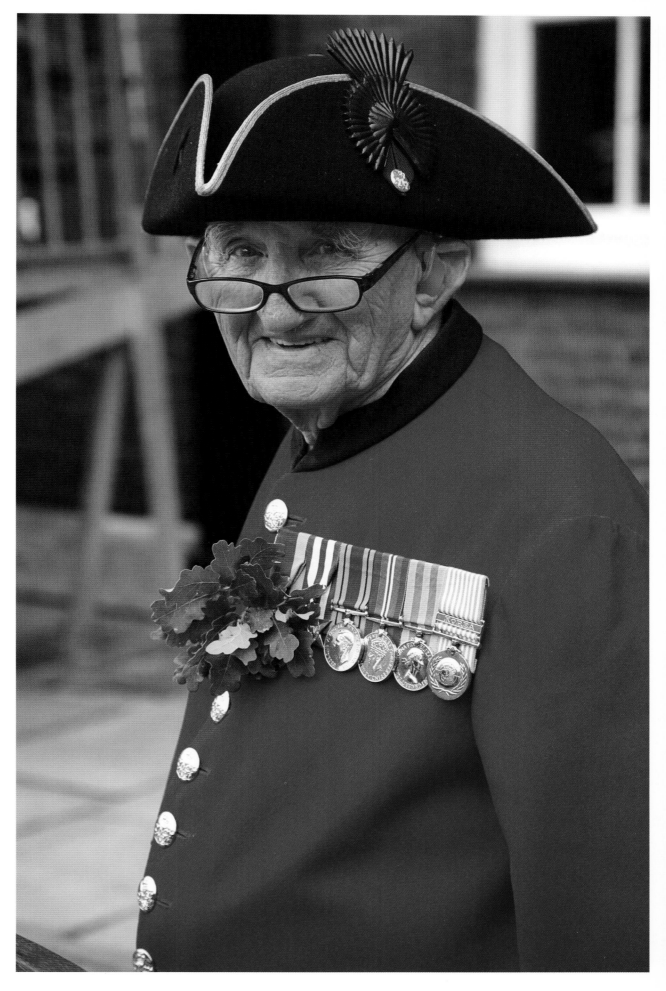

I.P. Kenneth Elgenia on one of the benches erected in the Hospital grounds during Chelsea Flower Show.

'Founder's Day Rehearsal'

The Scarlet mass moves,
 some sit, some join late.
Then take their seat again.
On a given note their Tricornes
 are raised.
Like black poppy seeds leaving
the Scarlet field.
Three times they rise.
These do not germinate,
but return to their grey
 headed domes.
No bird on high swoops low to feed,
but keeps high on wing
watching the Ladybirds highly
 choreographic show.
At last the aerial sentries do break,
with Peregrine speed to their nests
 they go.
While below the Scarlet breaks,
and quietly shuffles off to their
 respective homes.

Kenneth Elgenia
29 APRIL 2009

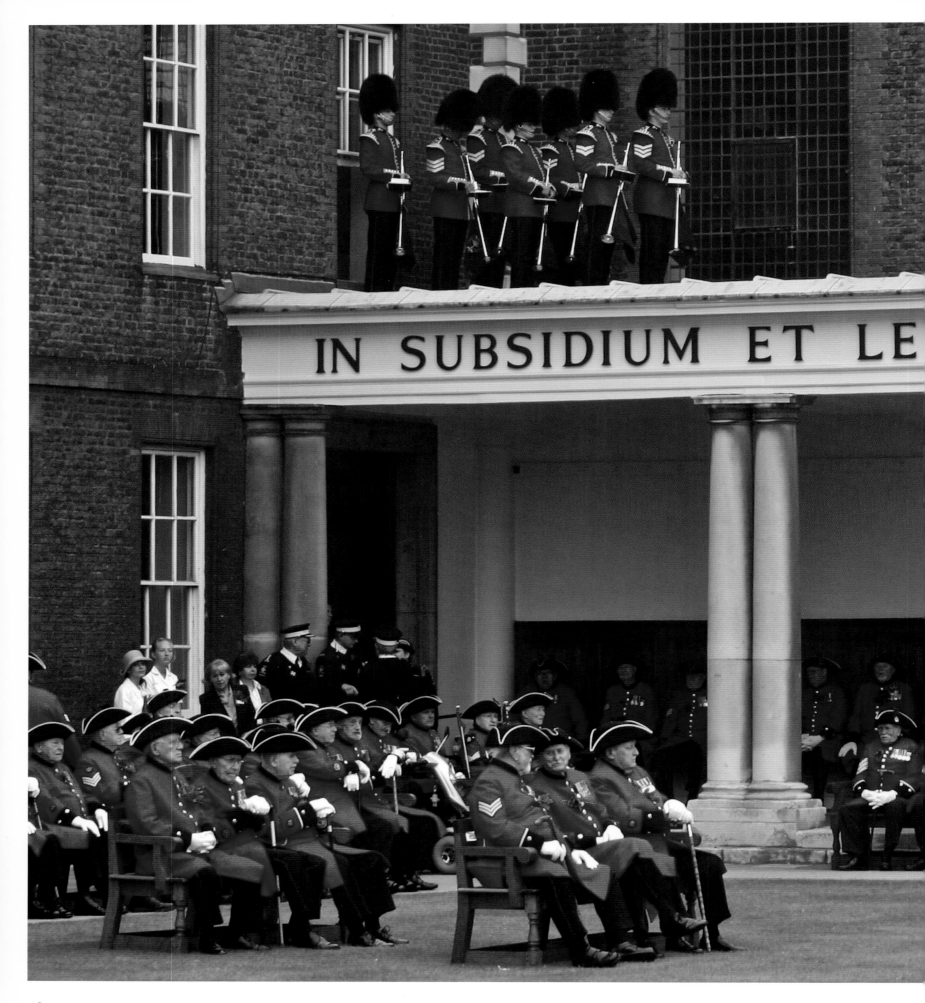

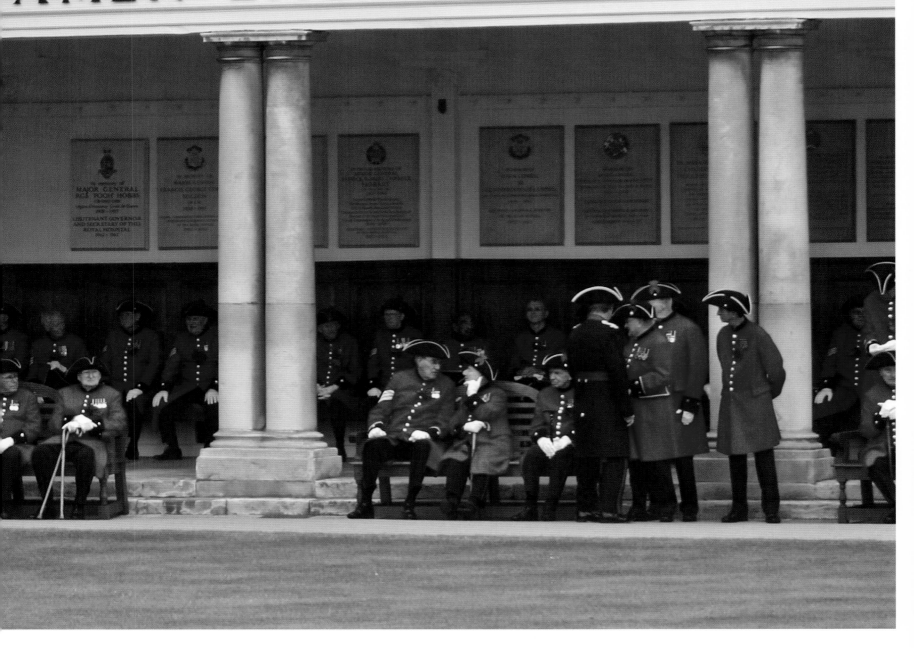

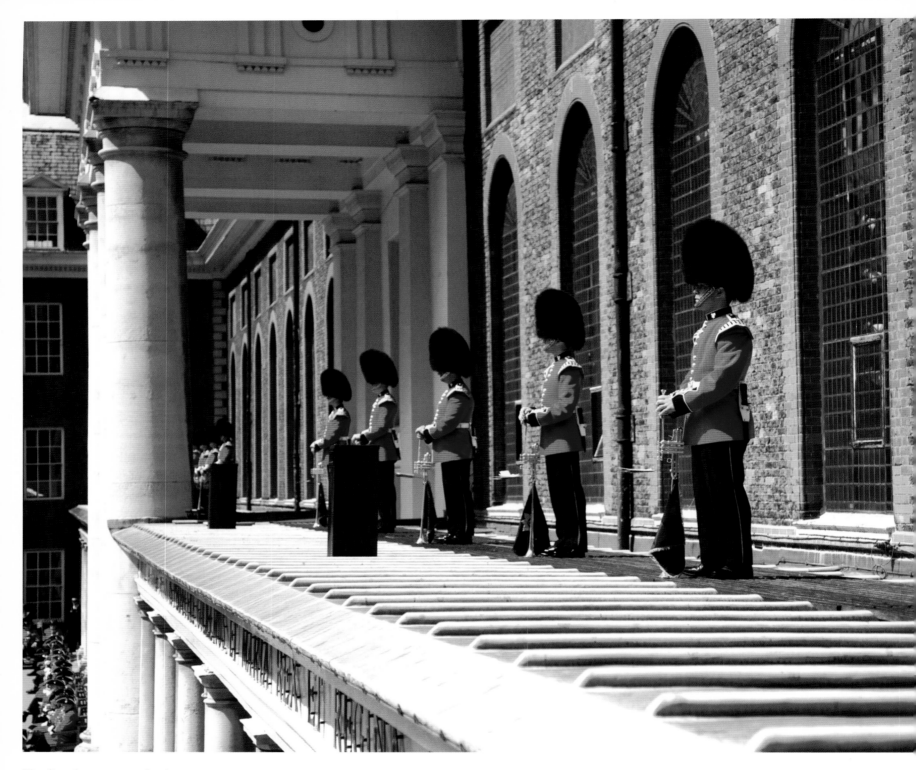

The Guards trumpeters, having
made their way from a window in
the Long Wards accommodation wing
(previous pages) and taken up position
on top of the Colonnade, await the
start of the Founder's Day parade.
Opposite, one of the In-Pensioners
who will be reviewed while seated
spots the photographer and smiles
for the camera.

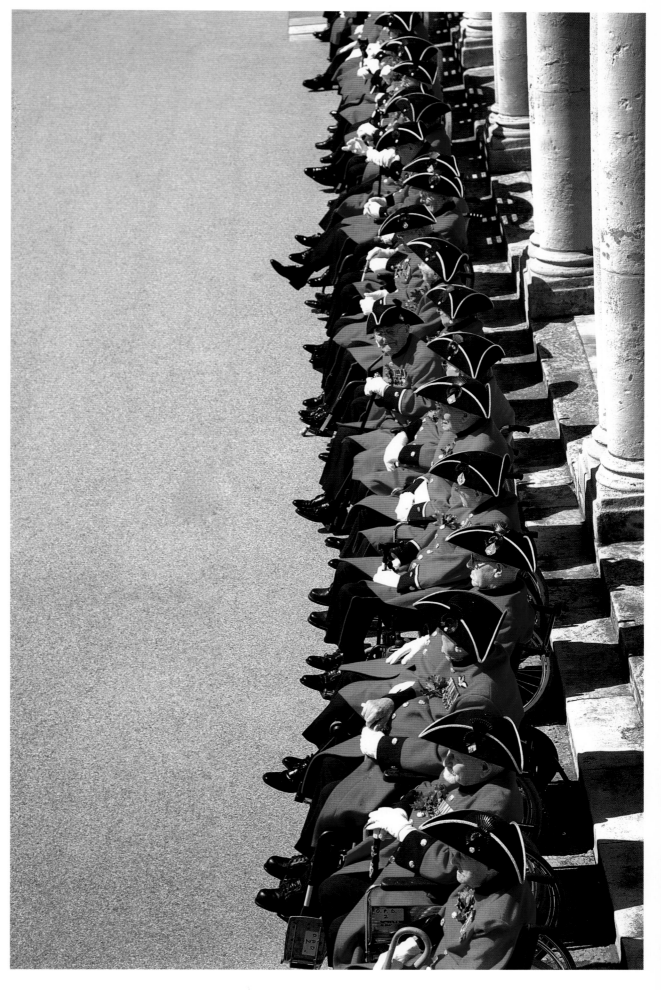

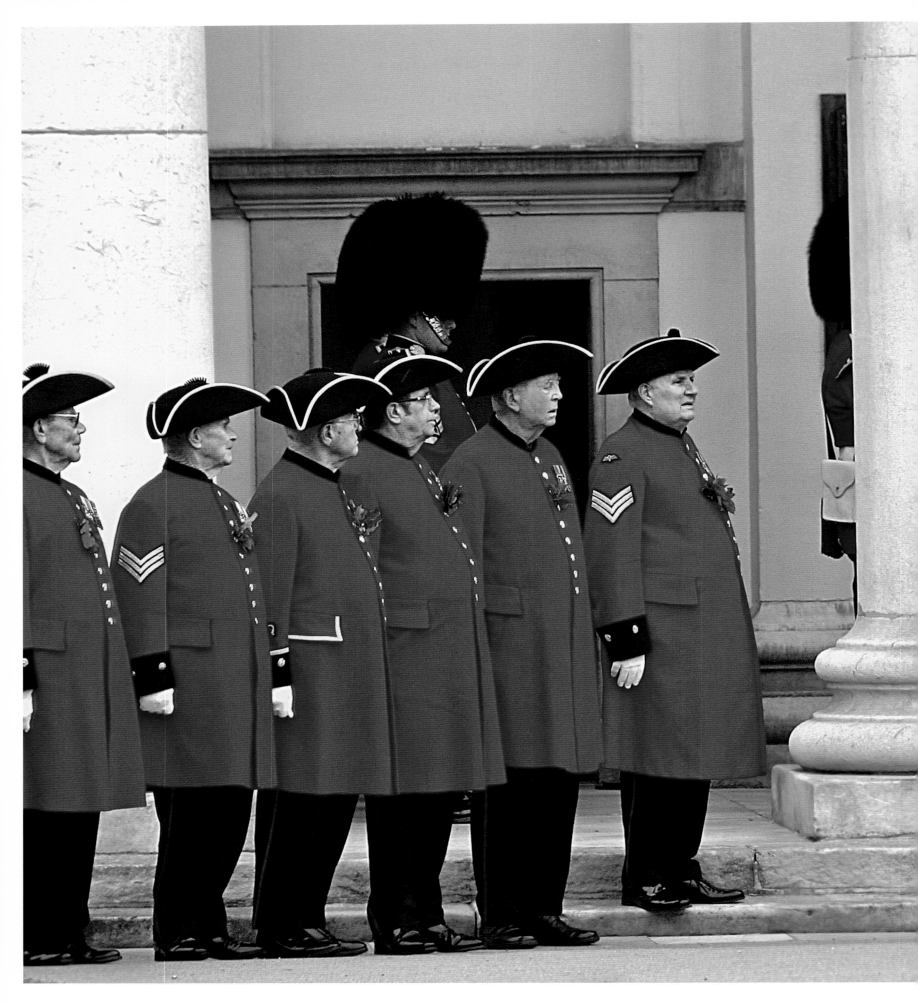

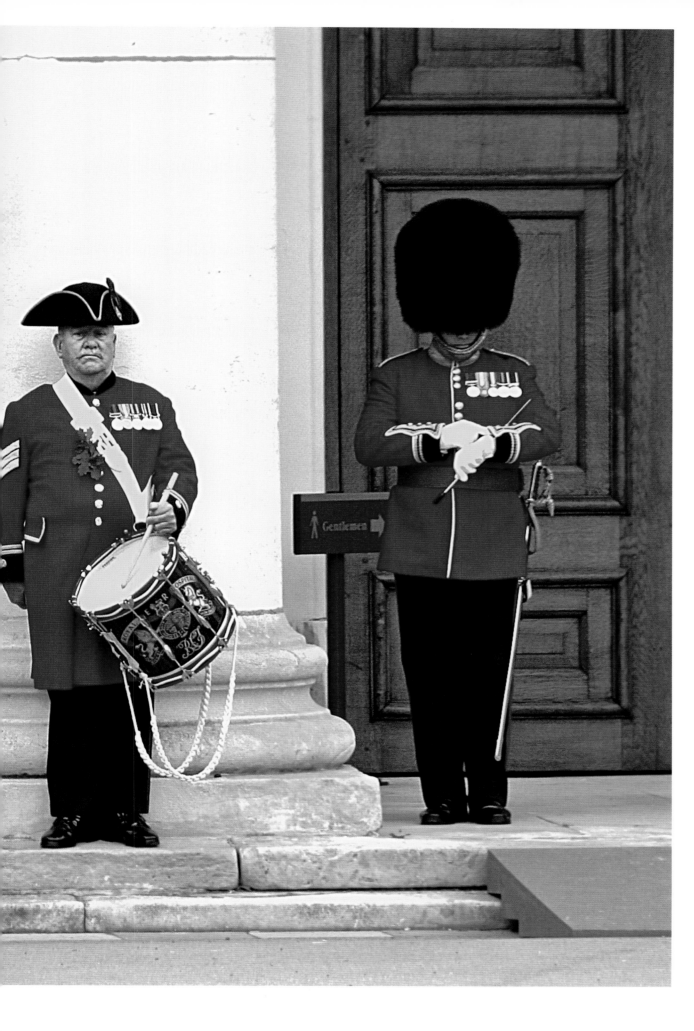

Royal Hospital duty drummer I.P.
Bill Miles and the Director of Music
for the Guards band count down
to the precise moment scheduled
for the In-Pensioners' marching-on.

The Hospital's Captains of Invalids present their companies to the Founder's Day parade commander, the Royal Hospital Chelsea's Adjudant.

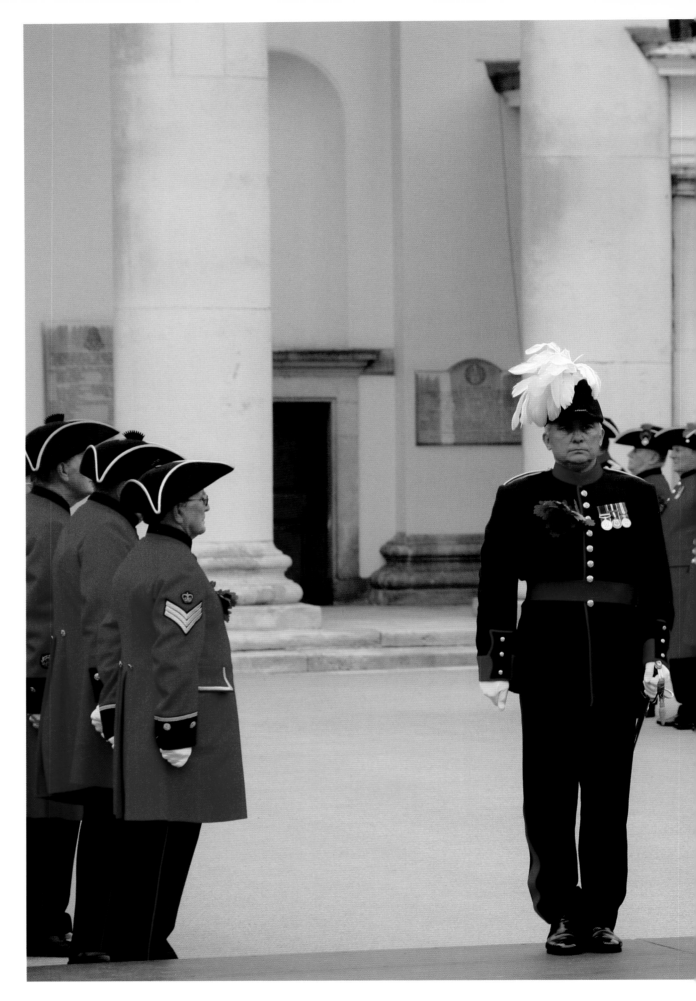

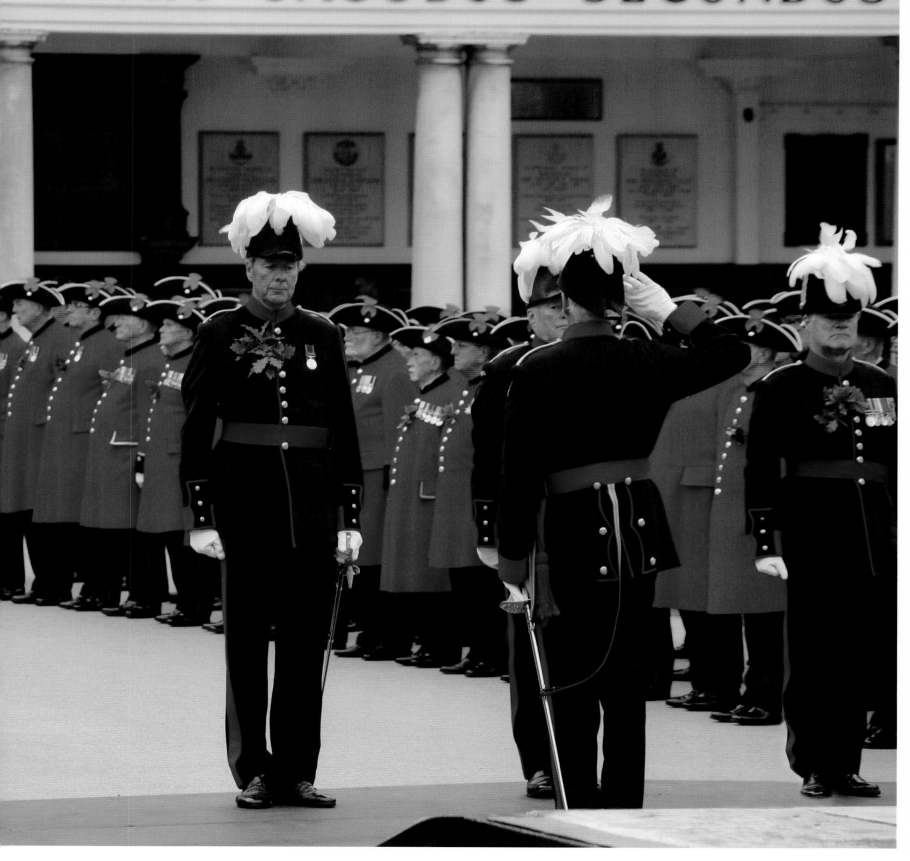

AUXIT JACOBUS SECUNDUS

On Founder's Day in 2011, the inspecting officer who reviewed the In-Pensioners was HRH Prince Harry, himself a military officer. He is shown here (in the blue beret of the Army Air Corps, on which is attached his regimental badge of the Household Cavalry) being escorted to the saluting dais by two halberdiers, I.P. Mal Smart and I.P. Kenneth Elgenia, and flanked by the Royal Hospital's Governor and Lieutenant Governor.

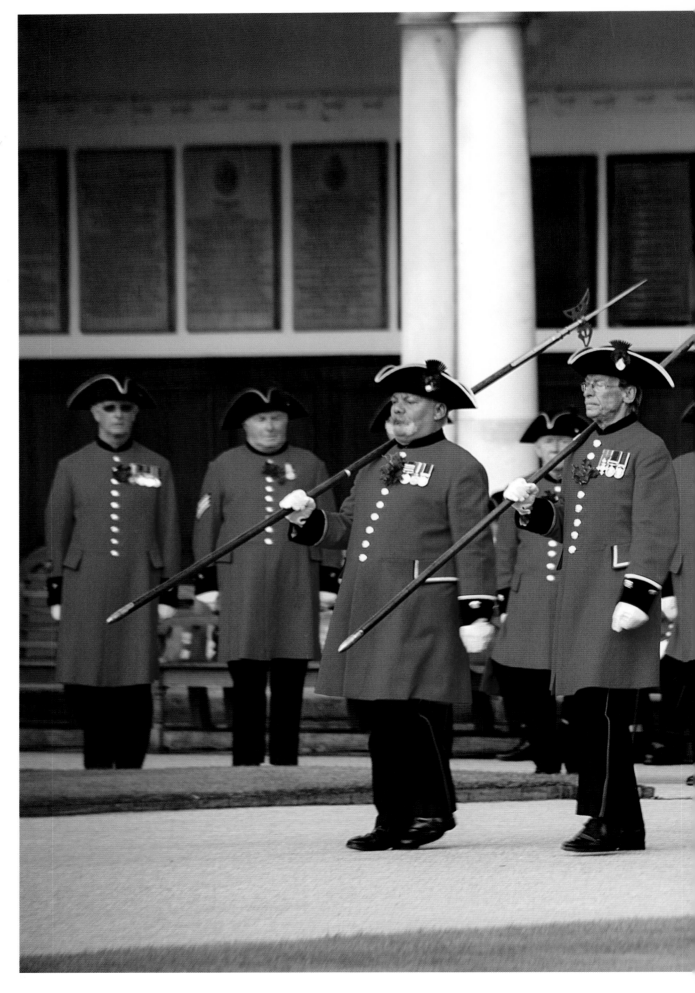

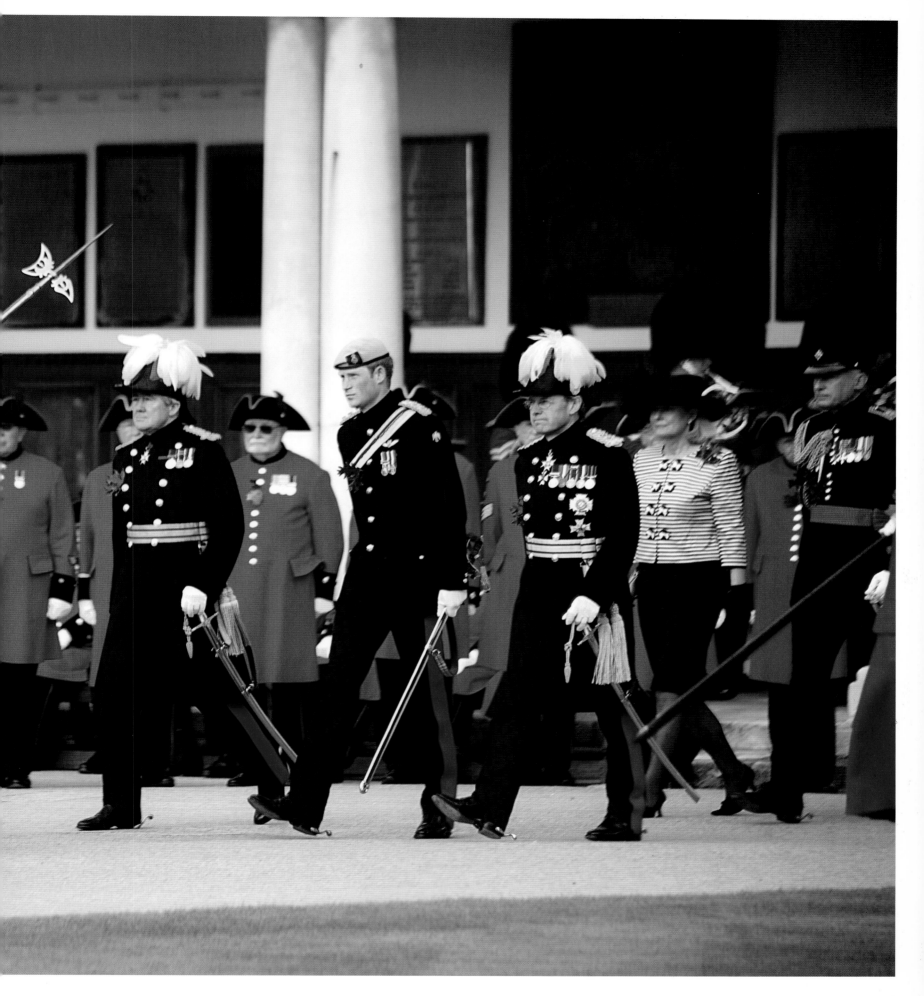

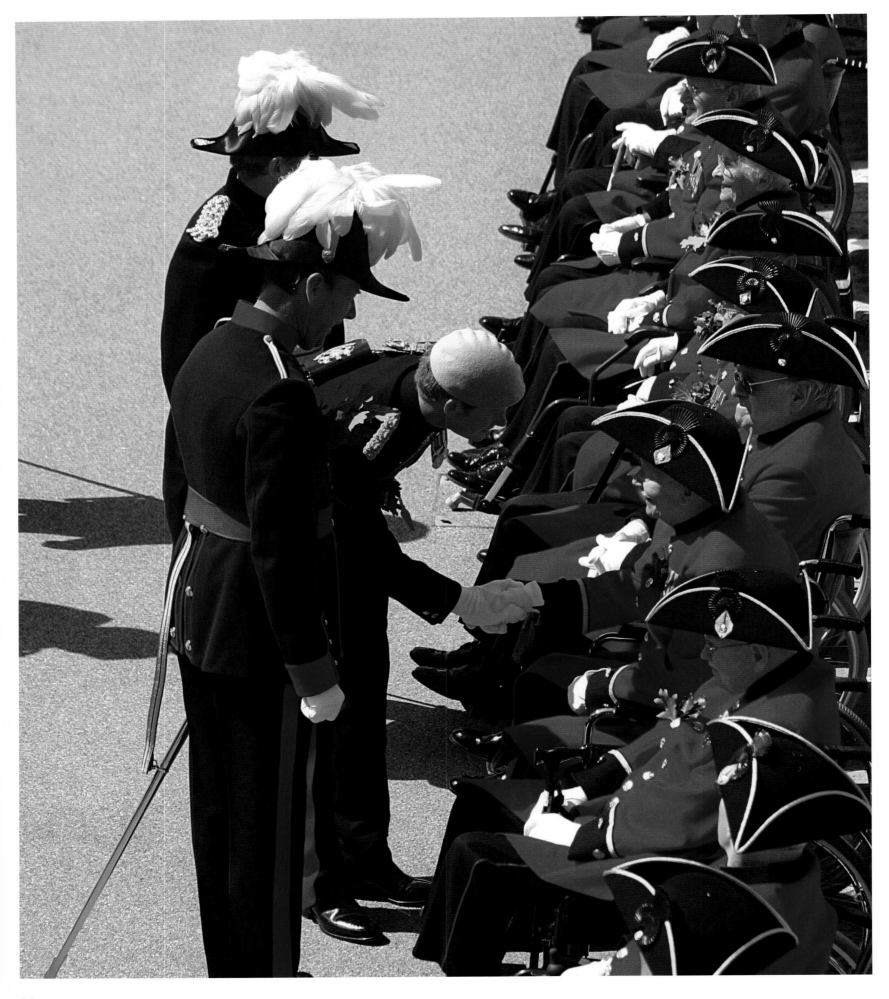

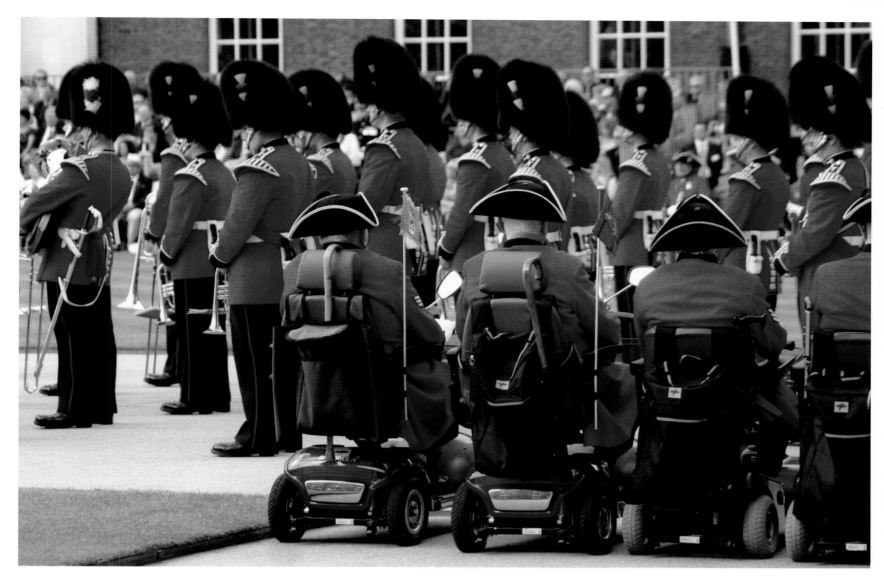

HRH Prince Harry chats to
In-Pensioners too frail to stand
(opposite). On Founder's Day, all
In-Pensioners are on parade.

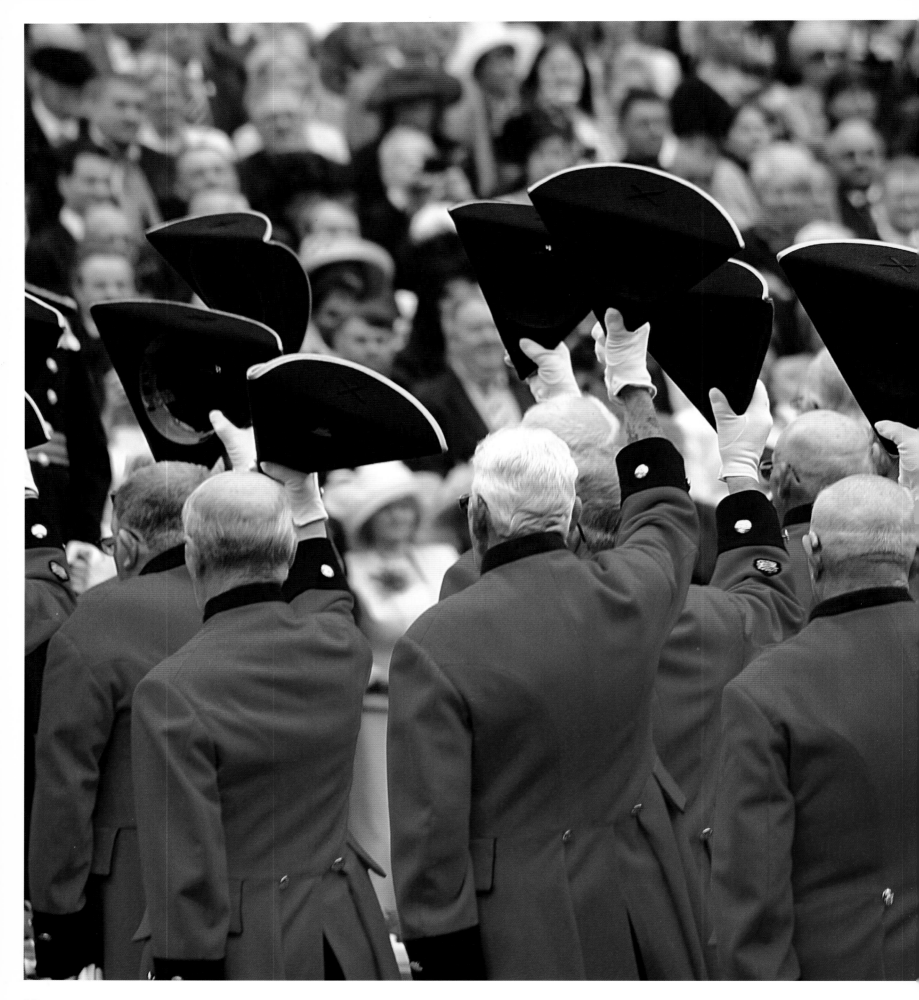

The Founder's Day parade ends
with In-Pensioners raising three
cheers, once for 'Our pious founder',
Charles II, once more for the
inspecting officer, and the last
for the reigning monarch.

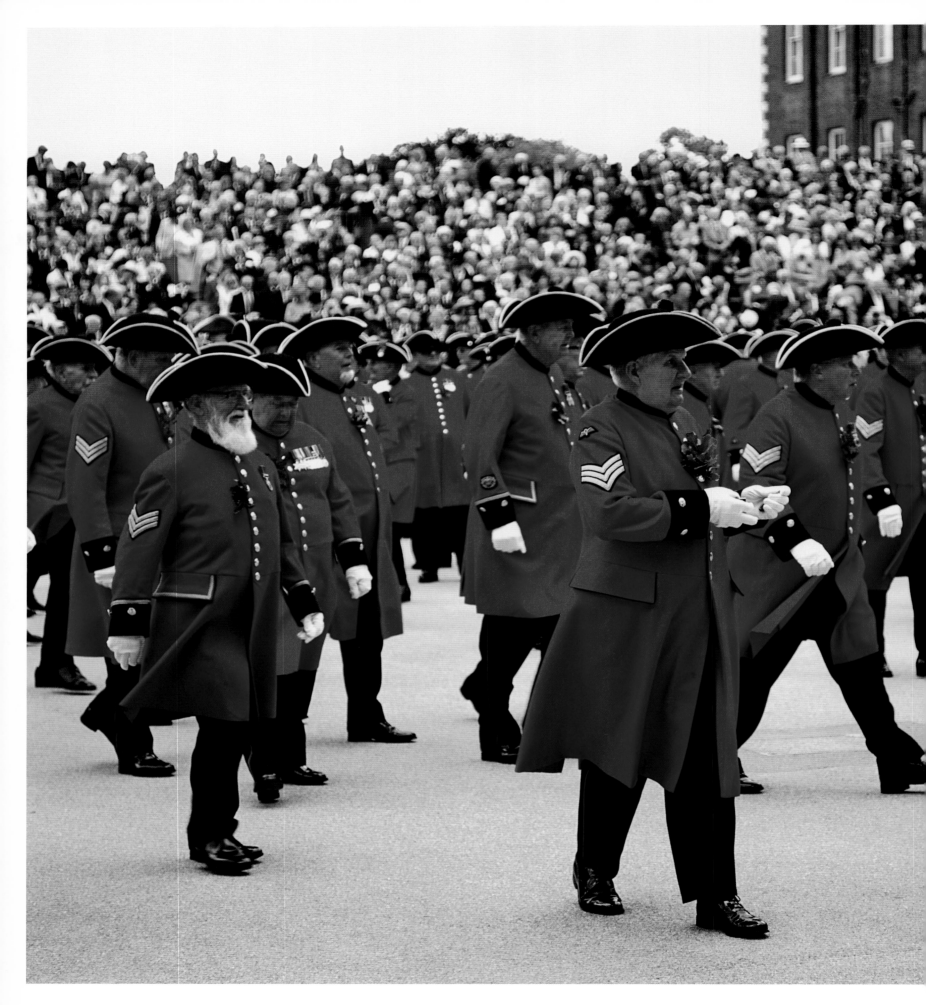

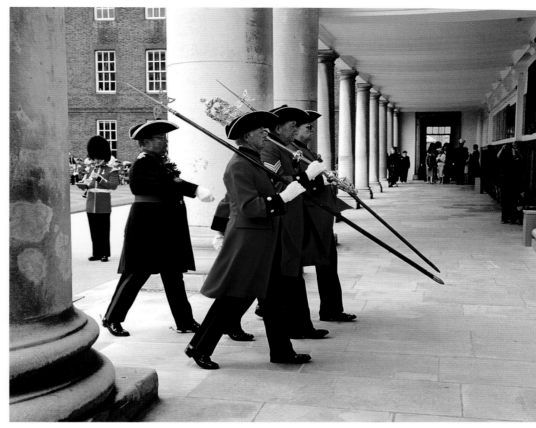

In-Pensioners leave the parade
ground as the Founder's Day
parade is dismissed.

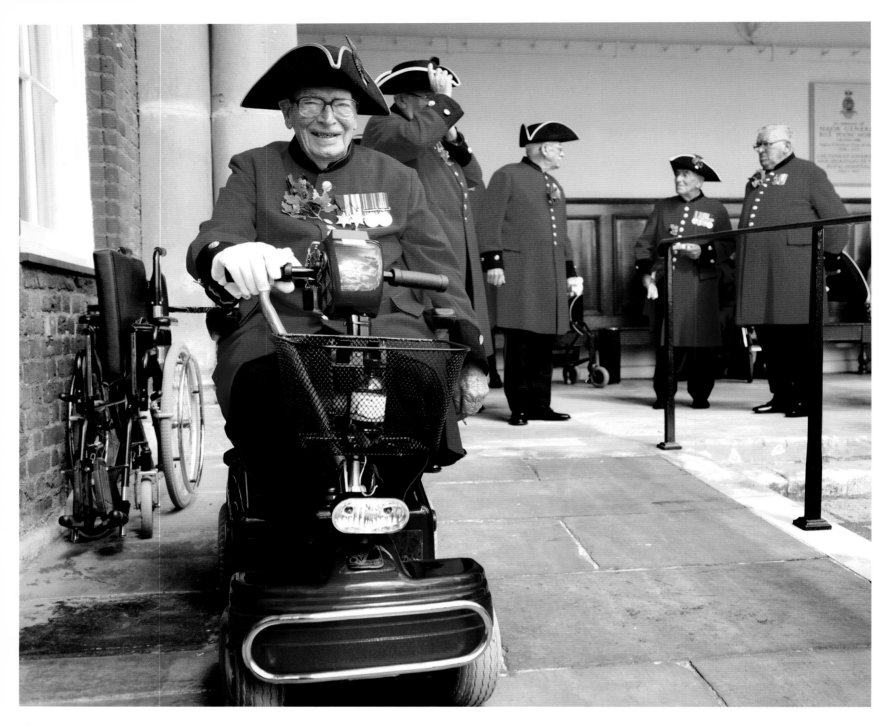

The gleaming medals on ribbons worn by In-Pensioners indicate some of the men's military history, and those pictured on these pages are from the Second World War. The Italy Star (shown opposite, top left, third from the right), for example, was awarded for operational services in Italy and other locations from June 1943 to May 1945. The Burma Star (shown opposite, top right, second from the left) was awarded for service in the Burma Campaign (December 1941 to September 1945); its blue stripes represent the British forces, the central red stripe Commonwealth forces and the orange stripes the sun. The Defence Medal (opposite, top right,

second from the right) was awarded for service in areas subjected to enemy air attack or closely threatened. All the medals awarded by the United Kingdom since 1914 are recorded on a chart produced by military accoutrements maker Toye, Kenning & Spencer, founded in 1685 by French Huguenots.

Rank insignia is worn on the upper right arm. The badges above the right cuff are those of Warrant Officer, which is the British Army's highest non-commissioned rank.

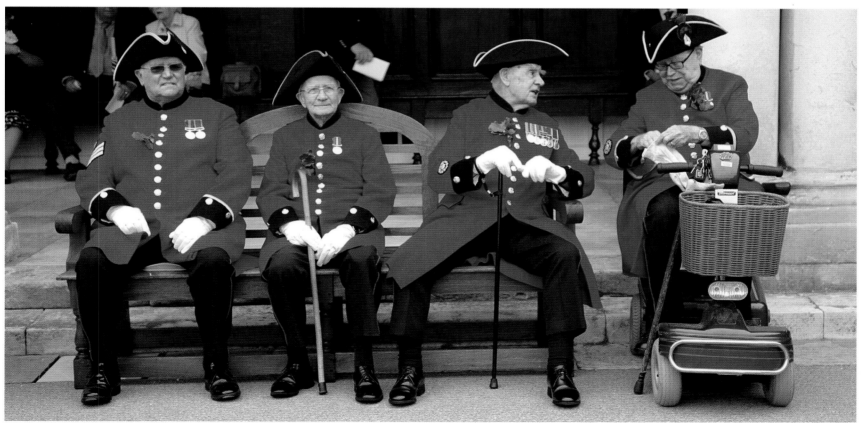

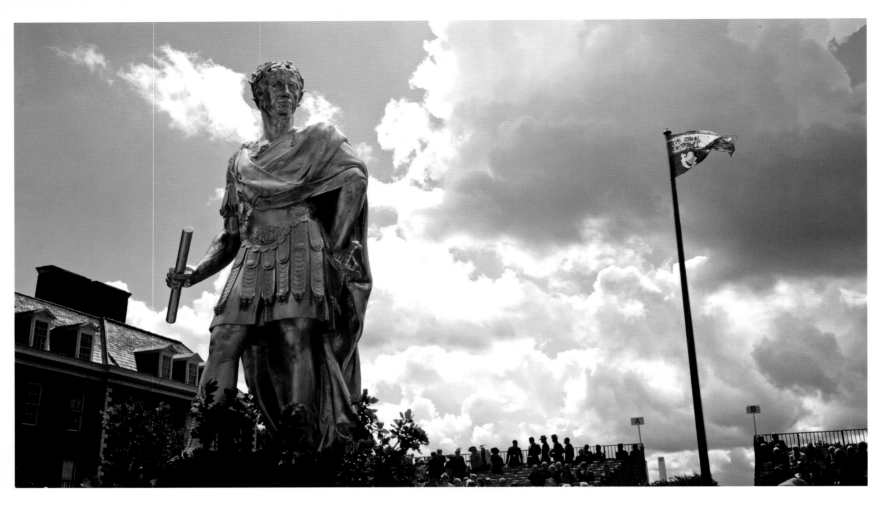

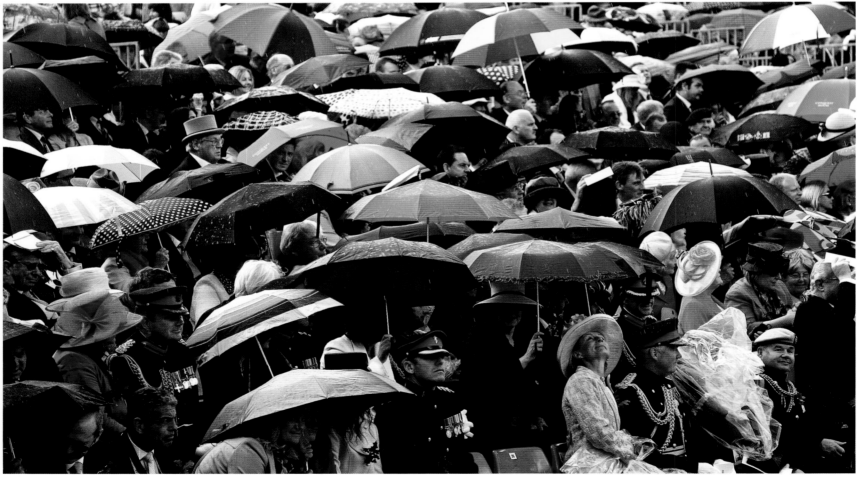

The Royal Standard flutters above the crowd of In-Pensioners' families and friends attending the Founder's Day parade despite the typically changeable early-summer British weather (opposite). Following the formal ceremony, the guests are invited to the informal festivities held in College Court, at which regimental music is played and lunch is served. For some years now, the In-Pensioners and their guests have also been treated to a display by a troupe of belly dancers.

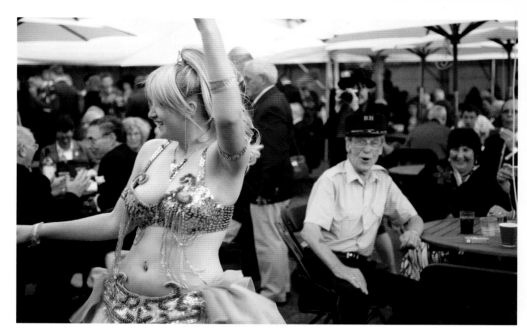

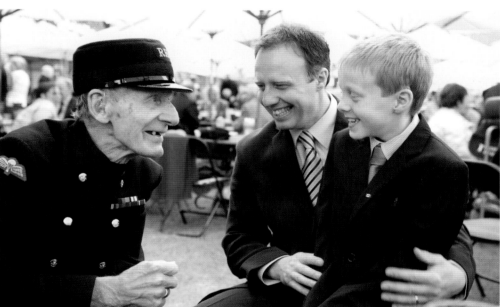

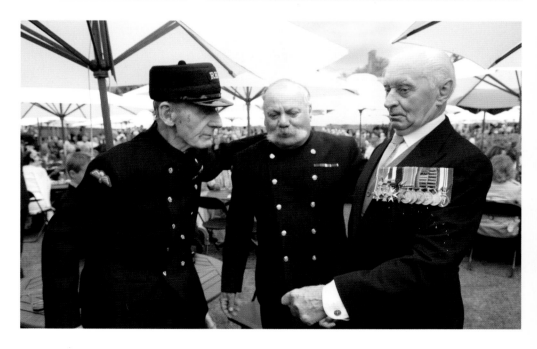

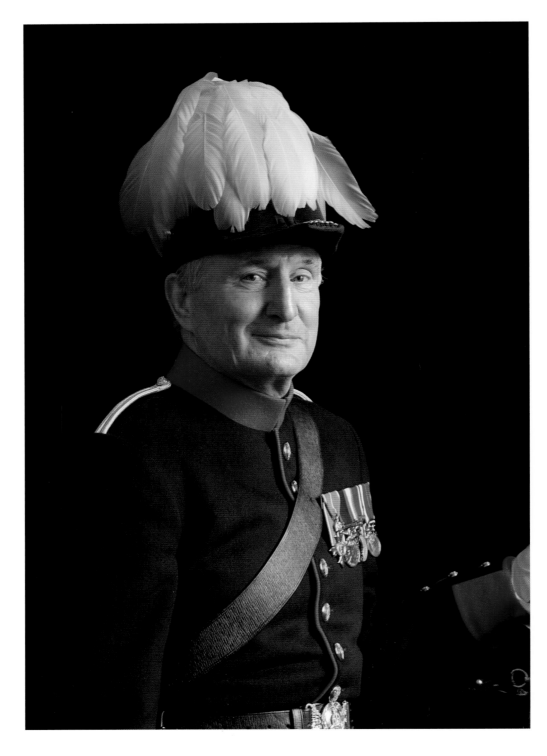

Lieutenant Colonel Andy Hickling, MBE
Quartermaster

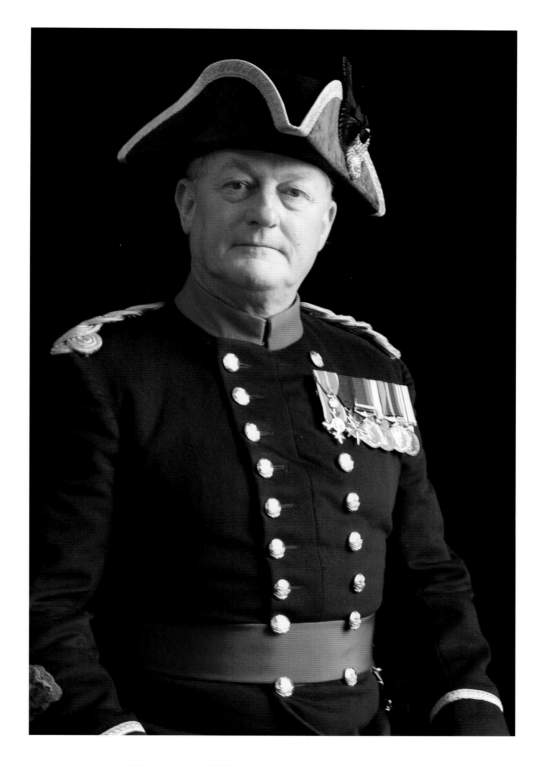

Warrant Officer Bob Appleby, MBE
Sergeant Major

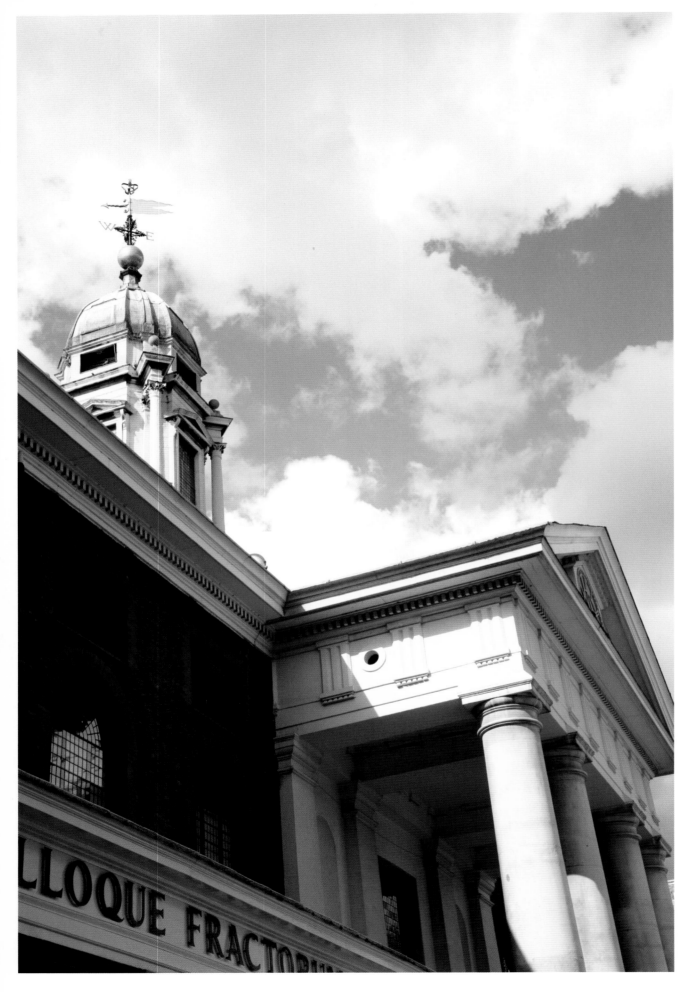

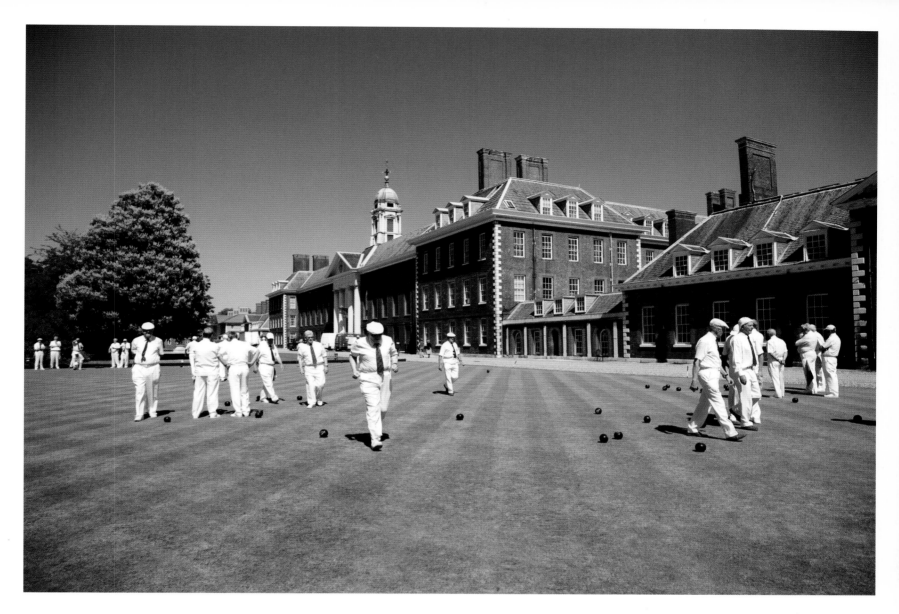

BOWLS

The game of bowls plays an integral part
in the daily life of the Hospital during the
summer, and is probably the In-Pensioners'
most popular pastime. The bowls team travels
to compete against civilian clubs around the
United Kingdom, and even abroad (recent
destinations have included Tunisia and
Cyprus), and also hosts many home matches.

View of the main portico and
the cupola (opposite), taken from
Figure Court.

The long, warm months of summer bring many In-Pensioners out on to the Royal Hospital's bowls lawn. Unlike the I.P.s' scarlets and blues, whites and woods are not provided by the Royal Hospital.

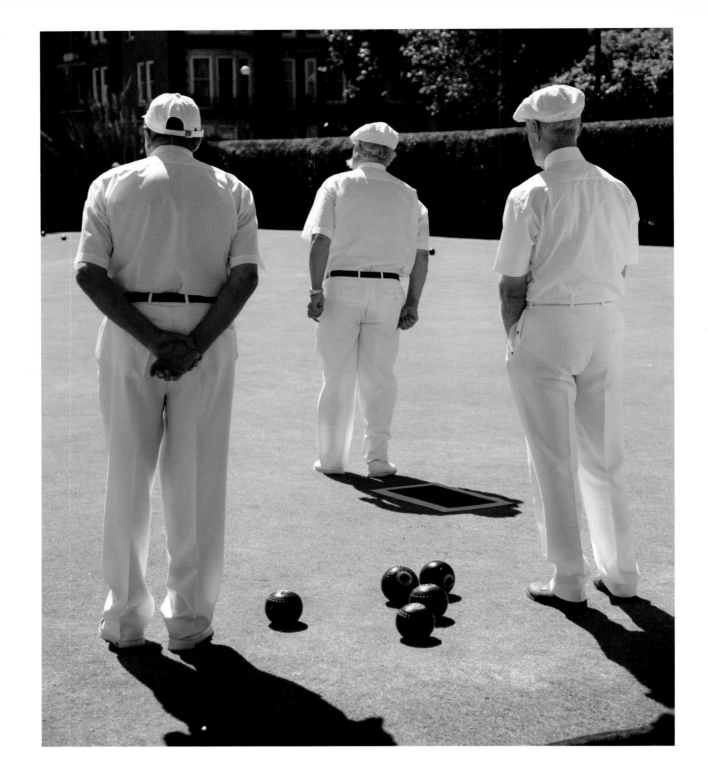

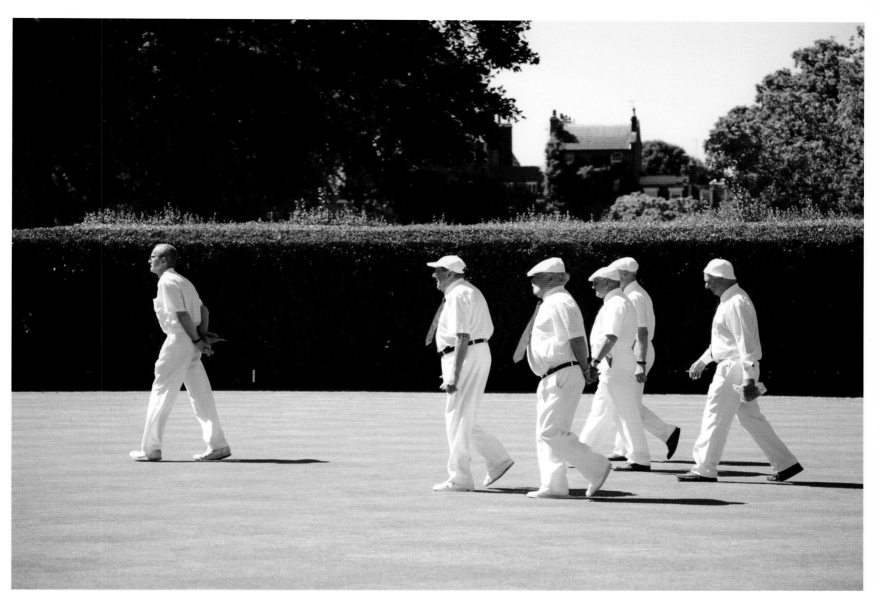

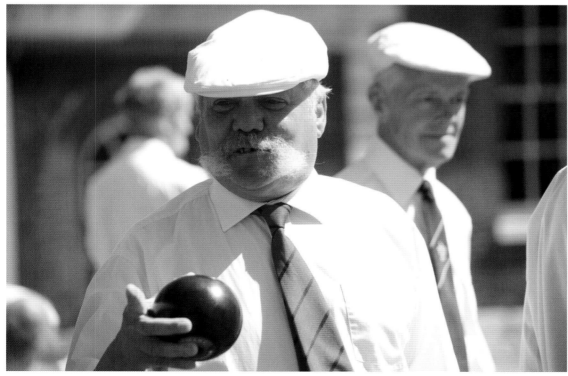

Activities are laid on throughout the year for the In-Pensioners, whatever their level of fitness. Below, an 'England v. Ireland' ball game. Opposite, an afternoon of laser-rifle shooting in the Royal Hospital's grounds.

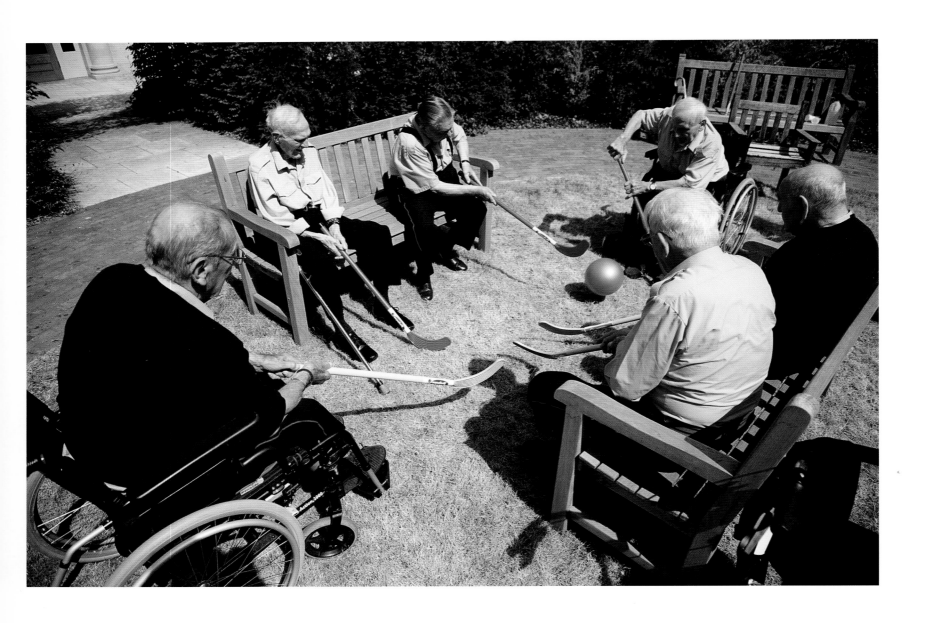

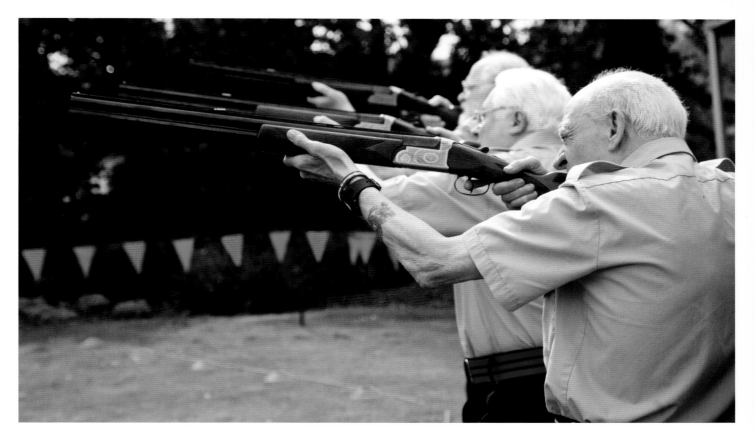

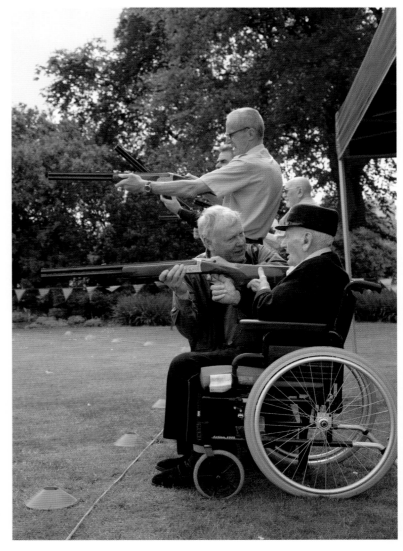

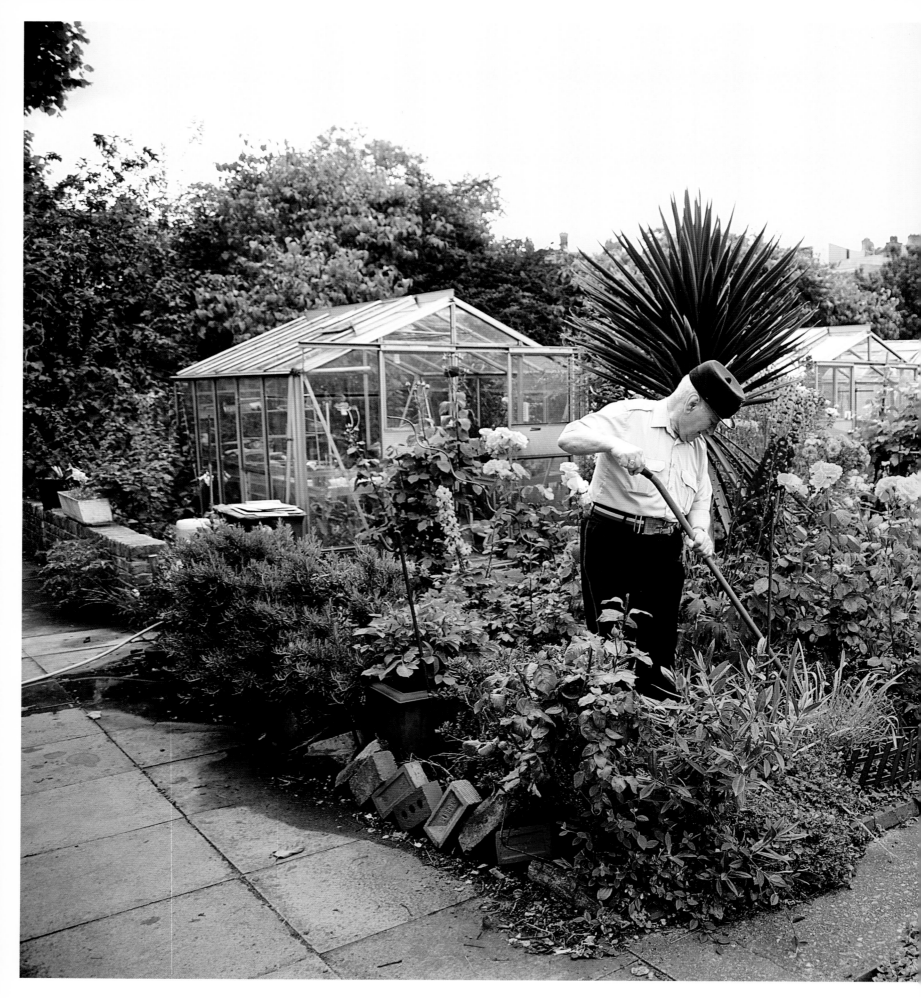

I.P. Paddy Fox, BEM

I was a recruiter for the army for nigh-on twenty years, and I recruited something like 2500 lads altogether. I was based at Horton, a pit village in Northumberland. Normally you're in charge of an office with maybe three or four sergeants who go out recruiting, and you do all the paperwork. But this was a one-man office, and I used to get very involved. I used to hire a minibus and take all the mums and dads to passing out.

There were a lot of young people in the area, young families; kids would come in, fifteen-year-olds, saying, 'I want to join the army', and I'd tell them to fill the kettle and make a cup of tea. I learned more about a kid over a cup of tea than you would during an interview. Another sergeant, who came up to help me one day a week 'cause I was getting so many in, he said, 'You're mad, you make tea for these kids, they wash the cups, they break them. They should buy you a mug when they sign on.' I ended up with 1600 mugs in my office. I used to take two pictures of every kid with his mug, one for my 'mugshot' album, one for his mother, so she'd know where her lovely mug had gone.

I've got two or three mugs with me now, but I had to get rid of all the rest, I couldn't bring them here. I gave one to the vicar and I gave all the naughty ones to the boys' club. The rest I took to Sedgefield car boot sale.

When I came here there were some allotments spare, and I got two of them. I was born in Tipperary, where nobody had gardens, but my mother came from Oxfordshire and she used to have flowers. I used to look after her garden when I came on leave. Here I grow flowers, I take them to the Infirmary and the restaurant. I've also got an apple tree, a buddleia and a cherry tree; I didn't plant them, they've been there I don't know how long. I put a bird feeder in, and I get blackbirds, blue tits, coal tits, all sorts; I put seeds and chopped cheese out – they love it. But the pigeons also come in – city pigeons, horrible flying rats – so I managed to purchase a catapult. The friend I share a greenhouse with, he's eighty-one,

he's a good shot, he really is. Our greenhouse is a no-fly zone.

Near the allotments we've got an alcove by the wall, where you can sit and you'd never think you're in London. I sit there and play the melodion. It's great, you're cut off from all the worries and cares. Just me and the birds. The robins actually know my whistle. They still haven't eaten out of my hand, but they come that close … I sit and talk to them, 'You're getting very fat, you know.' It's no wonder, with the chopped cheese!

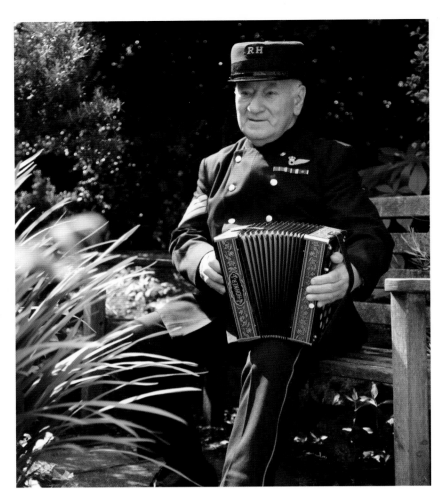

I.P. Paddy Fox in his allotment, playing the melodion (right, top) and (opposite) in his greenhouse.

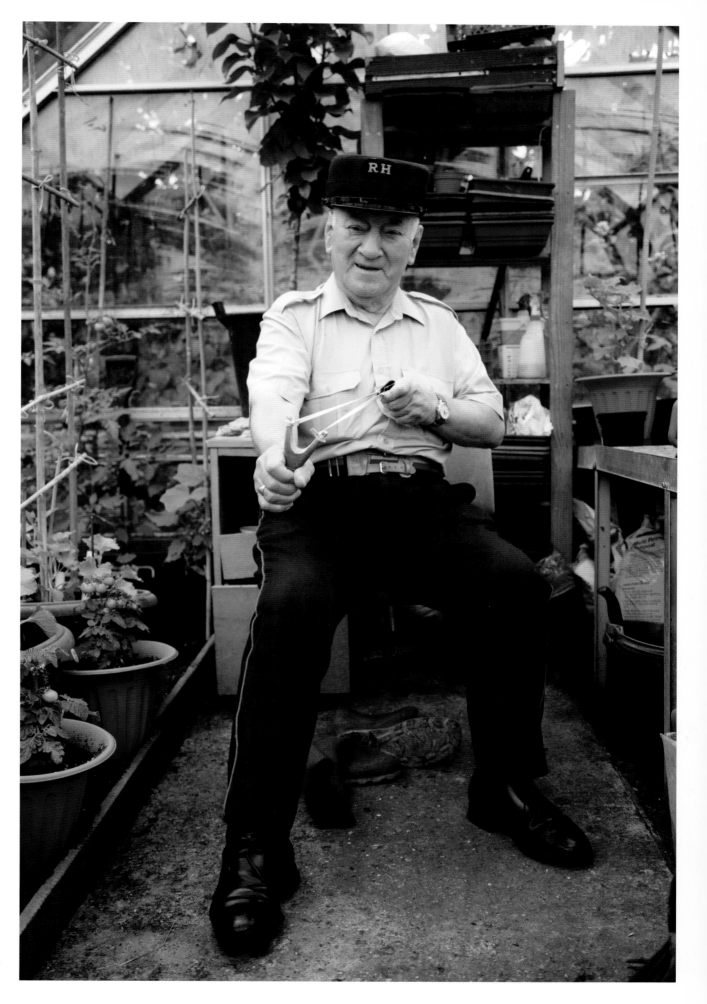

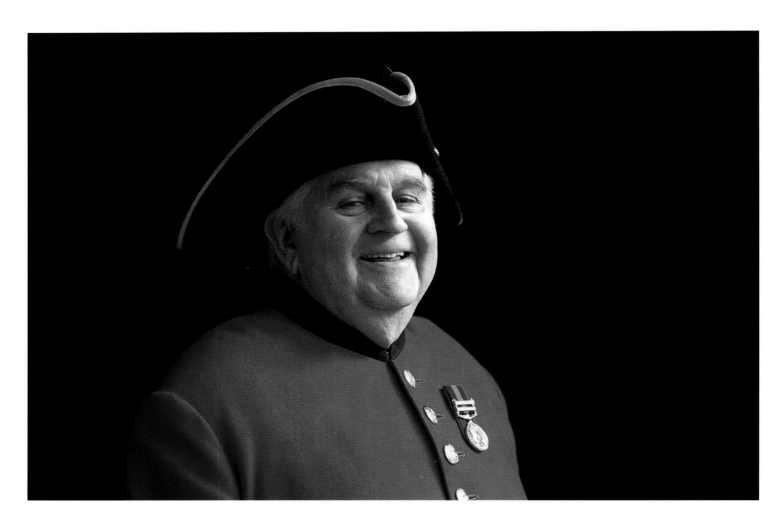

I.P. Tom Mullany

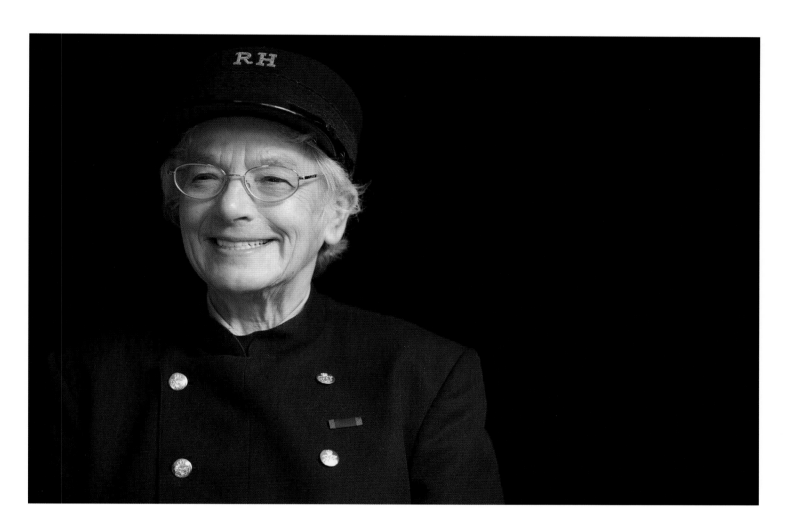

I.P. Marjorie Cole

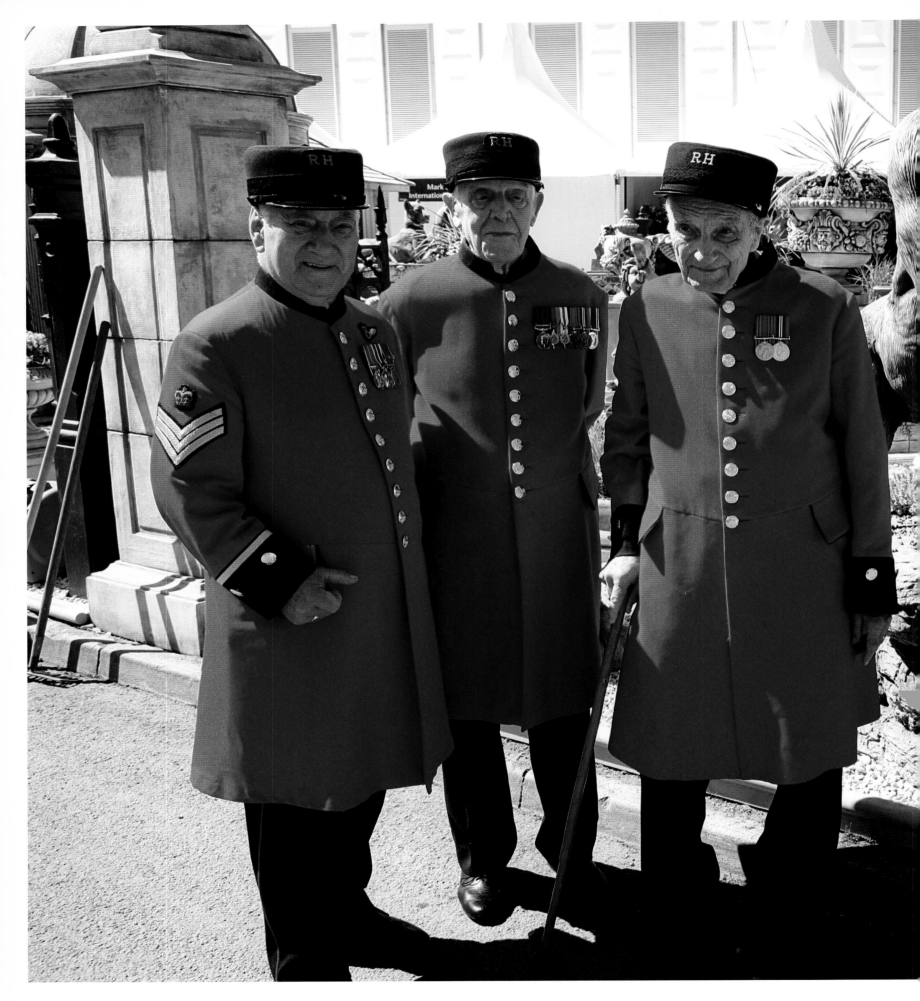

CHELSEA FLOWER SHOW

The grounds of the Royal Hospital can be hired by organizations for events, and the Royal Horticultural Society (RHS) Chelsea Flower Show, perhaps the world's most famous garden show, is held there over five days each May. For the general public, competition for tickets is fierce, but In-Pensioners are allowed free entry as long as they are wearing their scarlets. Keen allotment gardener I.P. Paddy Fox (far left, with two friends) always makes sure to visit the show and its themed garden displays.

Renowned horticulturalist Sir Harry Veitch was the first to hold a plant exhibition in the Hospital grounds, the one-off Royal International Horticultural Exhibition in 1912. By the 1920s the RHS Chelsea Flower Show was well established. Today the show is attended by some 157,000 people each year.

I.P. Fred Barber, I.P. Gerry Johnson and I.P. Joe Lennox (left to right in the photograph opposite, top) explore for the first time the new development on the site of the former Duke of York Barracks, where they stood guard many years ago. The barracks and their grounds, which were sold by the Ministry of Defence and vacated in 2003, have been replaced by upmarket housing and shops.

The In-Pensioners' distinctive scarlet and tricorne make them objects of interest for members of the public wherever they go. Much as if they were celebrities, I.P.s are often asked to feature in tourists' photographs, as happened in the case of this picture.

Every day the Royal Hospital's grounds are visited and appreciated by the public and children from neighbouring schools, who enjoy its sheltered lawns and the opportunity to watch rehearsals of parades in the company of In-Pensioners.

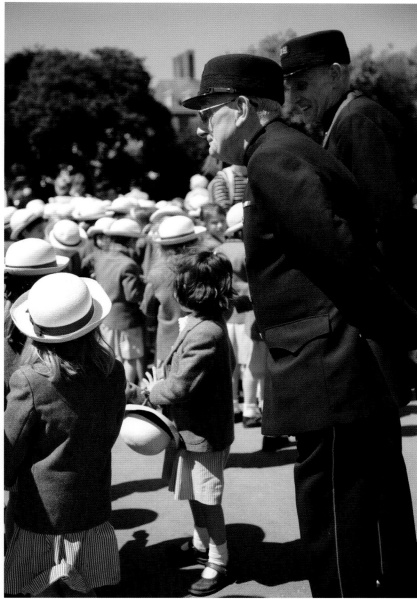

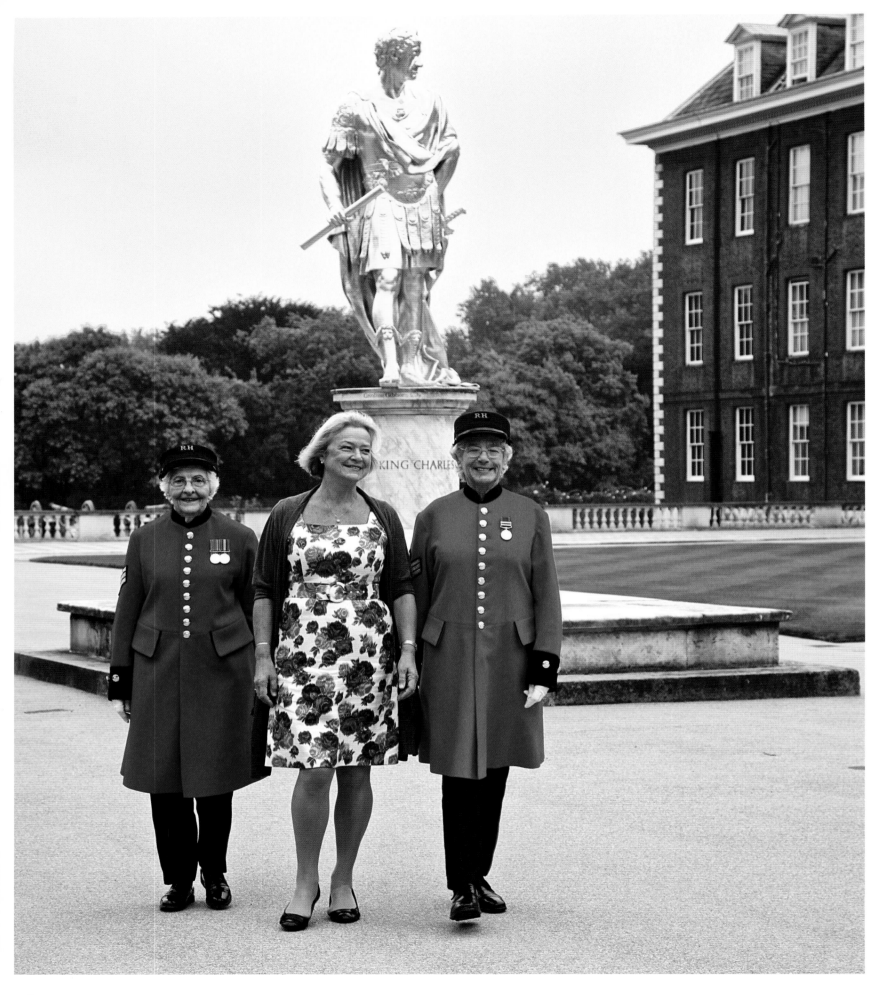

Kate Adie

Journalist, former BBC chief news correspondent

Kate Adie in the Royal Hospital's Figure Court with I.P. Dorothy Hughes (far left) and I.P. Marjorie Cole, who were among the first women to be admitted as In-Pensioners in 2009.

Going off to war in the company of 43,000 British soldiers is a singular experience, if you're the only woman. In 1991, while heading for Kuwait across the Arabian Desert in Saudi Arabia, I had a number of reminders of the practical ingenuity needed to survive in the ultimate male environment – not least being the challenge of getting a decent all-over wash in the desert with a plastic bowl and a litre of water, and within 20 yards of fifty blokes all doing the same.

The first Gulf War (1990–91) saw the last deployment of Victorian attitudes to battlefields: every female soldier, however useful in various units, had to remain in the rear echelon as we went forward in the invasion. However, war correspondents, a score of us, were treated as a breed apart, neither fit for combat nor gender-specific; not for nothing were we referred to at Army briefings as PONTIs (Persons Of No Tactical Importance). Thus I spent months at the heart of a huge war machine: having to describe and convey to viewers at home the extraordinary feeling of going to war, and conscious of having to get to grips with the military way of life but not become part of it. A correspondent is there not to fight, but as a witness.

Again and again in the desert, and subsequently in four years of war in Bosnia, I was reminded that reporting on a conflict sometimes seems merely incidental to the day's activities. Much of the time is taken up with staying alive, coping with the lack of facilities, such as water, electricity, food and a reasonably comfortable place to sleep –

not to mention the sand, unidentifiable insects, damp ground and incoming fire. You have to deal with armed drunks, unreasonable gunmen, terrified locals, distraught families, thuggish militias; all this and you have to get pictures and separate propaganda from facts, and unfounded claims from truth. There's little of the glamour imagined by those at home.

It is the significance of conflict that draws us in: momentous events that touch everyone, whether they like it or not; lives lived at the extreme, the ultimate sacrifice; being able to watch and witness. War cannot be ignored, especially if it is conducted in the name of one's nation. Reporters bring one version back. Others will add their direct experience as fighters, victims and bystanders.

Victorian times saw the rise of the professional war correspondent, always male, observing a masculine military scene. But many women who went to war – both in the baggage train and, occasionally, serving as soldiers – brought back stories that still illuminate and resonate. The names of two of the most celebrated are to be found inscribed as Out-Pensioners [non-resident but entitled to a military pension] at the Royal Hospital Chelsea: Christina 'Kit' Davis, or Mother Ross (1667–1739; she had four husbands), who fought in Marlborough's campaigns; and Hannah Snell (1723–1792), who briefly served as a soldier, then enlisted as a marine in 1747.

And today there are women once again in the Hospital's rolls – just as there are women reporting war.

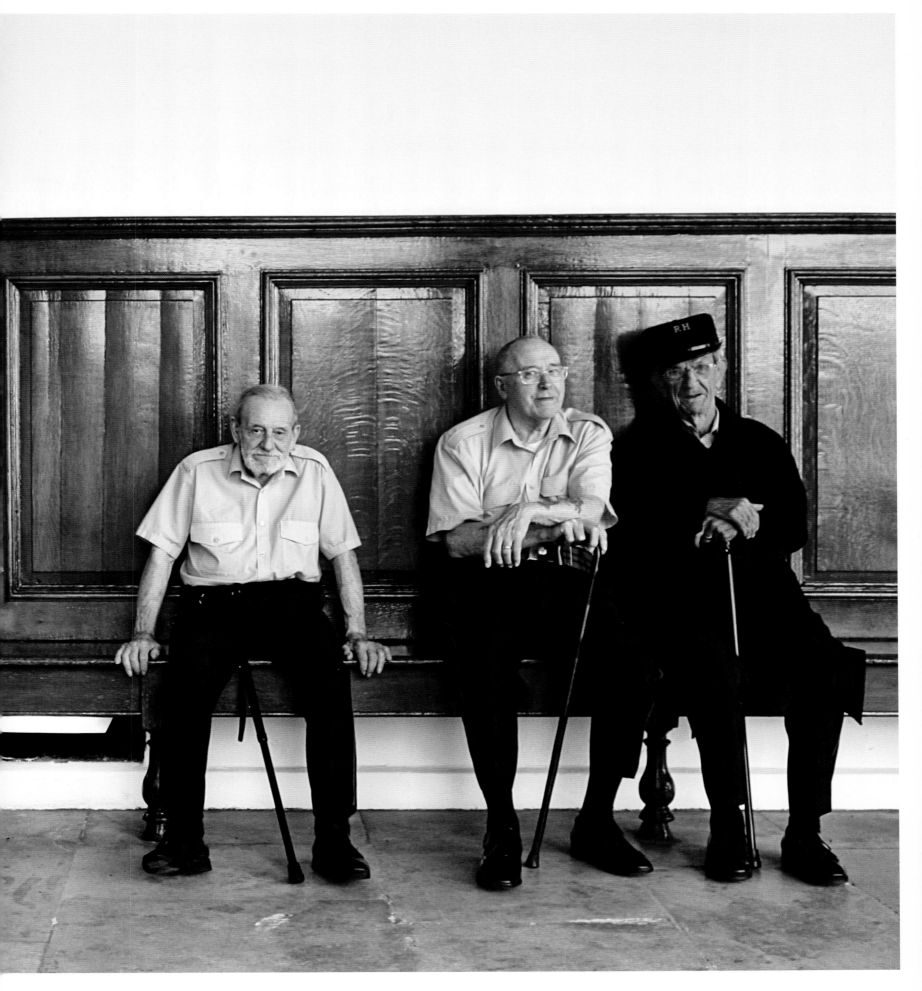

The spacious, light-flooded library, staffed by volunteer In-Pensioners, contains thousands of books, audio books and DVDs.

Previous pages: In-Pensioners in 'shirtsleeve order' enjoying the cool of the Colonnade in the summer heat. The oak benches and panelling are original features, dating from the construction of the Colonnade in the late 1680s.

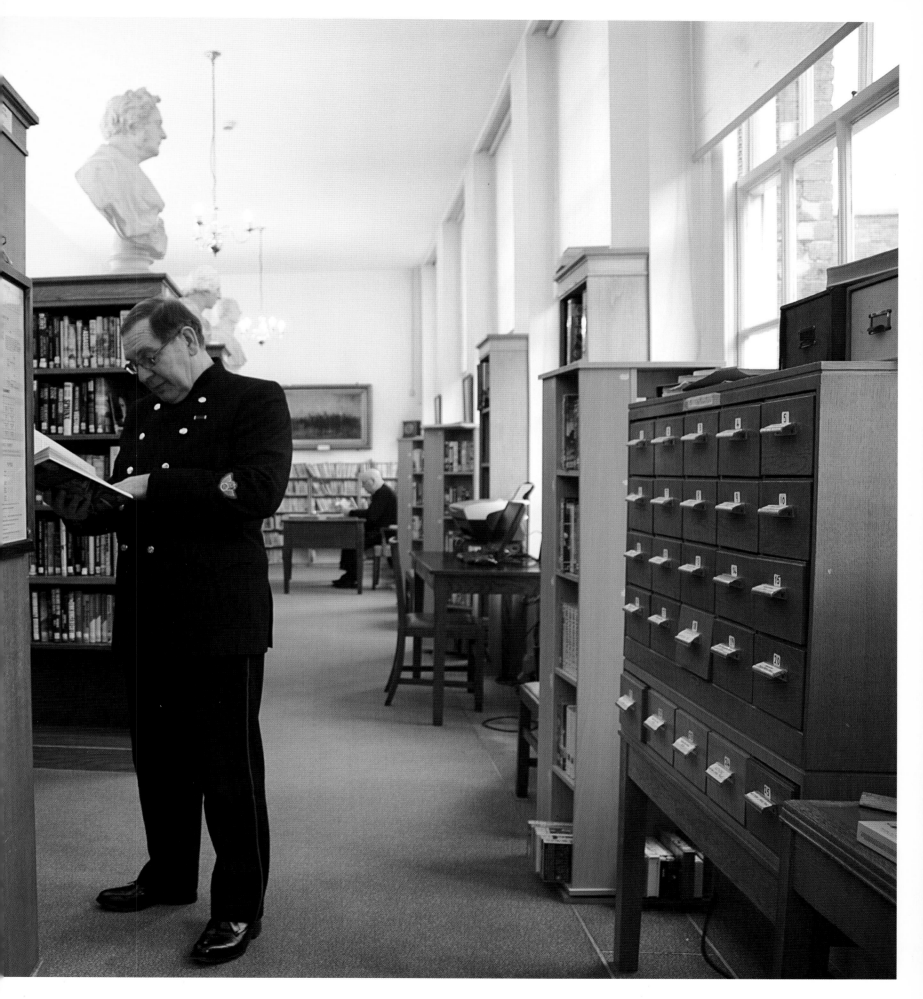

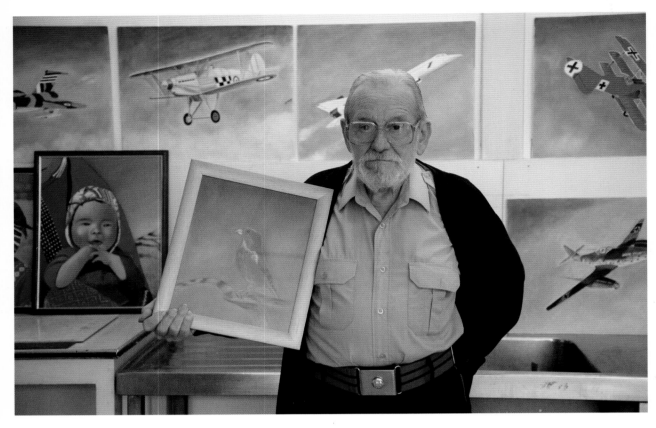

Keen painter and informal art tutor I.P. Ron Liles in the Royal Hospital's art studio. The studio was started by Lady Mackenzie, wife of General Sir Jeremy Mackenzie, the Hospital's Governor from 1999 to 2006.

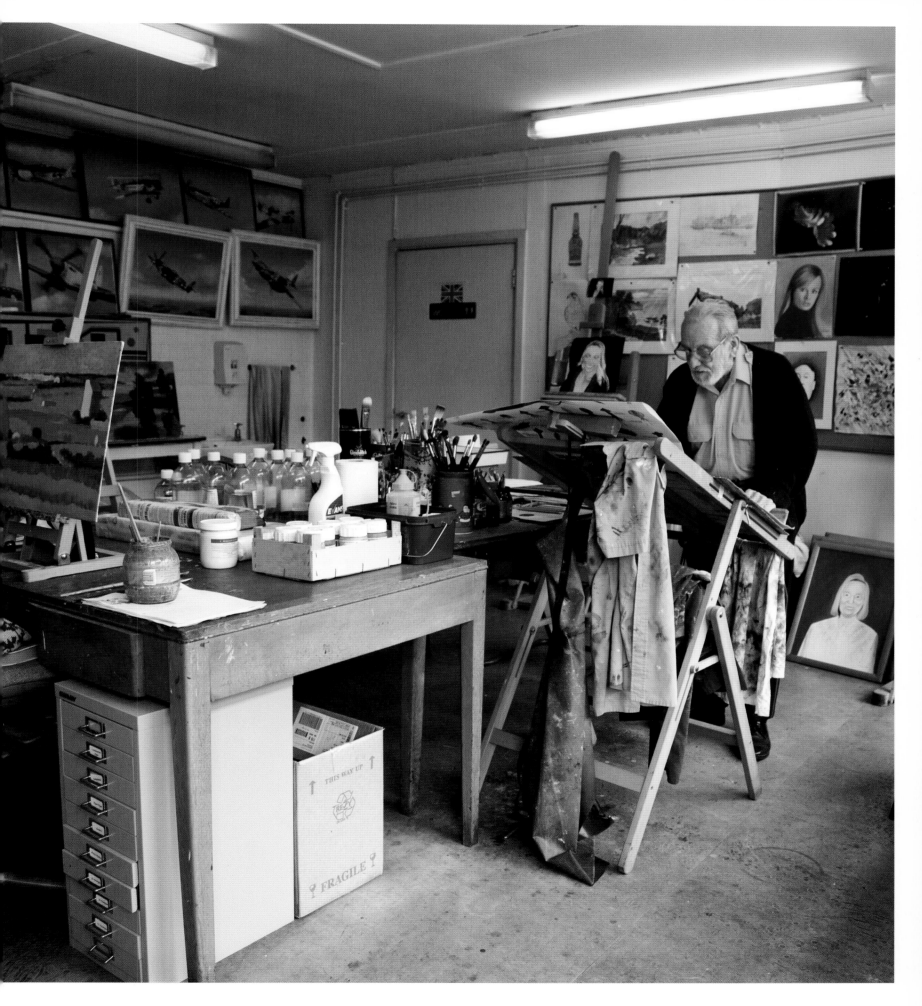

Soldiers recently returned from tours of duty in Afghanistan welcome In-Pensioners to the London Welsh Rugby Football Club in Richmond, south-west London, where Chelsea Pensioners were among those invited to a gala dinner celebrating the club's 125th anniversary in August 2010. Despite the damp conditions outside, festivities included a military tattoo with the band and corps of drums of the Welsh Guards (opposite) and songs from the London Welsh Rugby Club Choir.

All proceeds from the evening were donated to the Welsh Guards Afghanistan Appeal, which provides support to soldiers wounded in operations in that country and to the families and dependants of those wounded or killed in action.

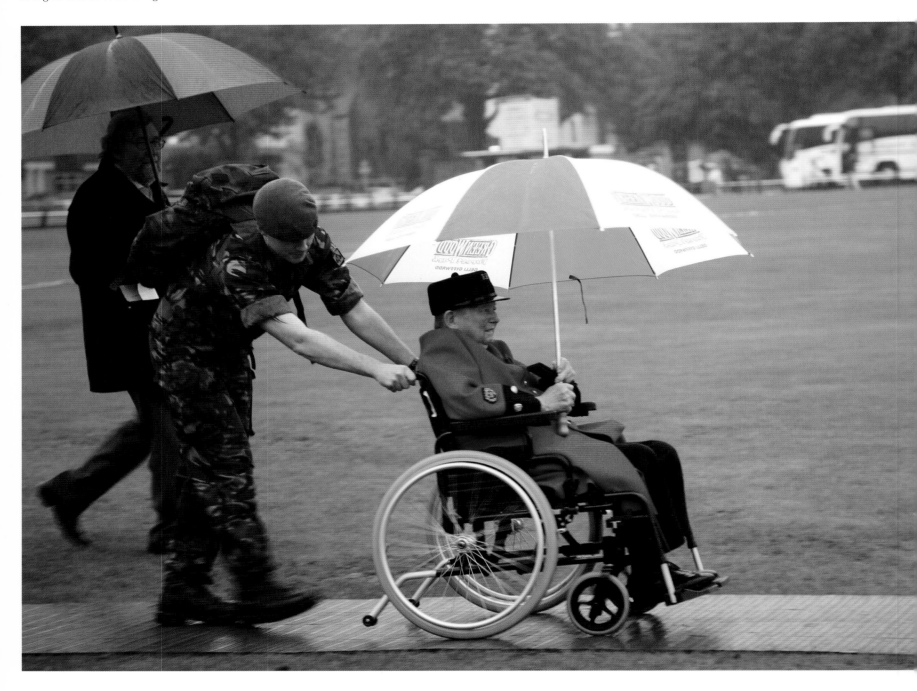

Autumn

As the leaves turn from green to brown, the stream of tourists that flowed through the Royal Hospital Chelsea's grounds all summer long is reduced to a trickle and the gift shop is quieter than at any time since the clocks sprang forward. Soon the In-Pensioners' greatcoats are lined up on pegs down the Long Ward corridors in readiness for the chill that is to come: there is still warmth in the earth, but a part of every season is a preparation for the next.

In the melancholic autumn light Patricia Rodwell captures intimate images of the Royal Hospital's living quarters, and highlights some of the memorials to British Army campaigns through the ages and to dear departed individuals.

Deciduousness is in the air, and its influence is not confined to trees and shrubbery; in 2010, the third season of the year concluded with the funeral of a popular In-Pensioner. This was naturally a sombre occasion, but one tempered with a sense of reconciliation to the inevitable. Death is a part of life. Those who remain are as certain as they can be that the final years of Charlie Boyce, who entered the Royal Hospital in 2002 at the age of eighty-six, could not have been lived more happily than with his comrades-in-arms, in surroundings that provide old soldiers with an unsurpassable combination of comfort and camaraderie.

HRH Prince Harry, himself a captain attached to the Army Air Corps, spoke for many when he said on Founder's Day in 2011: 'The comradeship that comes with [soldiering] is one of the things I treasure most in life. The army, for me and thousands like me, is a family. In that respect, for veterans coming here, it must be like coming home.'

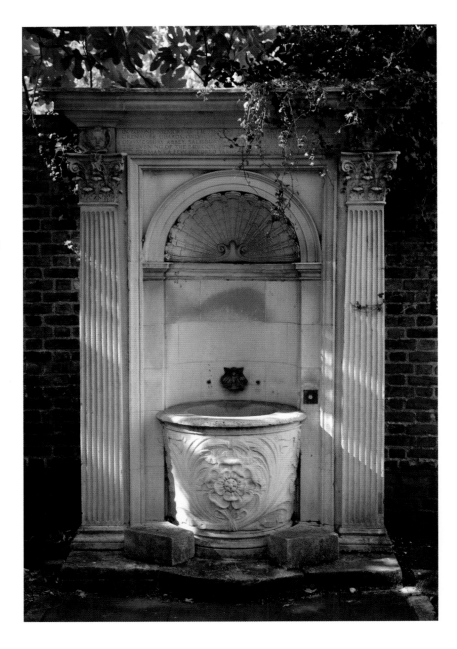

Previous pages:
Autumn leaves falling in Light Horse Court.

Clockwise from above:
A memorial to a First World War soldier of the Grenadier Guards who died in battle near Ypres, Belgium, in October 1914; avenue of plane trees in the South Grounds, their leaves beginning to fall to the ground; In-Pensioners relaxing in 'undress' uniform.

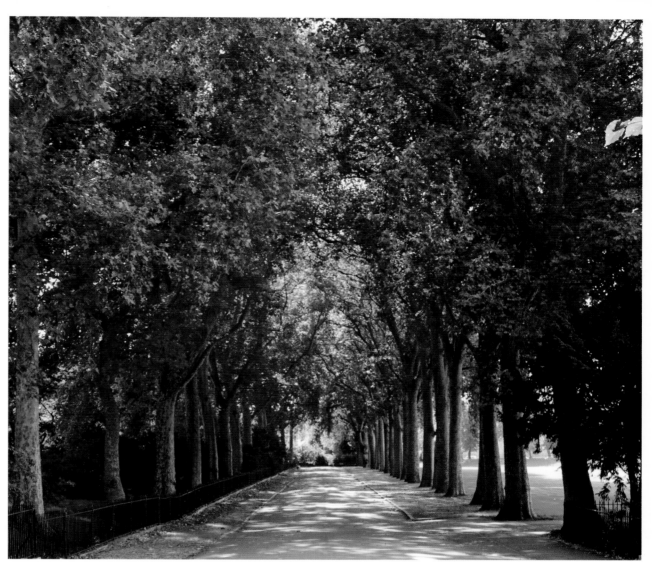

Not Abbey Road, NW8, but Royal
Hospital Road, at its junction with
Tite Street, London SW3.

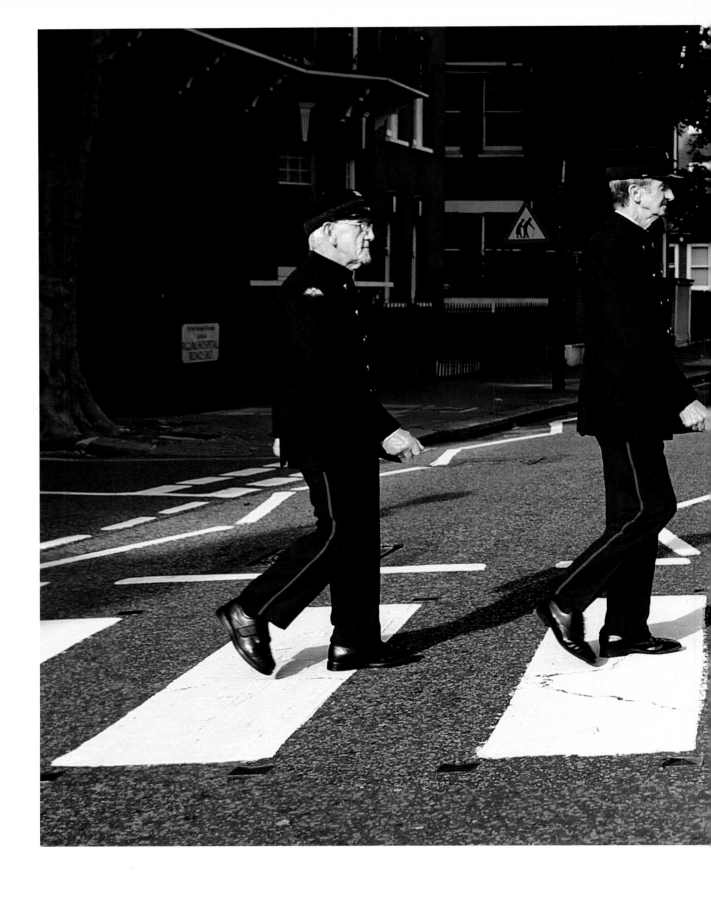

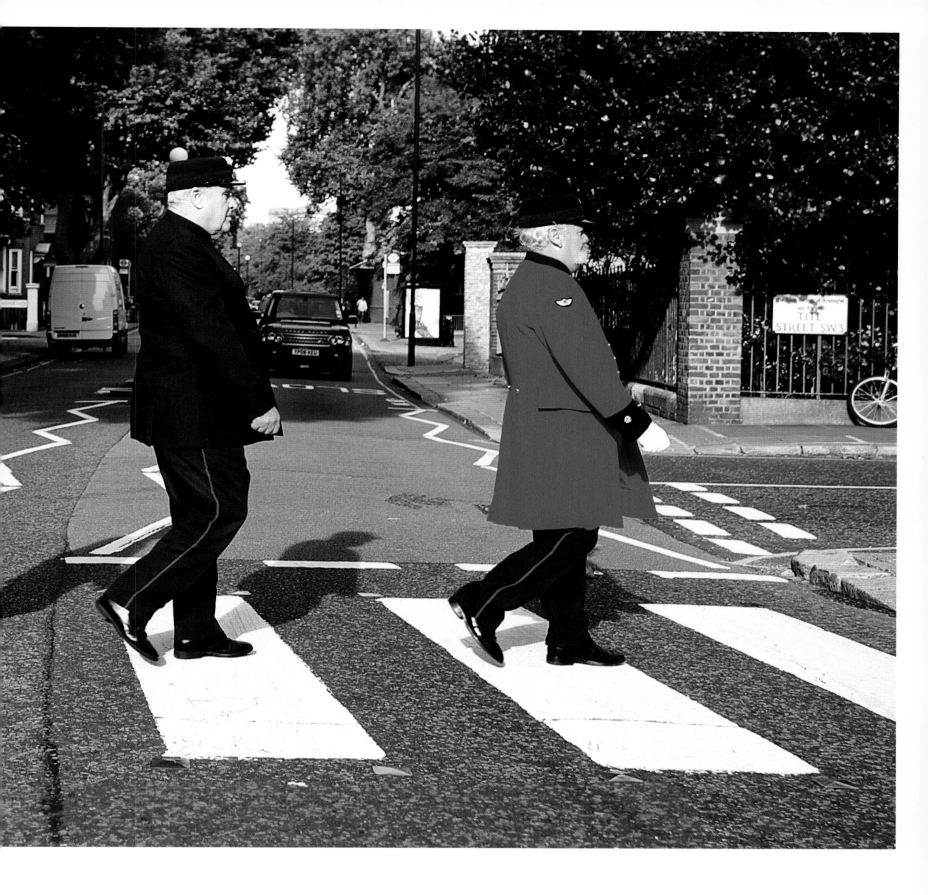

A visiting group is taken round the Royal Hospital by volunteer tour guide I.P. Brian Cummings. Opposite, a few of the In-Pensioners gather outside the Hospital's walls to wave off the group in its coach. Each day about three guided visits are given, and it is not unusual for some visitors to keep in touch with the I.P.s they have met.

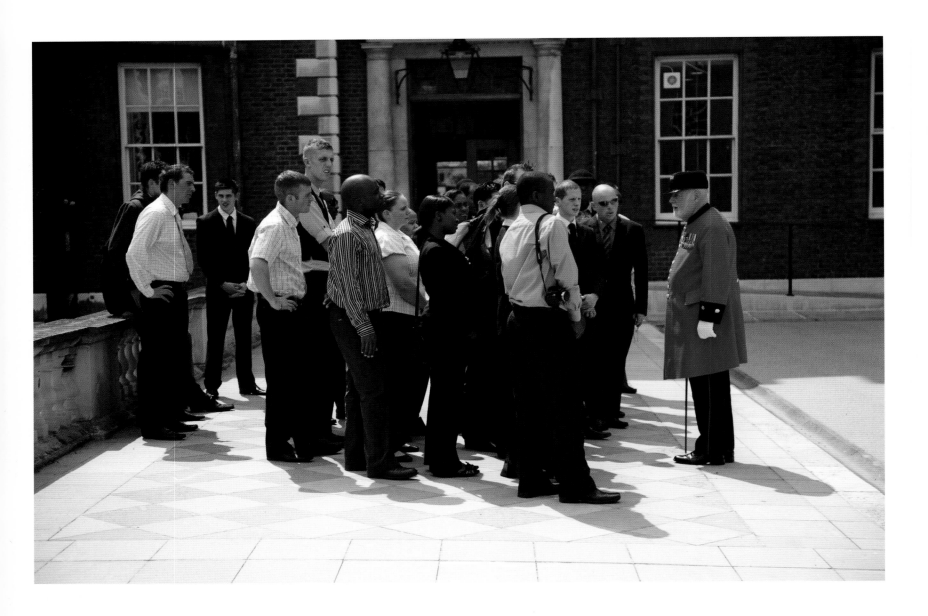

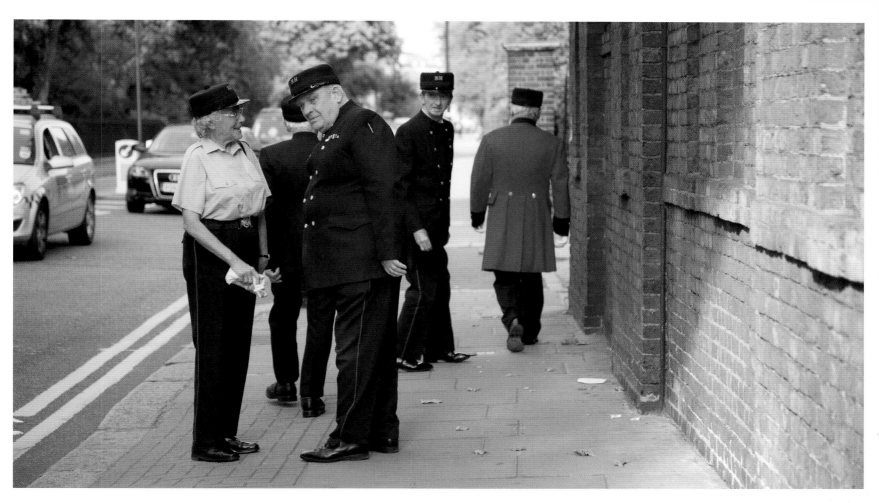

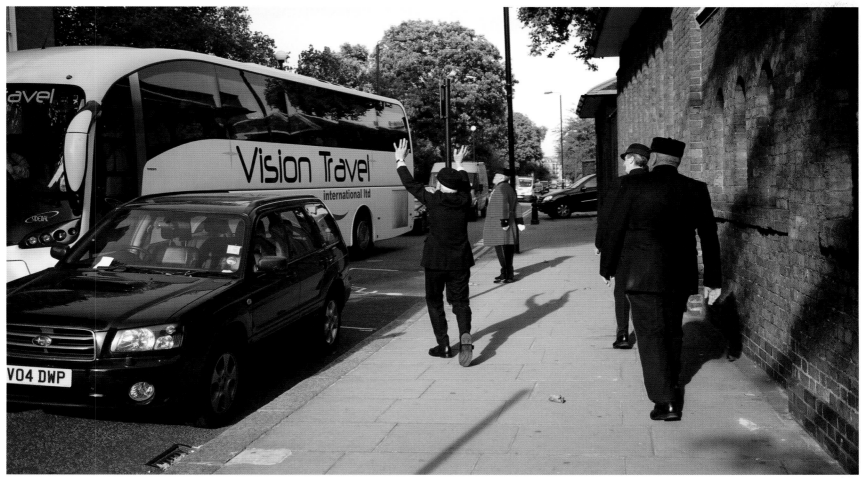

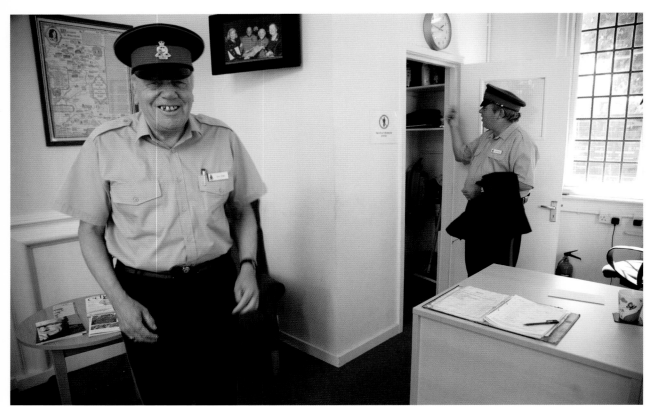

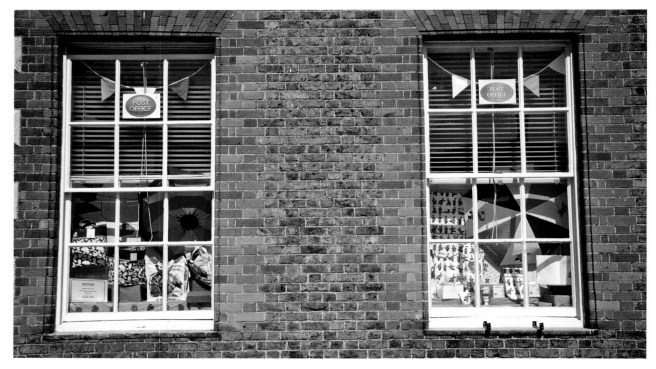

Gate Constables Mr Elder and
Mr Gillespie (top) prepare for their
shift in the guard room.

The Hospital's discreet gift shop
(above and opposite) also houses a
fully serviced sub-post office, which
is open to the public. Letters posted
from here are collected each day by
Royal Mail.

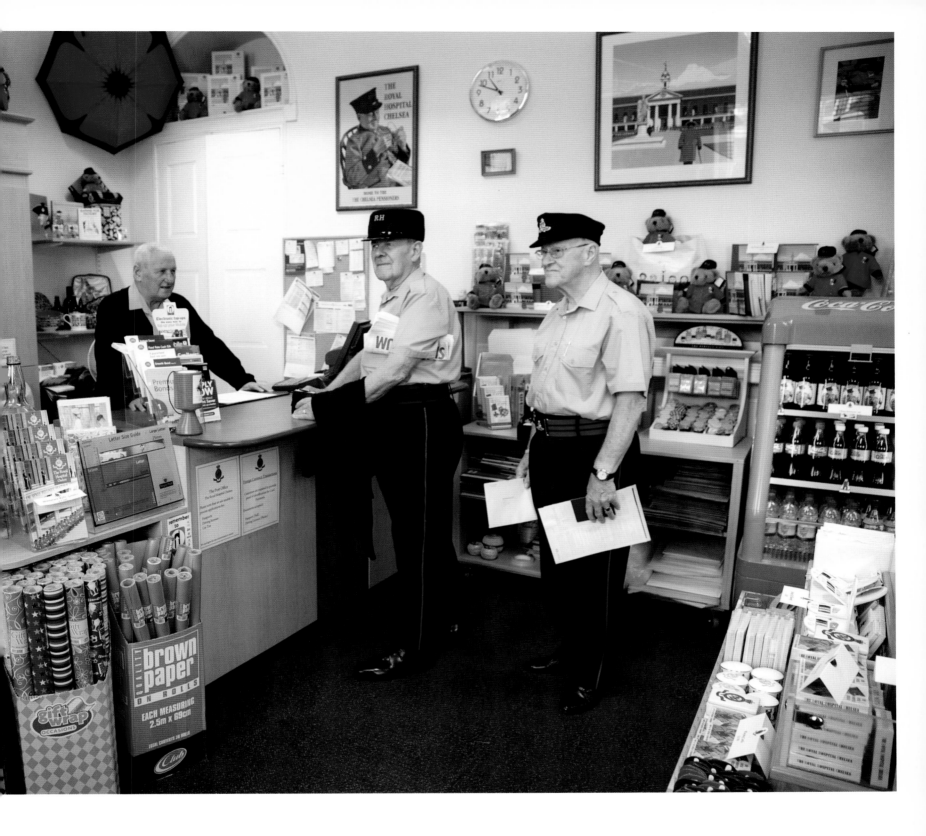

The In-Pensioners' Club is a popular place for a get-together, or for a moment of quiet appreciation of a good pint of ale.

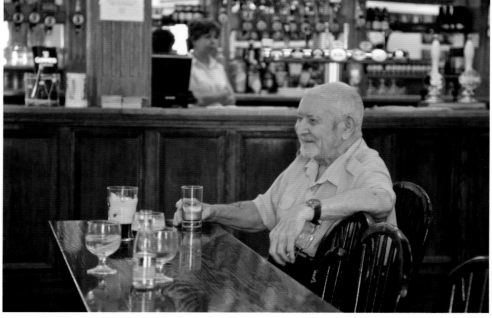

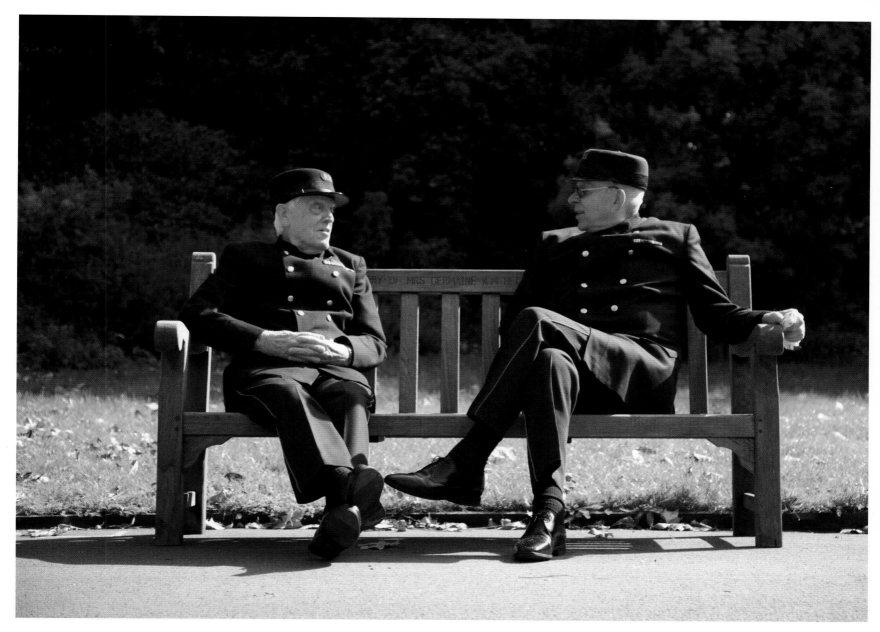

With autumn bringing fewer
visitors to the Royal Hospital and its
grounds, In-Pensioners have more
opportunity to spend time relaxing
and reminiscing.

I.P. Martin Geary

I.P. William Brierley

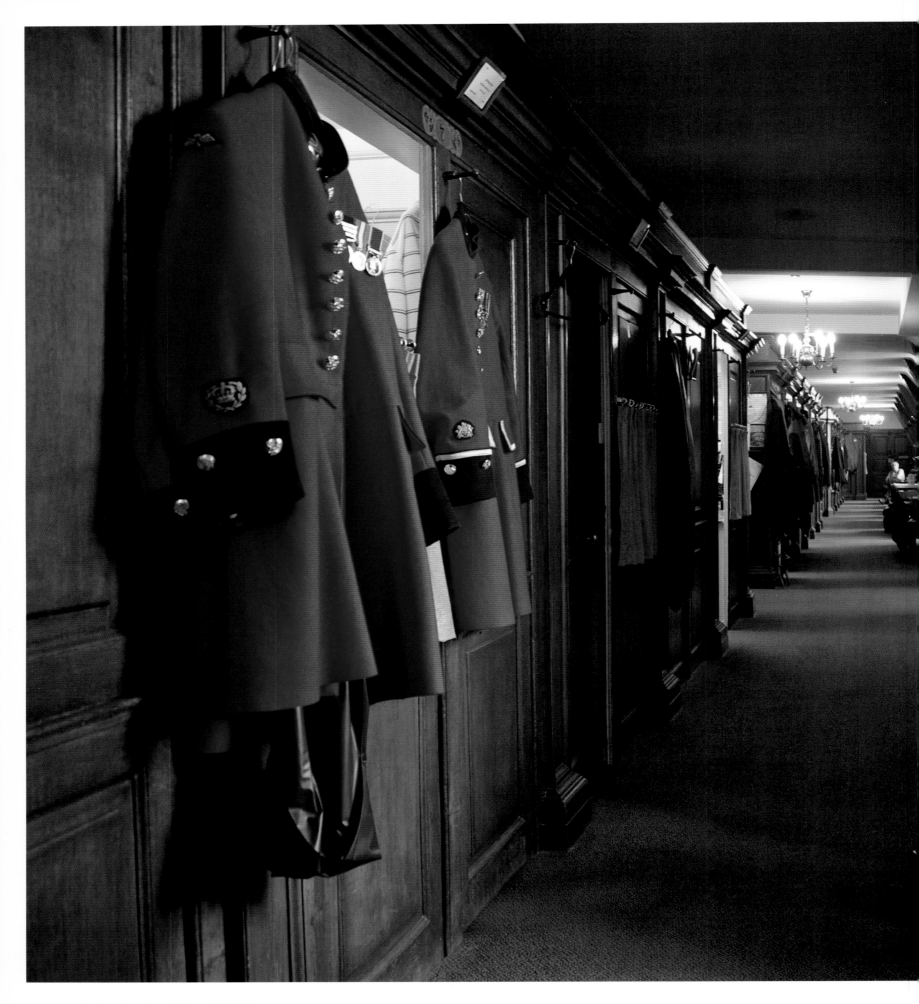

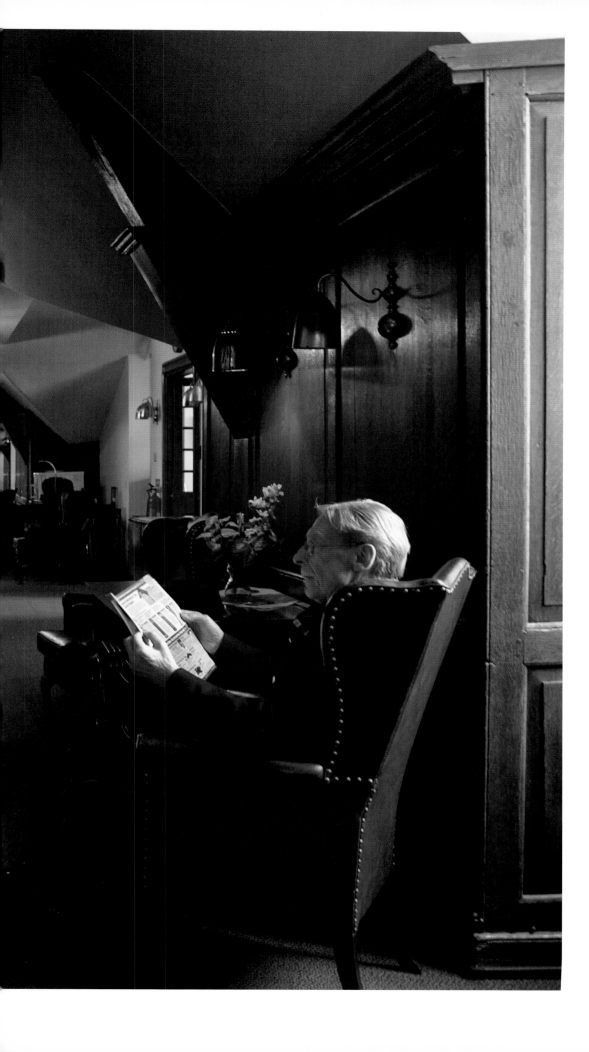

THE LONG WARDS

The top floor of one of Wren's original four-storey Long Wards, which contain the In-Pensioners' living quarters. There are two Wards per floor, set back to back; each houses eighteen small one-person rooms or cubicles, known at the Royal Hospital as 'berths'. None of the berths has a window on to the outdoors, but an unglazed opening (just visible in the left foreground, between the scarlets), next to the door, allows in air and light from the windows in the main passageway. When the opening is ajar, a half-curtain grants some measure of privacy in the berth, and the occupant can ensure complete privacy by closing the opening's wooden shutter. The berths have been enlarged since Wren's day, but retain the original doors and shutters.

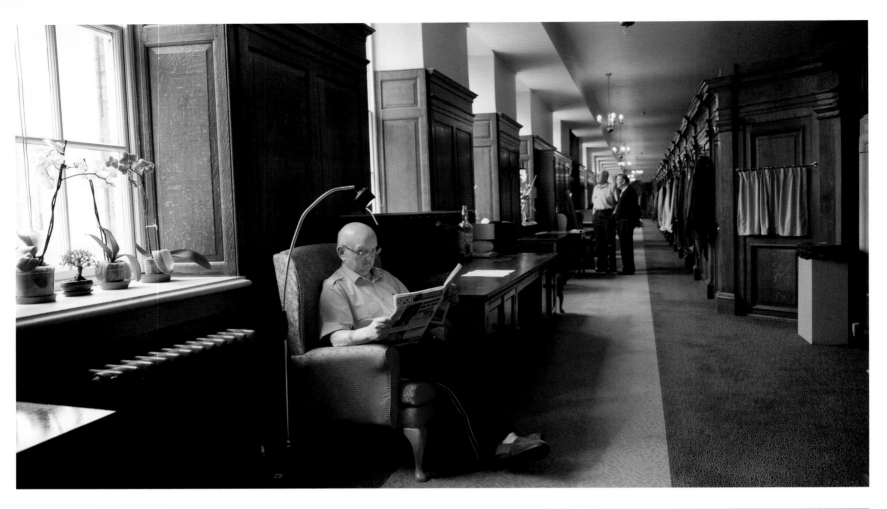

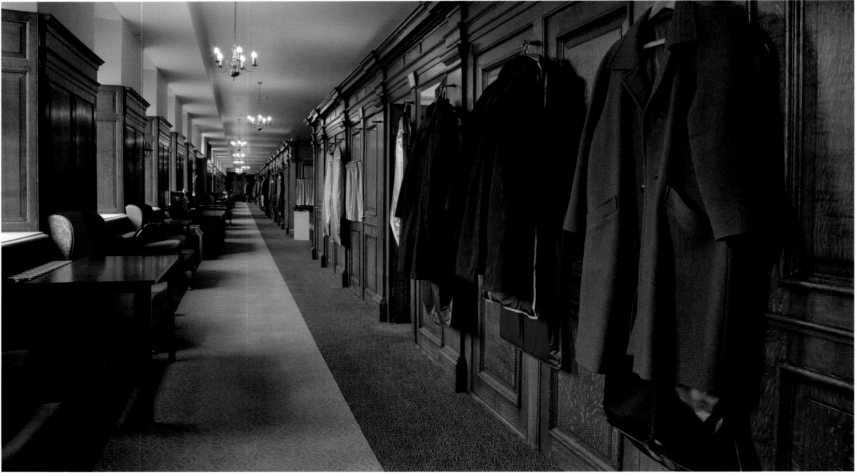

As on every floor of the Wren Long Wards, on the ground floor (opposite) 'ablutions' are at either end of the Ward. The Royal Hospital is currently embarked on a programme that will see every berth become en suite while retaining the historic fabric of the buildings.

The main stairs at the northern end of the Long Wards, part of Wren's original scheme for the Hospital in the late seventeenth century, were built shallow and wide for the convenience of aged and infirm In-Pensioners and their bearers. Each landing is equipped with a bench on which to rest.

The fireplaces in the Long Wards are the originals from the late seventeenth century.

I.P. Bill Moylon

[On returning in 1945 from the Japanese prisoner-of-war camp in Thailand], first of all you were overwhelmed by people and by your family, who wanted to do everything for you. I'd been home for only two or three days, and I told my family, 'I've got to go away for a little while to get myself sorted out.' I travelled around the country for about three or four weeks, on my own, where no one knew me. Then I came back and it was all right, I was able to settle in, and people could come to me and ask me whatever they wanted, it was no problem.

But you see, what you keep getting, even now, all these years after, you still get a flashback, you remember your mates as they were, you know. But I got myself sorted out and was able to adapt.

I didn't stay in the army. We were allowed so much leave [by the military] for every year we'd been overseas, but they also put us on indefinite leave, because of course we were still all suffering the effects of malaria, dysentery, cholera and typhus and all these diseases that we had out there. I've got some problem because of my age – I'm ninety-five – but I've looked after myself.

When we left England, we'd no idea where we were being sent. We crossed the North Atlantic over to Canada and eventually they transferred us off British troop ships on to American ones, although the United States was not in the war at that point. We sailed down via South America and Africa. We'd been on the American ships for about a month, and when we got one day off from Cape Town, Pearl Harbor happened. And that brought the Americans into the war, although they'd been helping us in a great way prior to that.

We got to India, where we did a bit of training for a few weeks. Then they put us on to a troop ship, the infamous *Empress of Asia*; she was literally a hell-ship. She had been built in 1912, and had been condemned years before the war but was brought back into service to carry troops. She was in a shocking state.

We sailed from Bombay, and again we didn't know where we were going. But we were on our way to the Far East. Some distance out of Singapore a flight of Japanese bombers came over, and one of them dropped his bombs, but fortunately they dropped down either side of our ship, so we were very, very lucky. [The *Empress of Asia* was separated from the convoy.] We were about 20 miles off Singapore and another flight of bombers came over, and we were hit about four or five times. The old ship being what it was, none of the firefighting equipment worked; she just burned like paper, and we had to abandon ship.

I jumped off one of the top decks and had about four hours in the water. Fortunately the bombing had driven the sharks out, because the waters around Singapore are shark-infested. After jumping, I got to a raft – just an air tank with ropes hanging round it, you hang on the side. Then another chap came and we started swimming to the nearest blokes to us, and eventually we had about sixty men. After some time we got picked up by an Indian gunboat and they took us into Singapore. We were straight into action. They gave us just a couple of bandoliers of ammunition and a rifle; we didn't have any tin hats or any gas masks.

Our people were well prepared at Singapore for an invasion from the sea, but they never expected an invasion from overland – which is what the Japanese did. They came right down through Malaya on pushbikes, literally, and they were able to take over the island. I would say they were far superior fighters to us because they were more devoted to their country and it was such a great honour for them to die for their emperor and all this business. They had a different outlook on life from us.

I was in the first party [to be taken by the Japanese] from Singapore to Thailand, travelling in cattle trucks. The stench in there after a couple of days was terrible. When we arrived, we had to build a camp at a place called Non Pladuk, which was a marshalling yard, and that was to be where the railways coming from Bangkok, from Malaysia and the one we were going to build, coming from Burma, would all join up. But then they picked 140 of us, we were supposed to be fit men, and we went to this area in the jungle where the bridge over the River Kwai was eventually built.

There was nothing there at the time, and when we met the man in charge, Colonel Saido, he said, 'There'll be no prison fences, the fence is the same for the Japanese as it is for you: the jungle. There's no way out of it.' And there was no way out of it, unless you had ample food and medical supplies; there was no way you could survive otherwise.

Of course, Thailand is a beautiful country. The jungle's a beautiful place, with lots of lovely birds, orchids, all absolutely virgin jungle, but the problem was that you had mosquitoes, bugs, flies, lice, sand flies, and everything wanted to suck your blood. We had no treatment. The only thing you could do was to find a big termite mound or ant hill, and put your loincloth, full of body lice, nits and that, on top of it. It was amazing to watch the ants and termites picking off the bugs! In the conditions that we were living in, tremendous numbers of us died.

[The Japanese] army was exceptionally cruel. The soldiers were brought up to be brutal, not only to their enemies but to their own people, too. They could be brutal to anyone who was below their status in life. At that time, brutality in the men was like vitality, or like being macho. Literally, they were indoctrinated, and they lived by their indoctrination. After reading about this after the war, how they were brought up like this, really you couldn't hold it against them because they were doing what they thought was right. That was their way of life, that's how they were taught to do it, the same as we in this country were taught to take care of people.

They were exceptionally brutal. We could never understand why they wanted to be bashing people about, how they needed us so much to build this railway and yet their value for the life of people under them was so very low. You were nothing, you were just a cog in the machine that could be disposed of.

As far as the ordinary Japanese people are concerned, I have great respect for them. They are just normal people. Going there to live among them is an entirely different experience from what we'd had meeting up with their army in the war. When I went there with my son, they were so kind to us. They realize how they had wronged us in the treatment they'd given us, and I even had apologies from them. Of course, the country itself has never officially apologized to us, but the ordinary people, they realized that they'd made tremendous mistakes and said that they would never get involved in a war again.

The people themselves are excellent people. They couldn't do enough for you. It's no good nursing grievances; you can't hold the sins of the father against the children. The sad part of it was, for us, that so many of our young mates in their early twenties had died of starvation and overwork, with no medical supplies, in terrible conditions, no clothes, just a loincloth. Almost unbelievable that we were in that state.

We were working anything from fourteen to eighteen hours a day. We were just walking skeletons. I was there for three and a half years. People ask you how you survived. Well, every day was a problem, and you had the choice of two things: either you did it right or you did it wrong. If you chose the right way to do things, and to a point appeased the Japanese as well, and were one jump ahead of them, you had a good chance of survival. But at the time, you don't think of that. All you're doing is living day to day.

Bill Moylon's memoir, A Very Pleasant Journey Through Life, *detailing his capture and period as a prisoner of war, is available from the Royal Hospital Chelsea gift shop.*

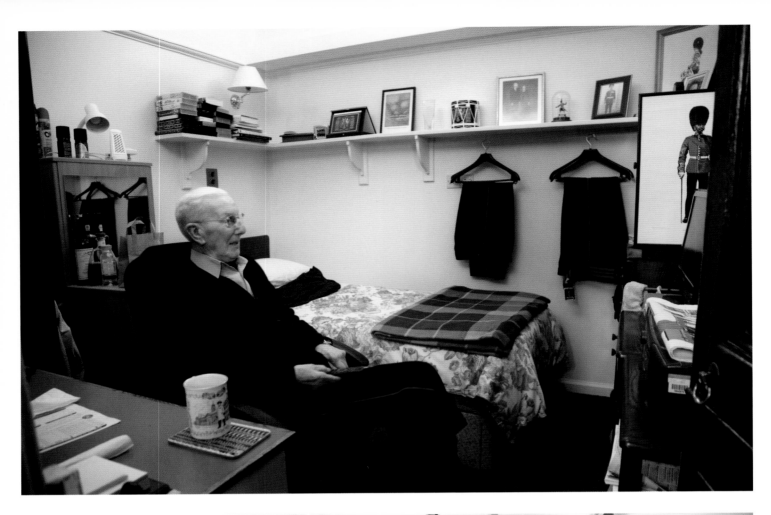

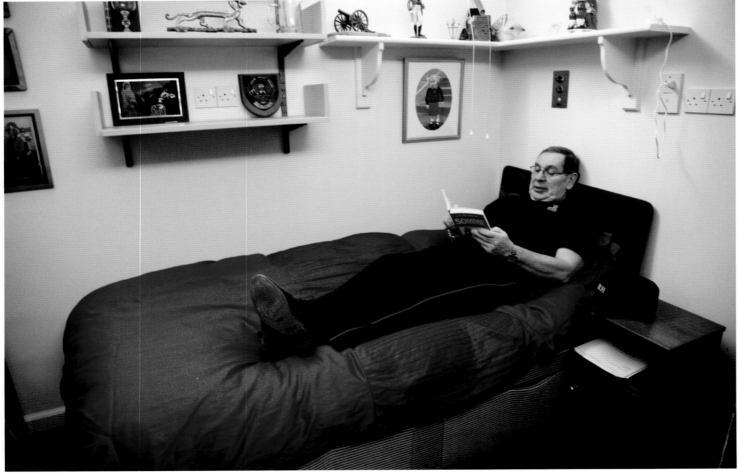

Each berth measures about 2.8 metres square (9 × 9 ft), is furnished with a bed, a table, a chair, a wardrobe and a chest of drawers, and is fitted with an internet and television power point. In-Pensioners may bring their own furniture and decorate their berth as they wish, but cannot change the carpet or the colour of the walls. These rare images of In-Pensioners' berths were taken with the kind permission of their occupants, I.P. Norman Mitchell (opposite, top) and I.P. Jim Hawtree (opposite, bottom, and right with I.P. Mal Smart).

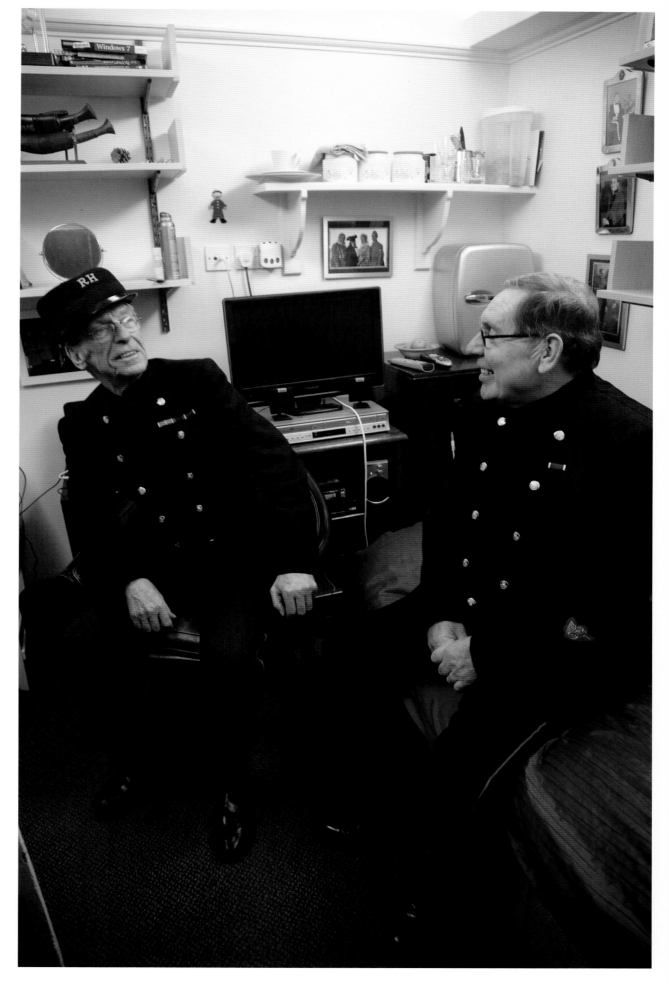

I.P. Dorothy Hughes

I.P. Dorothy Hughes, one of the first women admitted as In-Pensioners in 2009, at the age of eighty-five, in her study area in the new-style Long Wards opened in 2010 (opposite). Berths here are the same size as those in Wren's Long Wards, but also include a separate study area and an en-suite bathroom.

Dorothy Hughes, who was born in Swansea, was a Sergeant gunner with 450 Heavy Anti Aircraft Battery on the outskirts of London during the Second World War, one of a small number of women to handle the big guns set up in an attempt to bring down German bomber planes flying over England.

On becoming a civilian after war service, men were given shoes, a suit, a mackintosh, one shirt, one tie and a cardigan.

Women had fifty clothing coupons and had to return all their uniform within fourteen days. The coupons were for one year and included shoes. I was demobbed in 1946, and as my family home had been 'blitzed' I had very little clothing left. No way could I have used half my yearly allowance to buy a wedding dress. So a dusky pink 'afternoon' dress had to do. Clothes rationing had been introduced in June 1941, so my family couldn't help out. Nightwear was made from parachute silk, which one could buy with coupons.

Most women made their own dresses and coats from Utility patterns given free in magazines. They had no pleats or pockets, and used the smallest amount of material. Knitting wool was also rationed.

One could have borrowed a white dress, but women tended to keep theirs as an heirloom. My wedding flowers were pink and white tulips and fern foliage from a neighbour's greenhouse.

I.P. Walter Swann

I.P. James Mitchell, BEM

Mark Austin with I.P. Gerry Johnson
(centre) and I.P. Eric O'Donnell.

Mark Austin

Journalist, co-presenter of ITV's News at Ten

'Broken by age and war' is how Charles II described many of the veterans of the seventeenth-century battles between Royalists and Parliamentarians that so shaped the future of this United Kingdom. It was to help them, the poor, homeless and often wounded old soldiers of the English Civil War, that the restored king decided in 1681 to found the Royal Hospital Chelsea.

Charles II saw the need to help soldiers who could no longer help themselves. Henry VIII's dissolution of the monasteries meant that the Church often couldn't fulfil a role it had previously taken upon itself. And so Sir Christopher Wren was commissioned to design and build a home for heroes.

'Broken by age and war' – and yet nowadays there seems nothing 'broken' about the men in scarlet, so grand in their stunning, decorated coats, medals on parade, pride in their hearts. There is pride in our hearts, too, at such a splendid sight.

No, there is nothing broken about them. Age does not wither them. They are old men with histories, with stories to tell and some they would rather not, who have been given refuge and help and a place to call their own. They are symbols of Britishness, of the great military tradition of this country and of what this nation should be all about.

It's difficult to imagine the streets of London without the occasional magical glimpse of the men in scarlet. We see statues of military heroes of the past standing tall and frozen in time, but these men still living, still walking among us, conjure in many exactly the same thoughts. They are a timeless reminder of the men who fought and who fight still.

Until recently there had been a sense that an era was coming to an end, that the Royal Hospital Chelsea had done its work and served its purpose. But two more wars fought on foreign fields have changed such thinking. Another generation of servicemen and women is now returning from battlefields overseas and having to cope with the life-changing realities of conflict: the horror, the brutality, the injuries and the consequences.

Many soldiers have been killed, of course, but many more have been seriously injured and may not be able to stay in the military. And it is not only physical injuries that can ruin lives: many soldiers are returning mentally scarred by what they have witnessed. Post-traumatic stress disorder can lead to problems within relationships and ultimately to poverty and homelessness. The Royal Hospital and its staff have a busy future, make no mistake.

There are plenty more men, and now women, too, who will covet the scarlet coat and all that it represents. They and the Royal Hospital Chelsea have a permanent place in the nation's heart. God Bless them and all those who look after them.

THE CHILLIANWALA OBELISK

The magnificent obelisk in the South Grounds is a memorial to more than 200 officers and men of the 24th Regiment of Foot who lost their lives in the Battle of Chillianwala on 13 January 1849, during the Second Anglo-Sikh War. The battle, which took place in the Chillianwala region of the Punjab, now part of Pakistan, was one of the bloodiest clashes fought by the British East India Company. The soldiers of the 24th were buried at the battlefield on which they fell, in three marked graves that are probably among the oldest surviving marked graves of British soldiers killed in action. The 24th Regiment later became the South Wales Borderers infantry regiment, then was absorbed into the Royal Regiment of Wales, which is now amalgamated into the Royal Welsh Regiment.

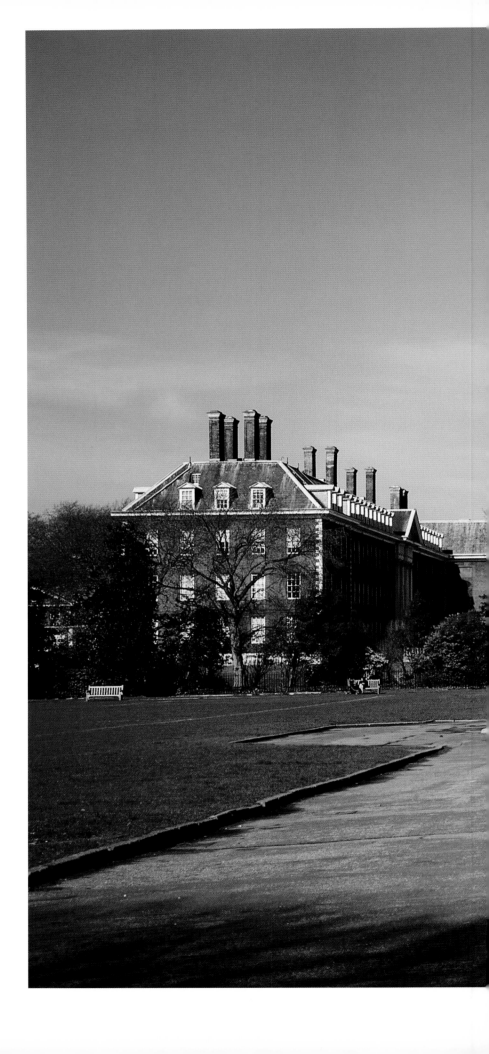

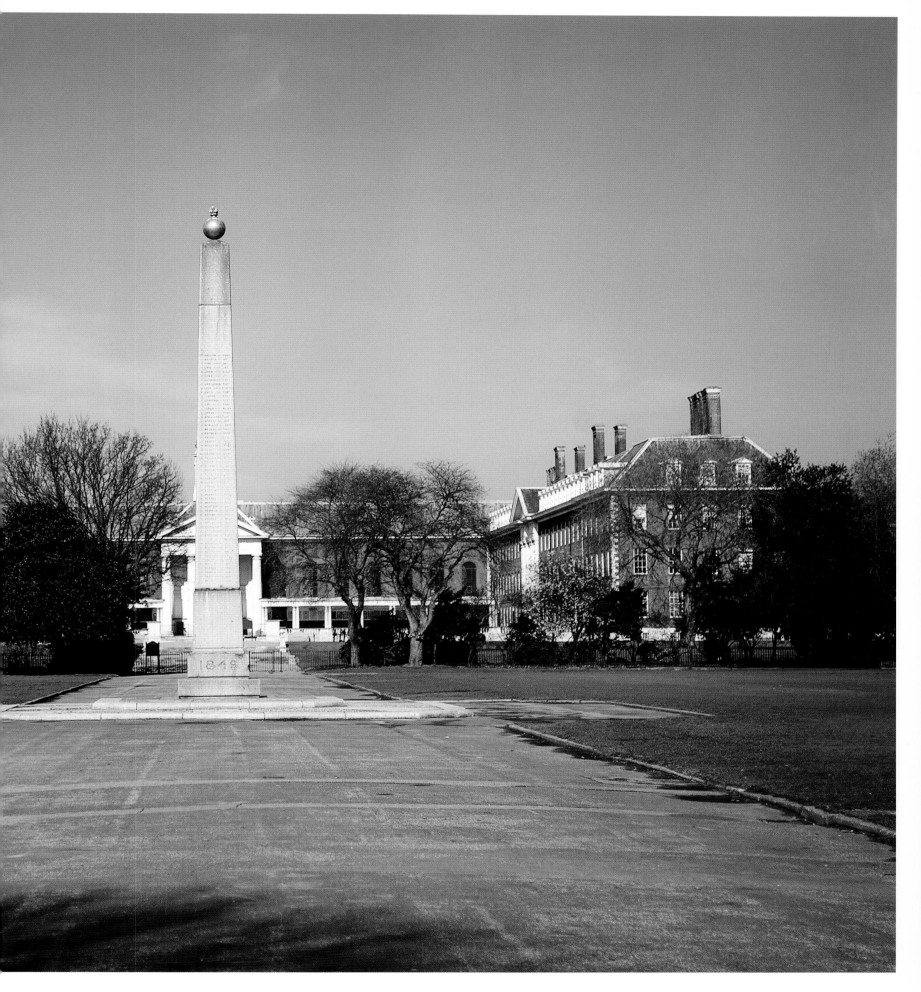

The names of the officers and men of
the 24th Regiment of Foot who died
at the Battle of Chillianwala are
meticulously recorded on the obelisk
that stands at the Royal Hospital.
Another similar obelisk was erected
at the site of the battle.

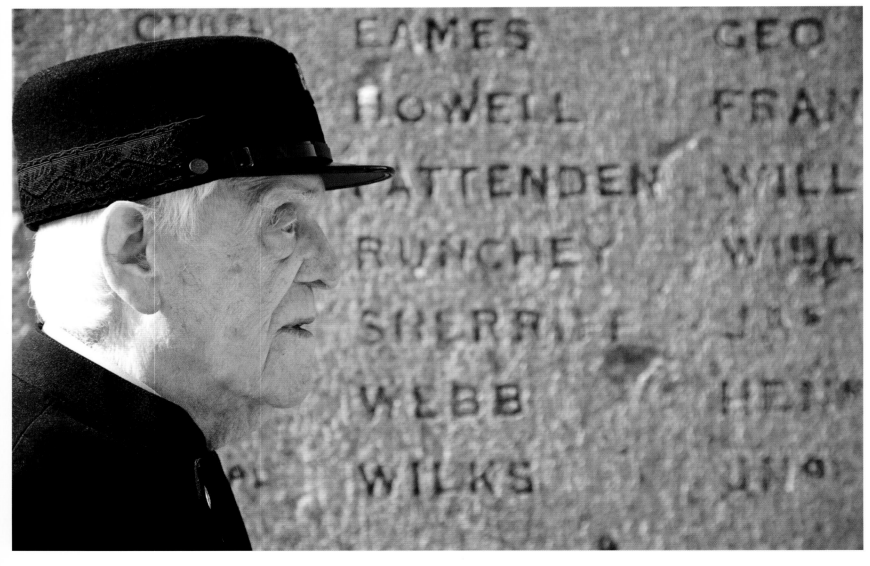

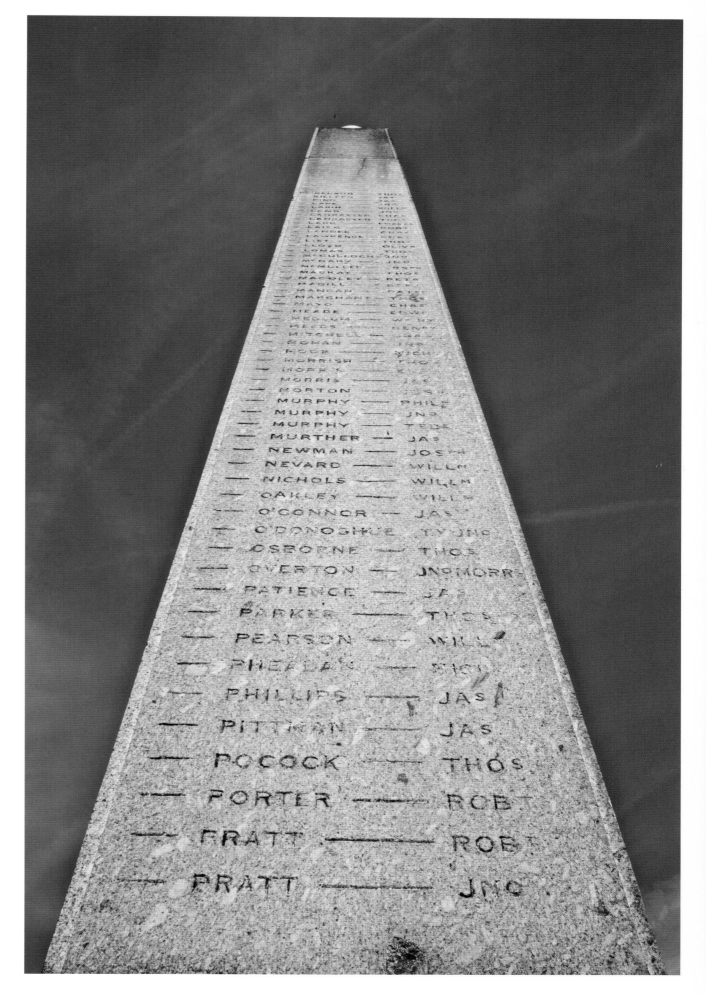

Some of the plaques in the Royal Hospital's Great Hall commemorating battles in which the British Army has been involved (right and opposite). The plaques record military conflicts in chronological order. Not yet featured on the wall is the current war in Afghanistan, which is still waiting to be 'closed'.

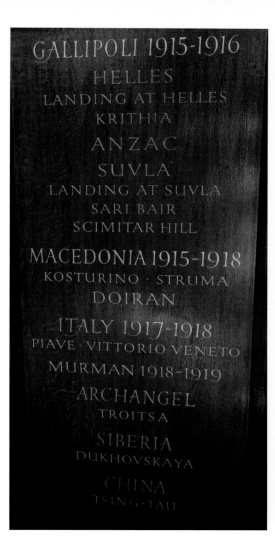

GALLIPOLI 1915-1916
HELLES
LANDING AT HELLES
KRITHIA
ANZAC
SUVLA
LANDING AT SUVLA
SARI BAIR
SCIMITAR HILL
MACEDONIA 1915-1918
KOSTURINO · STRUMA
DOIRAN
ITALY 1917-1918
PIAVE · VITTORIO VENETO
MURMAN 1918-1919
ARCHANGEL
TROITSA
SIBERIA
DUKHOVSKAYA
CHINA
TSING-TAU

NORTH-WEST EUROPE
1944 - 1945
FALAISE
FALAISE ROAD · THE LAISON
Dives Crossing · La Vie Crossing
Lisieux
La Touques Crossing · Risle Crossing
Forêt de Bretonne
THE SEINE, 1944
Amiens, 1944 · Brussels · Antwerp
Hechtel · Gheel
Heppen · Neerpelt · Aart
THE NEDERRIJN
ARNHEM, 1944
Nijmegen · Veghel · Best
Le Havre
Boulogne, 1944 · Calais, 1944
Antwerp-Turnhout-Canal
THE SCHELDT
South Beveland
Walcheren Causeway · Flushing
Westkapelle
THE LOWER MAAS
Aam
VENRAIJ
Asten
GEILENKIRCHEN

KOREA
1950 - 1953
NAKTONG
BRIDGEHEAD
Chongju
Pakchon

CHONGHON II

SEOUL
Chuam-Ni
Hill 327 Kapyong-chon
The Imjin
Kapyong

KOWANG SAN

Maryang-San
Hill 227 1 The Hook 1952
The Hook 1953

FALKLAND ISLANDS
1982
Goose Green
Mount Longdon
Tumbledown Mountain
Wireless Ridge

GULF
1991
Wadi al Batin
Western Iraq

IRAQ
2003
Al Basrah
Western Iraq 2003

DRUMHEAD REMEMBRANCE SERVICE

In-Pensioners and visitors gather for the Drumhead Remembrance Service, held on Armistice Day, 11 November, the anniversary of the end of the First World War in 1918. In days gone by, on the battlefields a makeshift altar of stacked drums was used as a point of worship, and on this day the tradition is continued at the Royal Hospital. Wreaths are laid to commemorate those who died in battle.

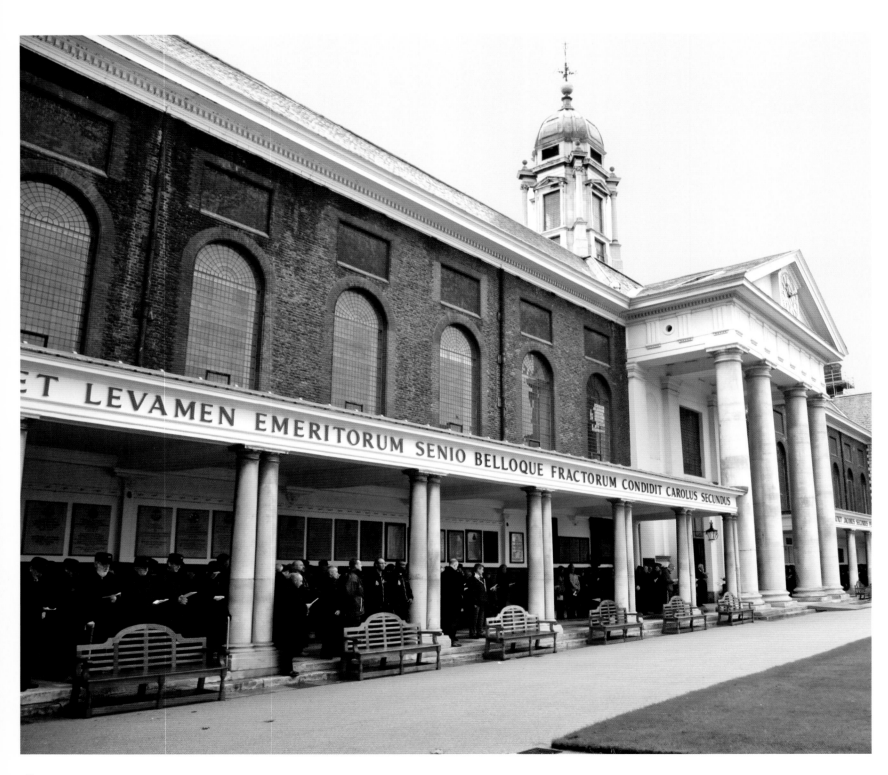

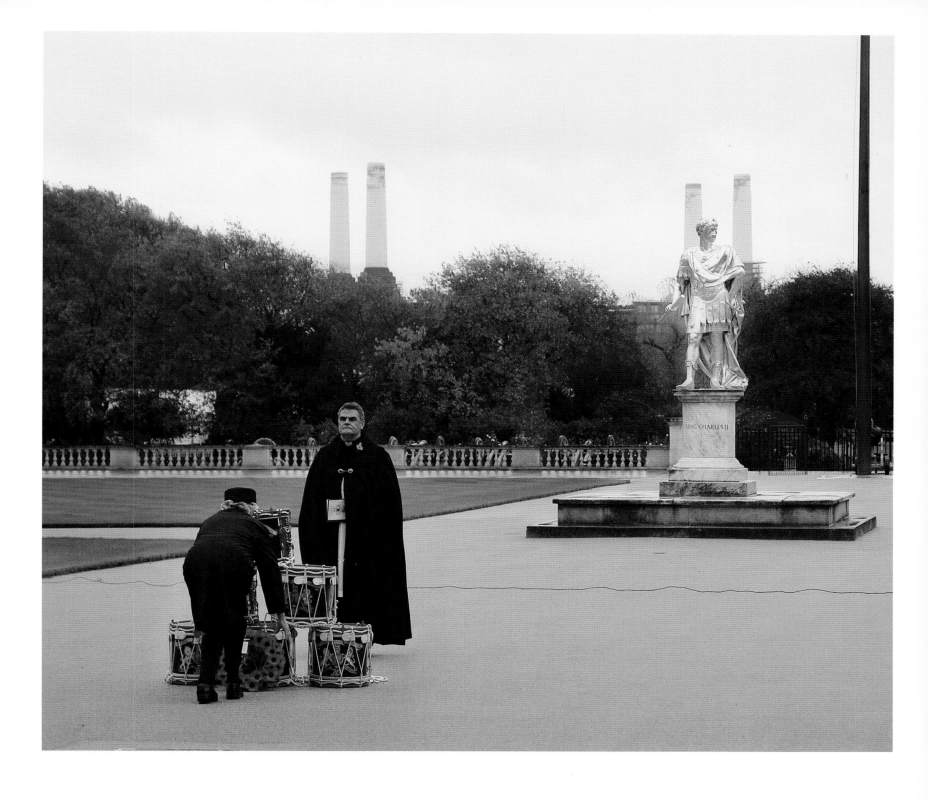

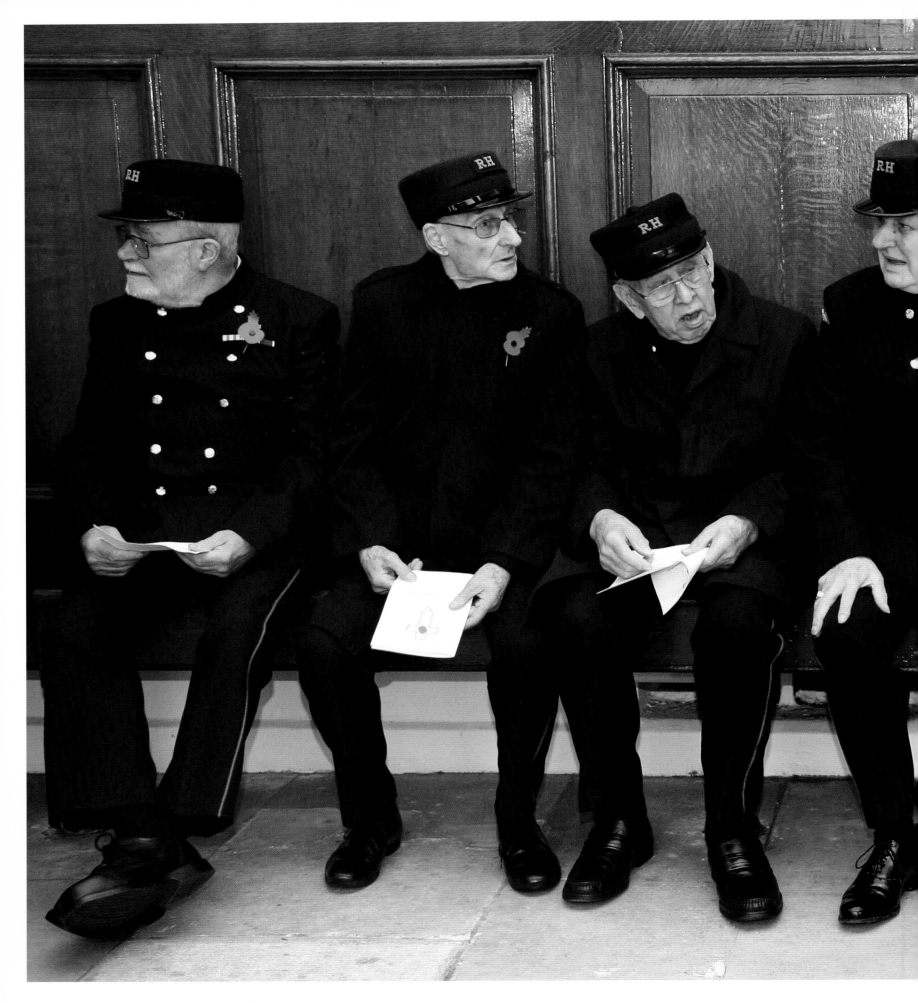

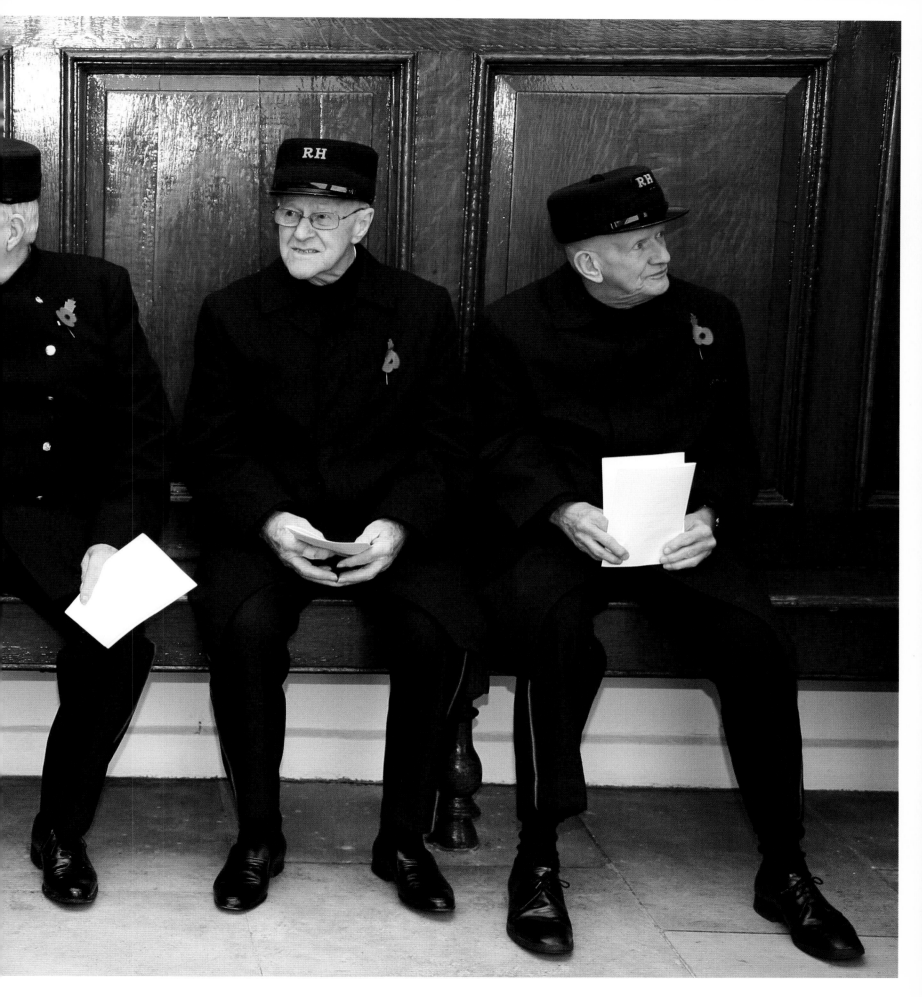

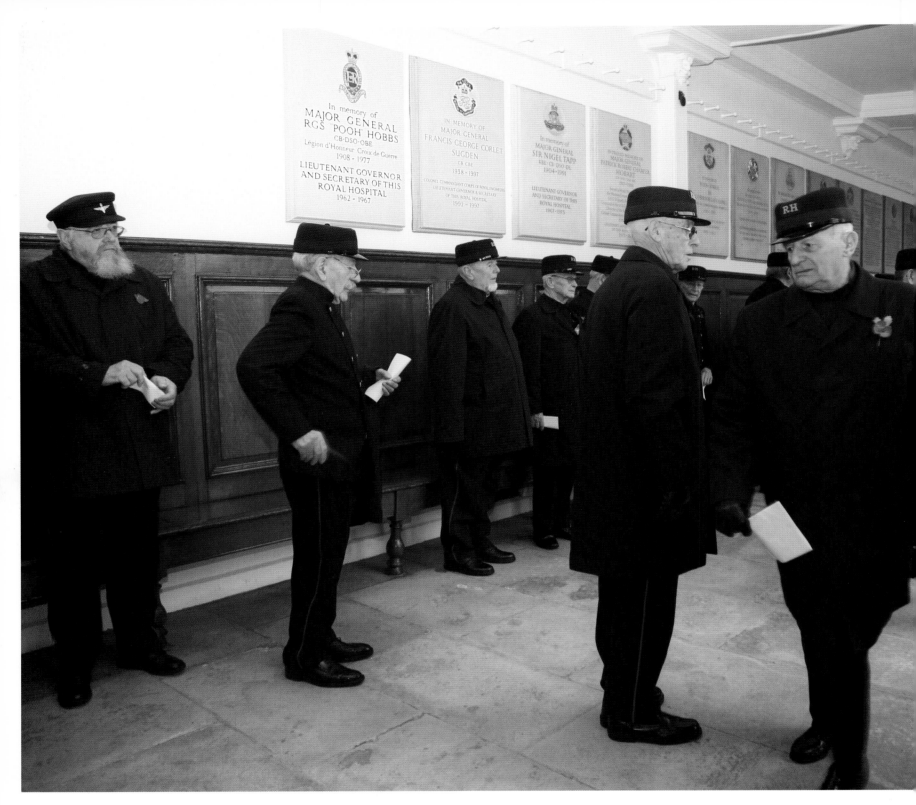

In-Pensioners await the start of the
Drumhead Remembrance Service
(above and previous pages), which
will be led by the Royal Hospital's
chaplain, the Reverend Dick
Whittington (opposite). Behind
them, along the whole length of
the Colonnade wall, are memorial
tablets to individuals and regiments
connected with the Royal Hospital,
such as Major Edward Wood
Humphrey of the Royal (late Bengal)
Engineers, who died in 1907, aged

seventy-four; his tablet, 'erected by
his brother officers and a few friends',
records that he served in the Indian
Mutiny of 1857, when he was severely
wounded, and that subsequently for
more than thirty-seven years he was
Captain of Invalids at the Hospital.
The tablets were first put up by
order of Queen Victoria in 1858,
to honour the heroism of soldiers
such as those on HM Troopship
Birkenhead, which was wrecked off
Cape Town, South Africa, in 1852.

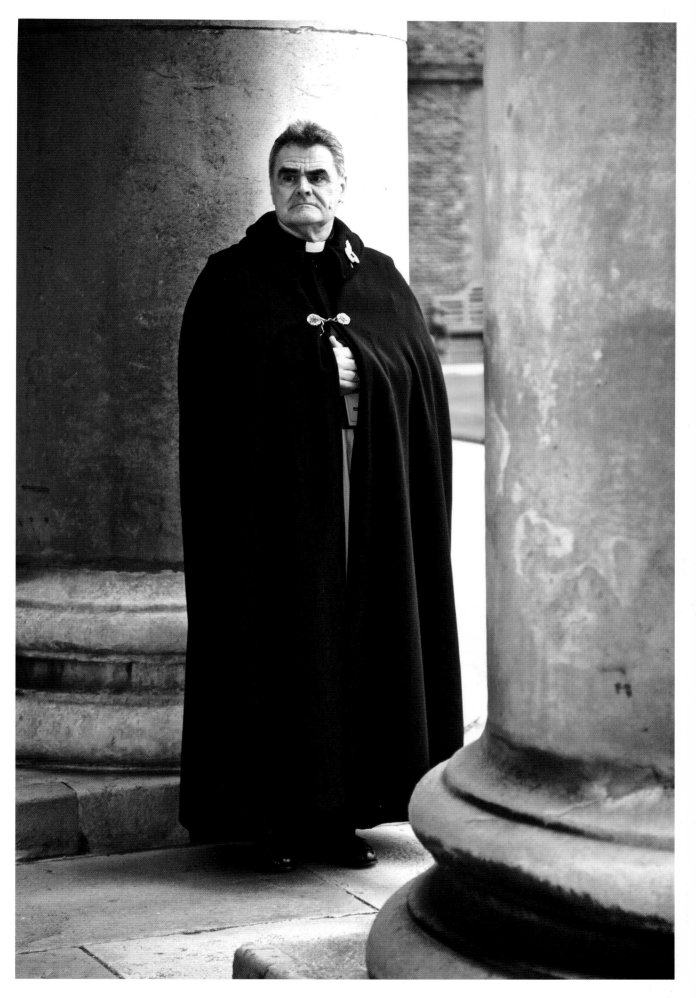

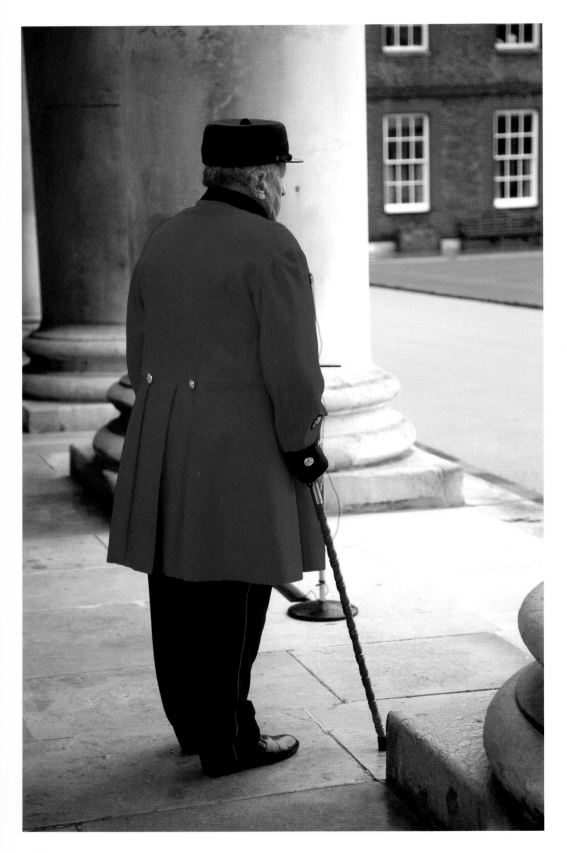

REMEMBRANCE SUNDAY

Remembrance Sunday, held on the second Sunday in November – the Sunday nearest to Armistice Day, 11 November – commemorates the contribution of British and Commonwealth military and civilian servicemen and women in the two world wars and later conflicts. Volunteer In-Pensioners attend the national ceremony at London's Cenotaph, but the Royal Hospital also holds a private ceremony on its grounds for I.P.s and others connected with the Hospital, during which a one-minute silence is observed.

IN MEMORY OF THOSE OFFICERS, IN-PENSIONERS
AND RESIDENTS OF THE ROYAL HOSPITAL,
NAMED HEREON, WHO LOST THEIR LIVES WITHIN
THE PRECINCTS BY ENEMY ACTION IN TWO WARS.

KILLED ON 16th FEBRUARY, 1918.
ERNEST LUDLOW, M.C., CAPTAIN OF INVALIDS, LATE GRENADIER GUARDS.
JESSIE LUDLOW, WIFE OF THE ABOVE.
ERNEST LUDLOW, SON OF THE ABOVE.
BERNARD LUDLOW, SON OF THE ABOVE.
ALICE COPLEY, NIECE OF THE ABOVE.

KILLED ON 16th APRIL, 1941.
EDITH TAYLOR, INFIRMARY NURSING SISTER.
ELIZABETH NICHOLSON, LONG WARD NURSING SISTER.
EDITH McMULLEN, LONG WARD NURSING SISTER.
OLIVE JONES, INFIRMARY NURSE.
JAMES HUTCHINS, WARDMASTER.
PATRICK JOHNSTON, IN-PENSIONER SERGEANT, LATE IRISH GUARDS.
WILLIAM CAMERON, IN-PENSIONER, LATE 2nd LIFE GUARDS.
SAMUEL JACKSON, ROYAL DRAGOONS.
WILLIAM MACGOVAN, DUKE OF CORNWALL'S L.I.
SAMUEL POPE, SHROPSHIRE L.I.
HENRY RATTRAY, 24th REGIMENT OF FOOT.
JOHN SULLIVAN, SOUTH WALES BORDERERS.
WILLIAM WEST, HAMPSHIRE REGIMENT.

KILLED ON 3rd JANUARY, 1945.
WILLIAM NAPIER, MAJOR, R.A.M.C., PHYSICIAN & SURGEON.
DEIRDRE NAPIER, DAUGHTER OF THE ABOVE.
GEOFFREY BAILEY, CAPTAIN OF INVALIDS, LATE MANCHESTER REGIMENT.
MARGERY MAY, WIFE OF CAPTAIN G.C.MAY, M.C., CAPTAIN OF INVALIDS.
EDWARD GUMMER, IN-PENSIONER, LATE YORK & LANCASTER REGIMENT.

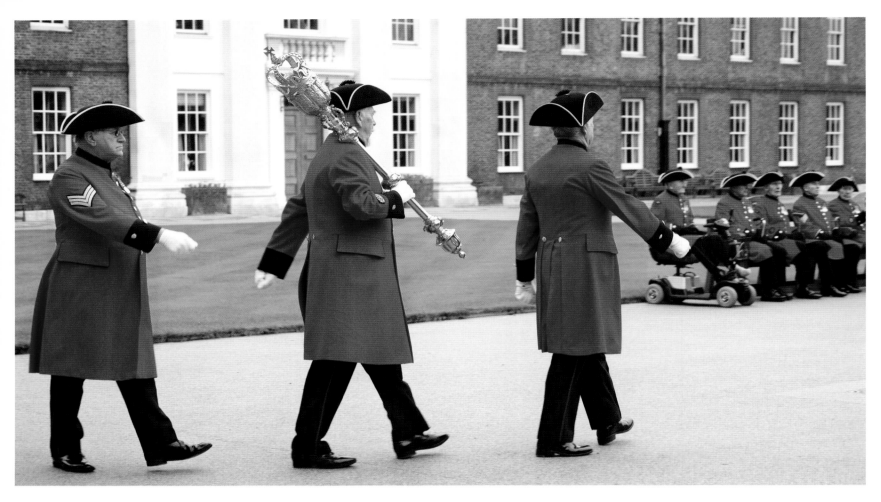

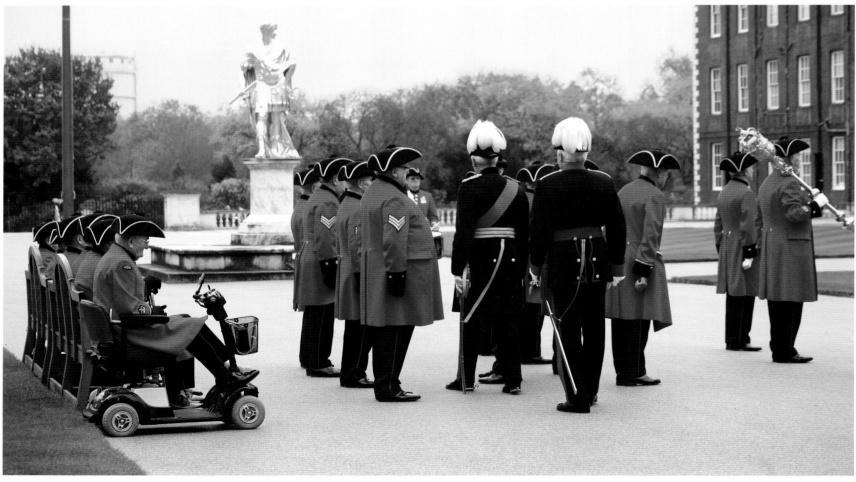

The Sovereign's Mace, symbolizing the regiment's rallying point, is ceremonially carried (by I.P. Cass Butler in these photographs) at the Royal Hospital's Remembrance Sunday ceremony, as it is at all its ceremonial parades. The mace, which weighs some 12.5 kilograms (28 lb), was presented to the Royal Hospital by Queen Elizabeth II in 2002.

The Remembrance Sunday parade is taken by one of the Captains of Invalids (in this case, Colonel Mark Baker, right) and reviewed by the Governor (wearing a red sash over his shoulder, opposite, bottom).

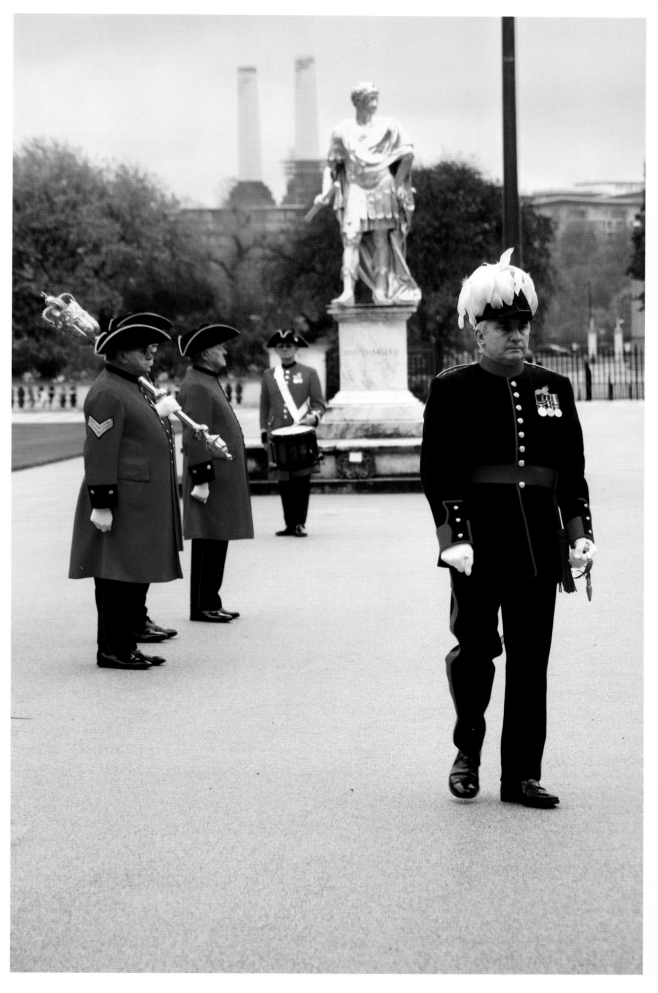

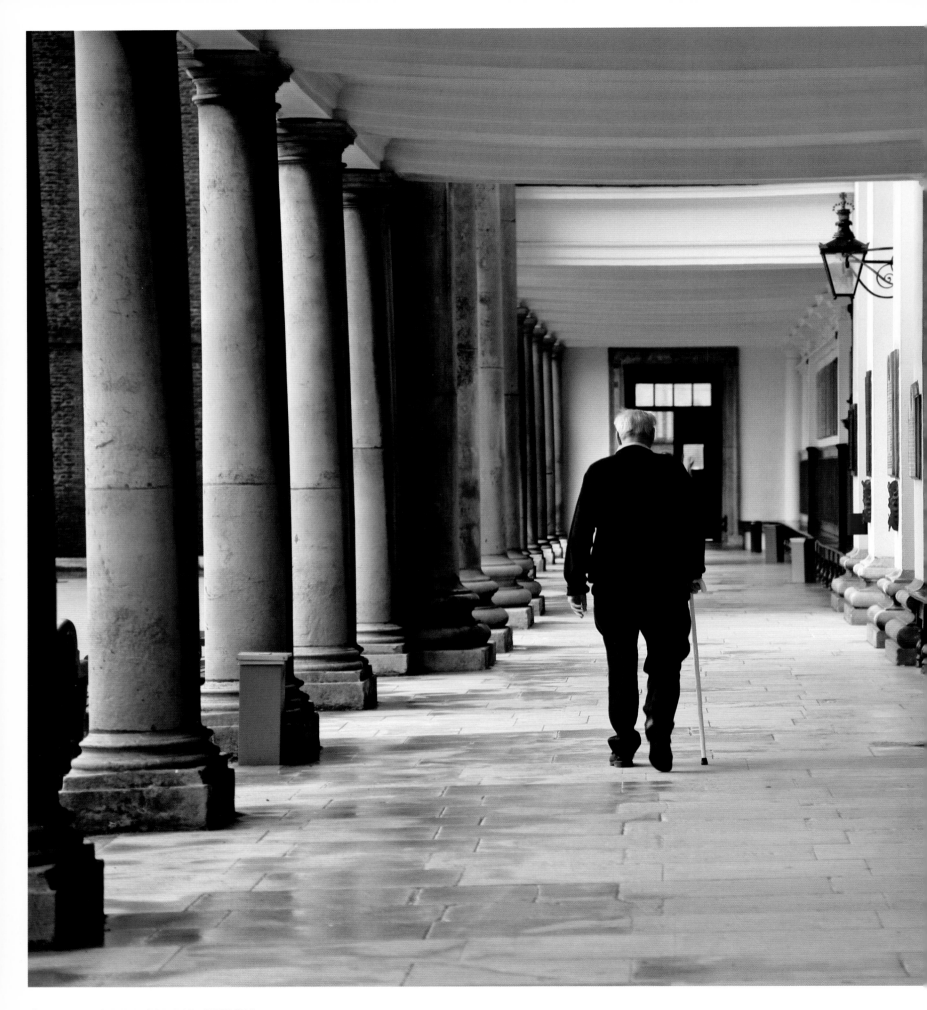

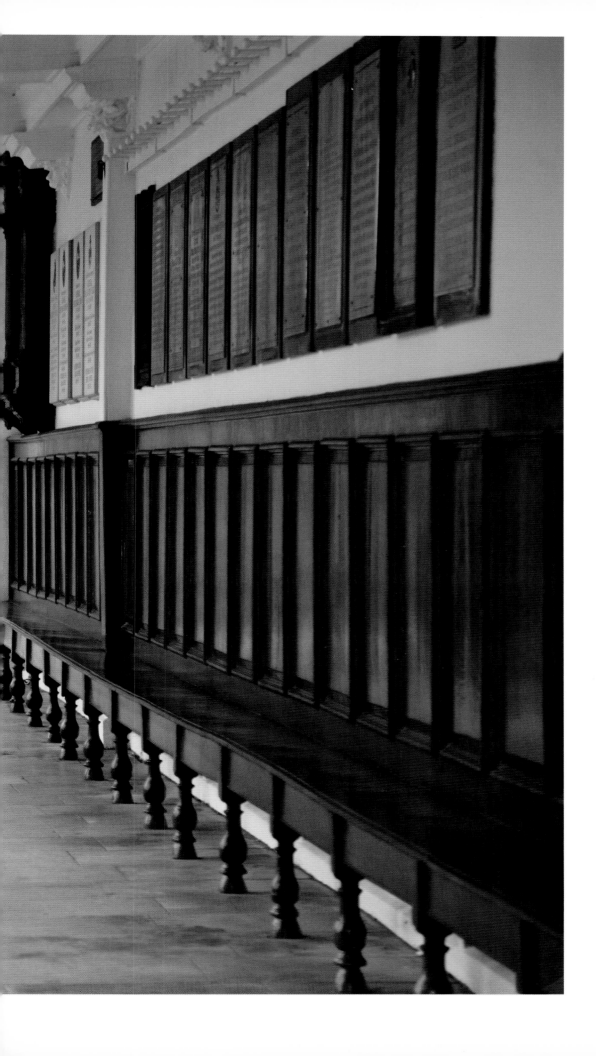

A quiet moment at the Colonnade during Remembrance Sunday.

Seasonal mist descends on the Royal Hospital grounds, which look as immaculate in autumn and winter as they do in spring and summer.

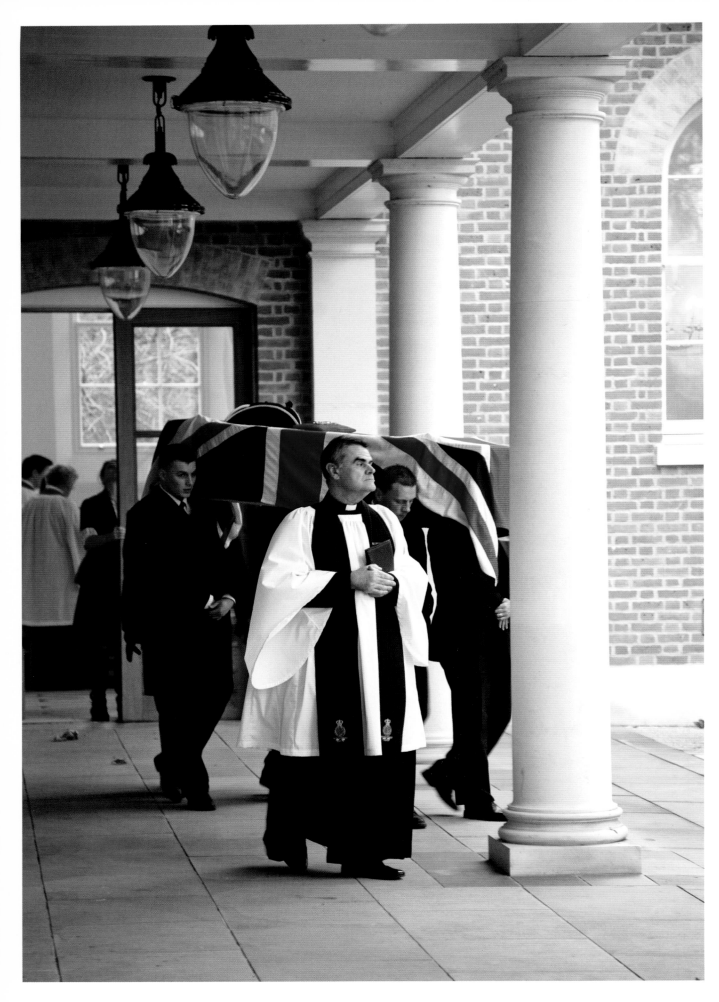

The Funeral of I.P. Charlie Boyce, DCM

In December 2010 the Royal Hospital Chelsea's Infirmary chapel (opposite) was the setting for the funeral service for I.P. Charlie Boyce, who entered the Royal Hospital Chelsea in 2002. His obituary published in the *Daily Telegraph* is reproduced here.

In April 1945 Charlie Boyce was in command of a section of anti-tank guns in support of a troop of C Squadron of 53rd Reconnaissance Regiment, which had been ordered to seize an important bridge at Kulverborstel, Germany.

At a bend in the road the leading troop came under fire from Germans with a clear view and an excellent field of fire over an open area. Returning fire, armoured cars immediately deployed to the right, as did Sgt 'Tiny' Boyce, so called because of his 6' 2" stature and champion swimmer's physique.

Having given orders for his leading gun to engage the enemy with high explosives, Boyce moved to the second, but found it silent because its Number One and Loader had suffered severe leg wounds. Boyce carried out a quick recce for a better position, despite there being no cover from the enemy's continuous mortar and machine-gun fire. After replacements for the wounded men had been found, the gun was soon in action.

Once he was satisfied that all guns were firing, Boyce ran to the aid of the wounded men, applying dressings. Seeing that one had a shattered leg, he improvised a stretcher from a gate, his considerable strength enabling him to drag it, with the man aboard, for 300 yards until they reached safety. Boyce then returned, carrying the gate, to the second wounded man, again using it as a stretcher to carry the victim to safety, all the while under fire.

This remarkable feat undoubtedly saved the men's lives. Also, by effectively maintaining the section of guns, Boyce 'contributed largely towards the success of the Troop operation', which captured and held the bridge. He was awarded an immediate Distinguished Conduct Medal, a medal seen within the Army as 'a near miss' for the Victoria Cross – its ribbon being pinned on his chest by the relatively diminutive-looking Field Marshal Montgomery.

Charles Bernard Boyce, one of four children, was born in 1914 in Birmingham. He left school aged fourteen and went to work at a grocery store. In 1940 he was called up, doing his basic training with the 2nd Monmouthshires. He made sergeant in only nine months, and his anti-tank company became part of 53rd Reconnaissance Regiment.

His war took him from Normandy to Hamburg, the 53rd seeing action in both the mounted (fast-moving forward reconnaissance) and dismounted (heavy infantry support) roles. This included working with the Americans to trap the Germans at the Falaise Gap, where 8000 enemy soldiers were taken prisoner. He also helped liberate Lille, whilst at the relief of Eindhoven, where Philips had a factory, the company's grateful employees presented Boyce and his comrades with a tiny wireless, which enabled them to listen to the BBC.

The 53rd, always well forward, often had to deal with Germans who were making a last stand. Yet Boyce could never resist prefacing his war stories with criticism of supporting forces on his own side, and recalled being on the receiving end of Allied rocket-firing aircraft and artillery — 'as if the German 88s weren't enough'. However, he always managed a smile, as if to say: 'That's war.' He was also involved in both the Battle of Arnhem and the Battle of the Bulge.

On his discharge in 1946, Charlie Boyce eventually joined the Prison Service, with which he became a Senior Officer. After joining the Royal Hospital, Chelsea, in 2002, he enjoyed growing strawberries on his allotment and indulging his love of organ music by regularly attending Chapel. He was much liked by all.

His wife, Kath, and a son predeceased him, and he is survived by three daughters.

Daily Telegraph
23 December 2010

Snow is fairly unusual in the final months of the English calendar, but in the year that Patricia Rodwell was granted access to all areas of the Royal Hospital the grounds were covered before and during much of Advent. The white coating on the lawns and cannon greatly enhanced the seasonal atmosphere in the run-up to what is traditionally the period of the Hospital's greatest conviviality.

On a keenly anticipated December day In-Pensioners and staff convene in the Great Hall to stir a vast pudding mixture, which will be cooked and then distributed in individual portions to all the old soldiers and staff. The first week of December sees the Cheese Ceremony, a tradition that has its origins in the year of the Hospital's foundation, when a local cheesemonger donated his wares as a special seasonal treat; today these provisions are gifted by cheesemakers from around Britain, in an event organized by the Dairy Council.

Another major event in the days leading up to 25 December is the presentation to the Royal Hospital Chelsea of a Christmas cake and some Christmas drink. These gifts have been sent every year since 1952 by the Returned and Services League of Australia in recognition of the enduring links in war and peace between Britain and one of its staunchest allies.

The year at the Royal Hospital culminates with the Christmas carol service, attended by In-Pensioners, staff and their families, followed by the Christmas Day service and, of course, the traditional English roast dinner with all the trimmings.

Previous pages:
The South Grounds, looking into the main quadrangle.

Above and opposite:
A covering of snow brings hush and quiet to the Royal Hospital grounds, while indoors the choir's voices prepare to be raised in celebration of the joy of Christmas.

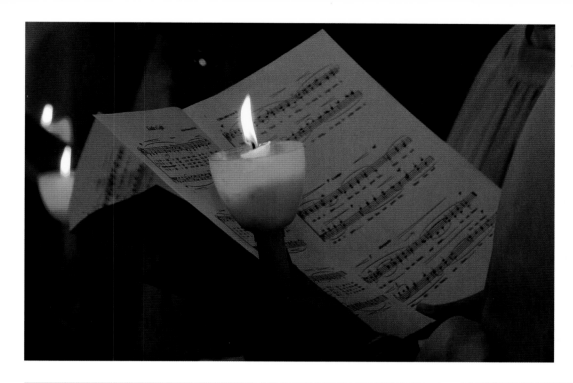

By the captured French cannon (see pp. 24–25) sits a collection of huge spherical shells intended to be used during the Crimean War (1853–56) in a Mallett's mortar, designed by Irish geophysicist and civil engineer Robert Mallett in the 1850s. Neither the mortar nor the shells were ever employed in action. An example of a Mallett's mortar can be seen at the Royal Artillery base in Woolwich, south London.

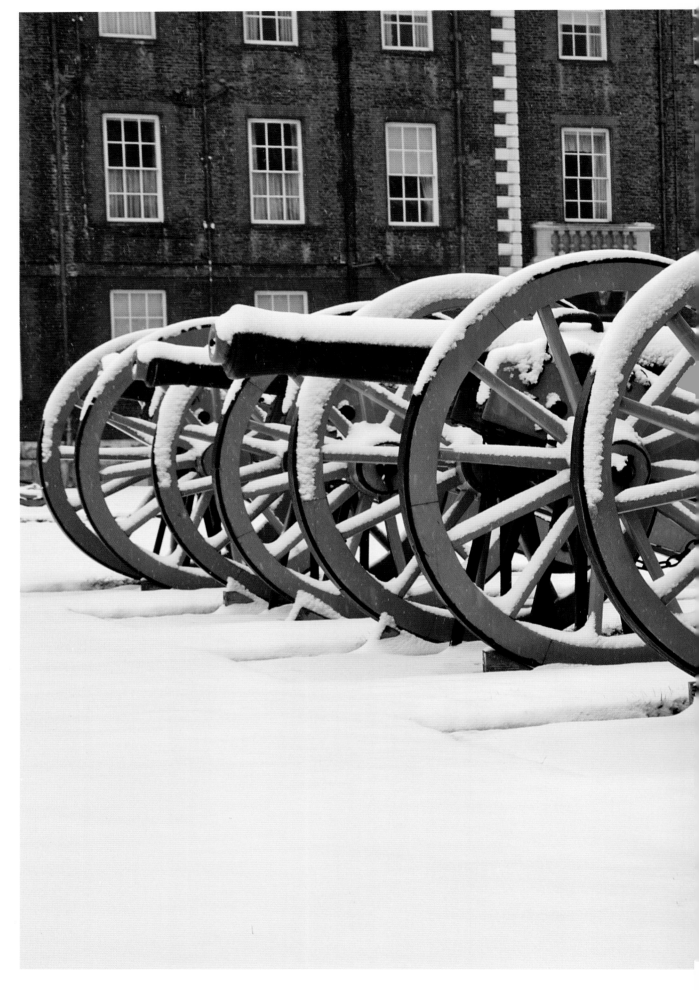

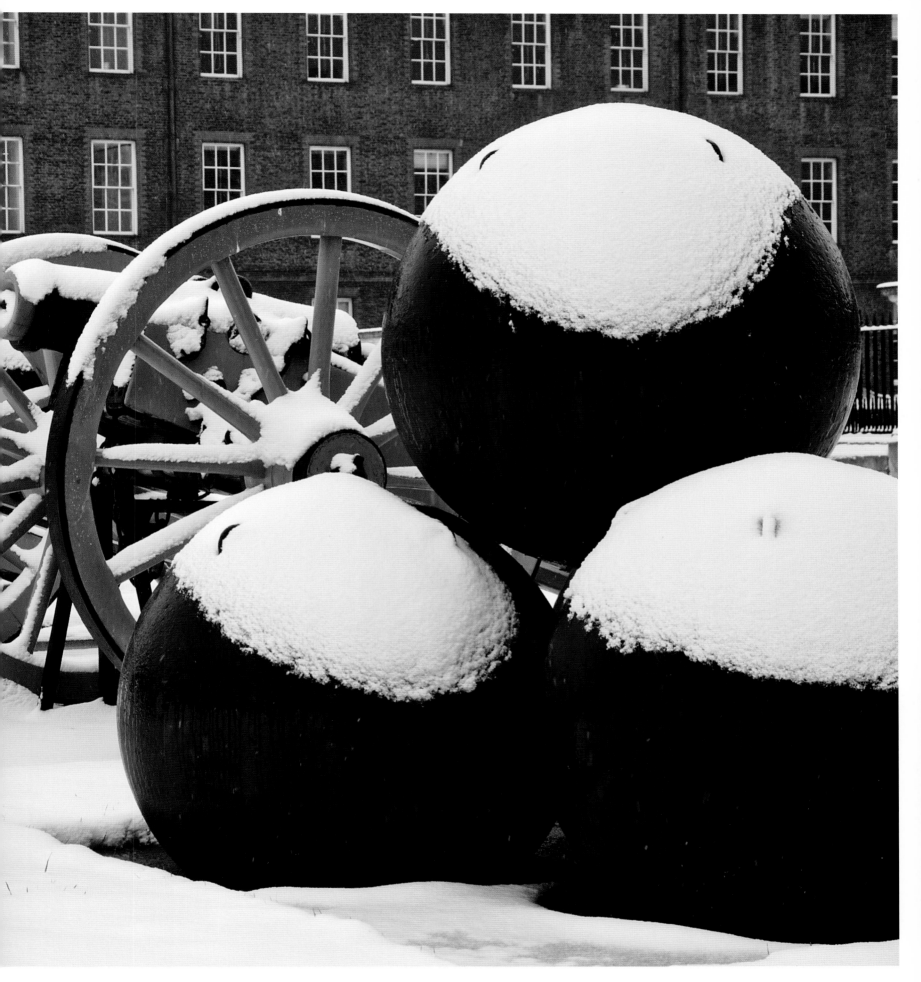

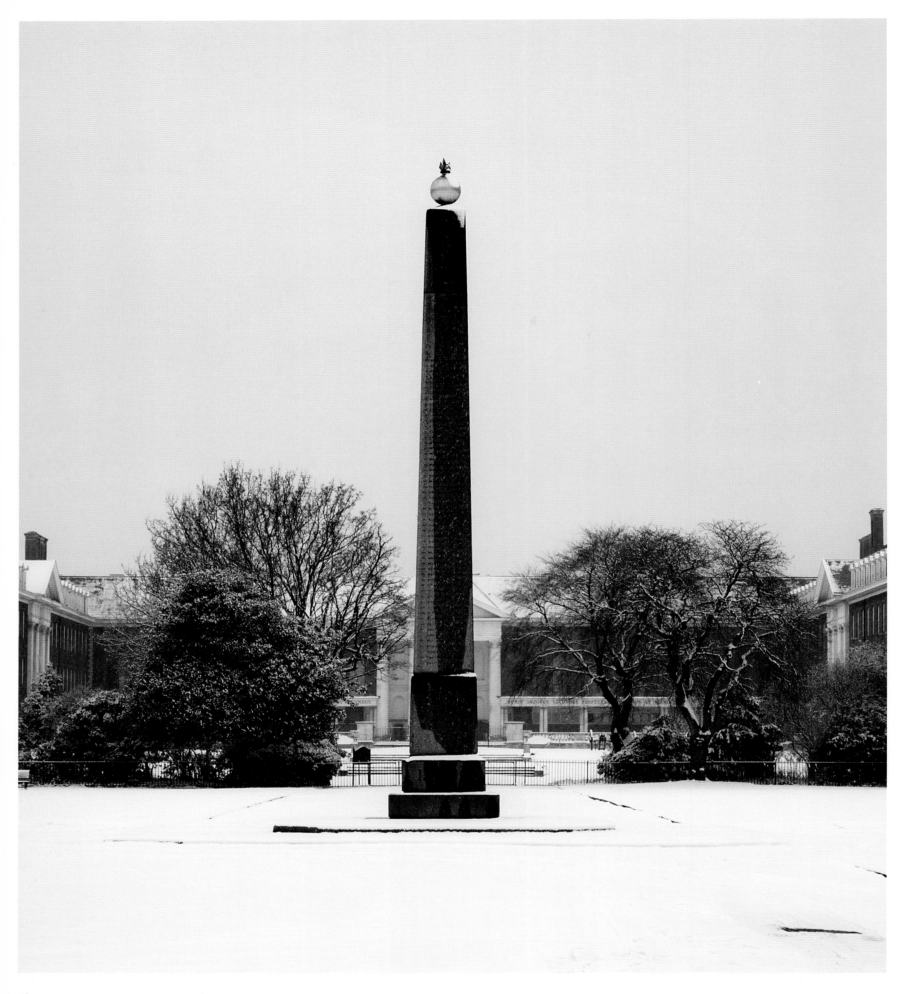

Outdoors in the grounds and courts all lies still under heavy skies and a layer of snow, but indoors all is movement and activity as the choir readies for the Royal Hospital's annual carol service.

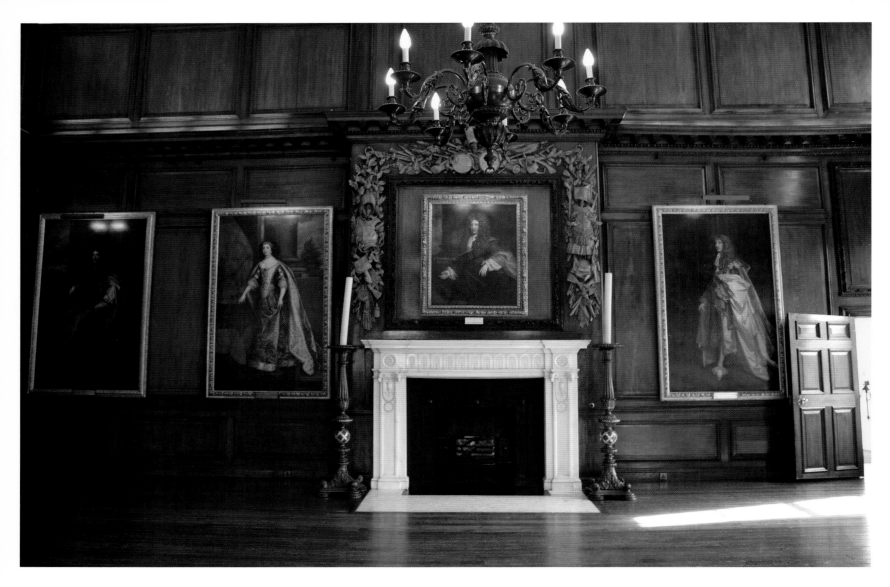

COUNCIL CHAMBER AND STATE APARTMENTS

The Council Chamber, which together with its Ante Room (not pictured) forms the major part of the Royal Hospital's State Apartments, has hosted monarchs and other dignitaries since the 1700s. Now used as the board room for the Hospital's Commissioners, for much of its life the room formed part of the Governor's apartments, which are largely situated on the floor above and provided Wren's accommodation and office during the Hospital's construction.

Designed by Wren as a one-and-a-half-height space (opposite, top), the room retains such original features as a heavily moulded ceiling by John Grover, wainscoting by William Cleere and, over the fireplace, a superb lime-wood carving that references the Hospital's military associations (right) by William Emmett. The room was redecorated by Robert Adam in 1776, and among the

elements introduced at that time are the marble mantelpiece and gilt girandoles (mirrors to enhance candlelight; one is shown opposite, top, on the far wall). Fine paintings line the walls, including portraits of Charles II and Queen Caroline, among others, by Peter Lely, and of William III by Godfrey Kneller.

The Council Chamber and its Ante Room are open to visitors by special arrangement.

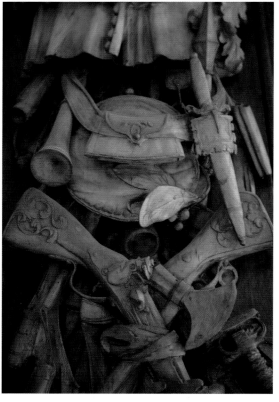

The Council Chamber rarely lies empty for long: it is the venue for many official functions hosted by the Royal Hospital's Governor, and can also be hired for private functions. The bottom photograph shows a dinner held to celebrate the launch of the Chelsea Pensioners' debut music CD, *The Men in Scarlet*, a collection of sixteen songs including 'Goodnight Sweetheart' and 'A Nightingale Sang in Berkeley Square', sung by seven of the I.P.s. At its release the album, which also features Second World War forces' sweetheart Dame Vera Lynn and Welsh mezzo-soprano Katherine Jenkins, and was produced in aid of the Chelsea Pensioners' Appeal (see p. 220), sold 100,000 copies in just one month.

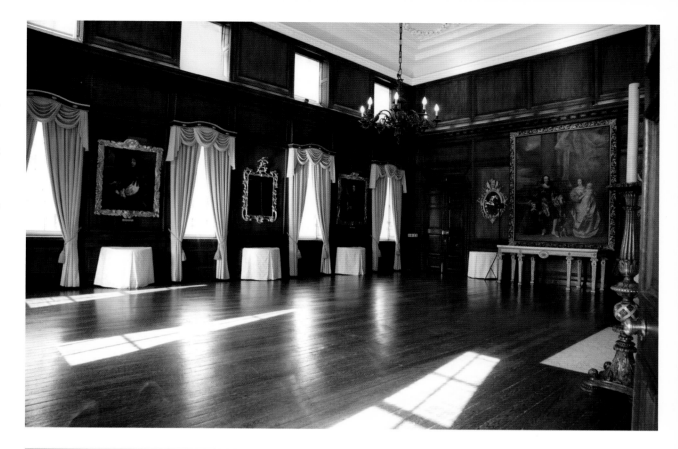

THE GREAT HALL

Below and opposite, staff prepare tables and the service station in the Royal Hospital's glorious Great Hall before lunch is served.

Wren's original late seventeenth-century plan had placed the kitchen next to the Great Hall, but there was no connection between the two areas; all food was carried from the kitchen along the Colonnade and through the Hall's main entrance. The Hall contained sixteen long tables (one for each Long Ward), which each sat twenty-six, the number then accommodated in each Long Ward, and it was heated by an open fire in its centre. The regulations drawn up by Wren stipulated that pensioners were to be served before the officers.

Towards the end of the eighteenth century the In-Pensioners started to take their meals in the Wards, and from the early nineteenth century the Great Hall was no longer used as a dining hall but for a variety of other functions, such as courts martial and Army entrance examinations. Thousands of people filed through the Hall to pay their final respects to the Duke of Wellington, victor at Waterloo in 1815, as his body lay in state here in 1852 for two days before his funeral. The table on which he lay is still kept in the Hall.

The Great Hall was restored to its intended purpose as a dining hall in 1955. The kitchens are now located below the Hall, with stairs communicating directly between the two.

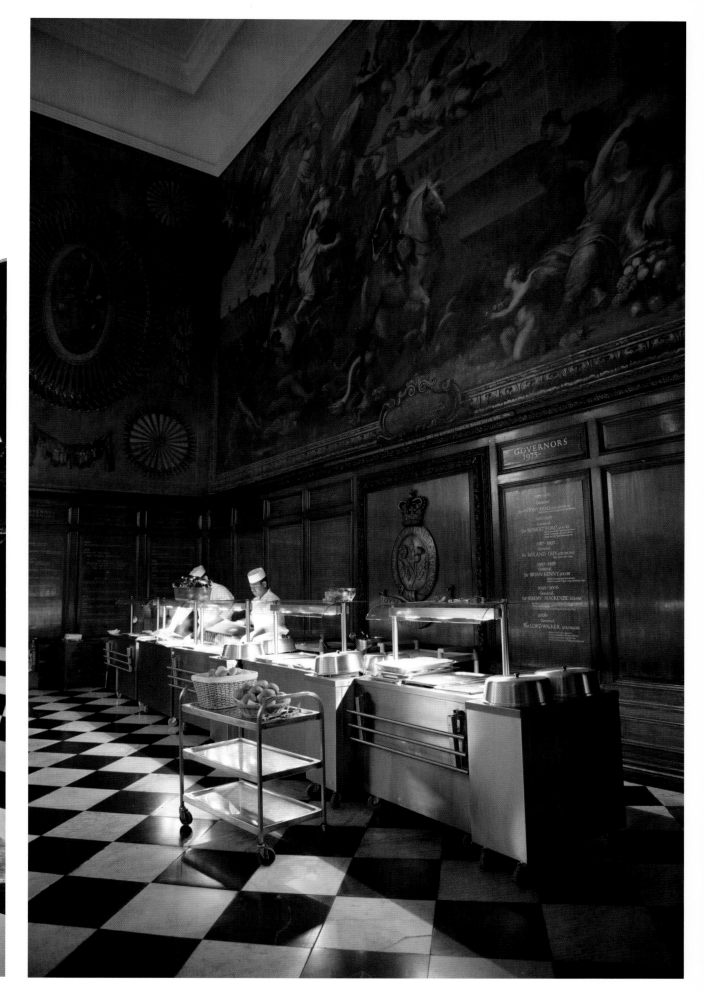

The Christmas spirit comes early to the Royal Hospital, as In-Pensioners and staff gather one December morning in the Great Hall for the annual mixing of the Christmas pudding. The chef and her assistants having set out all the ingredients according to a time-honoured recipe, each I.P. is invited to add ingredients (including a generous amount of Guinness) to a large tub and give a good stir. The mix is then made into individual Christmas puddings for the In-Pensioners.

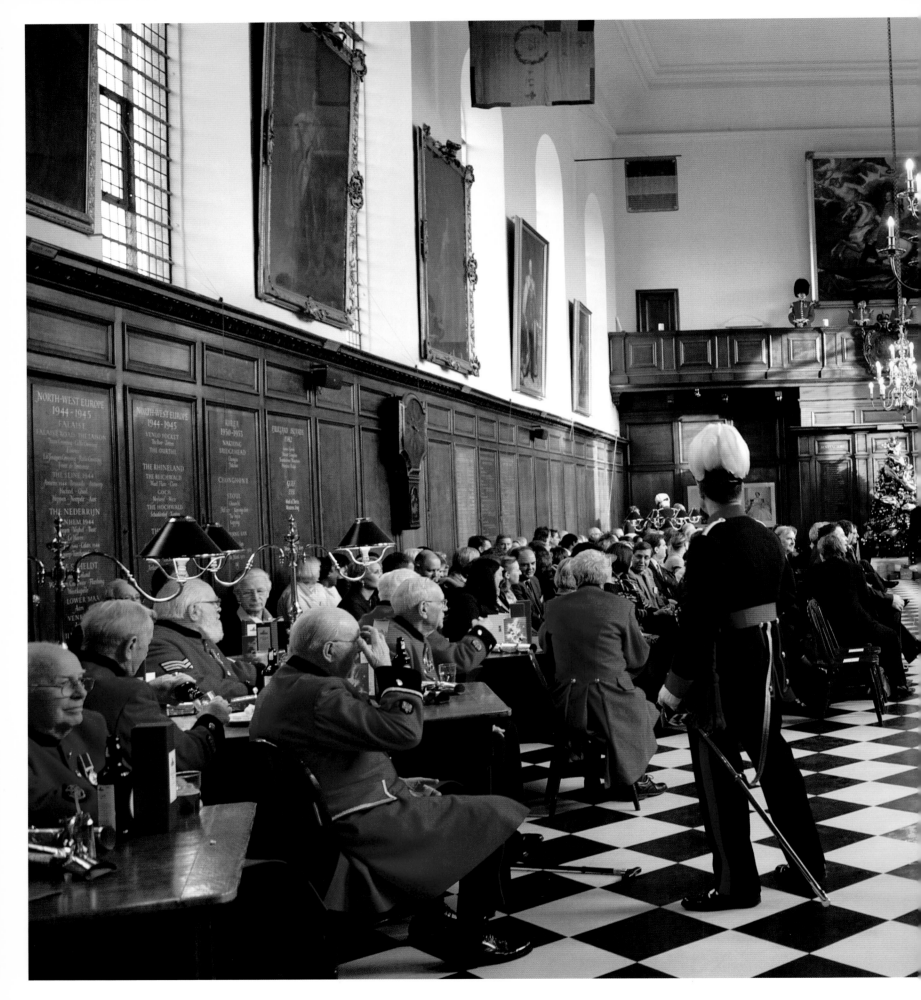

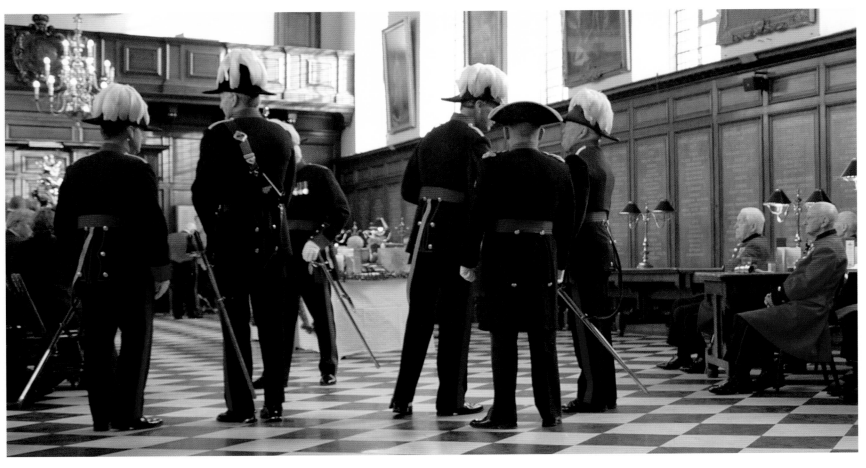

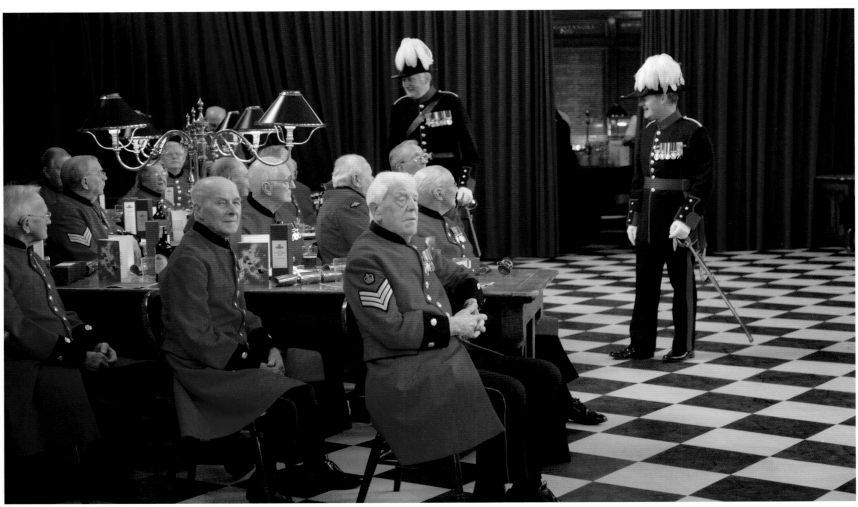

Officers check the Great Hall to ensure that all is in order before the start of the Cheese Ceremony (these pages and previous pages).

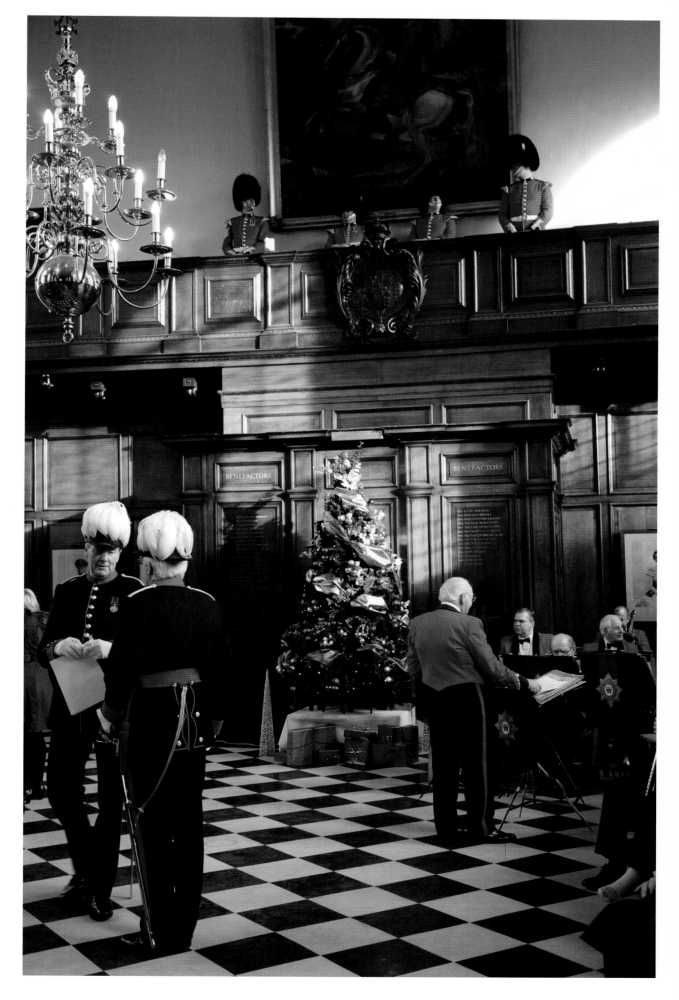

THE CHEESE CEREMONY

The gathering for the Cheese Ceremony, held each year in mid-December. The start of the festivities is announced by a fanfare from trumpeters of the Grenadier Guards (previous page).

In 1692 a cheesemaker presented the newly opened retreat for veterans with some cheese as a Christmas treat, and this was established as a tradition after the Second World War. Each year the Dairy Council, which sponsors the event, selects a sample from the 400-odd cheeses made in Britain and presents them to the Royal Hospital and its In-Pensioners.

Centrepiece of the event in December 2010, when this photograph was taken, was a giant Montgomery Cheddar, which was ceremonially cut by I.P. Patrick Brady, aged ninety-two, in the presence of In-Pensioners and officers, the mayor of the Royal Borough of Kensington and Chelsea (in which the Hospital is situated) and other dignitaries, commissionaires and retired staff, plus members of the Dairy Council.

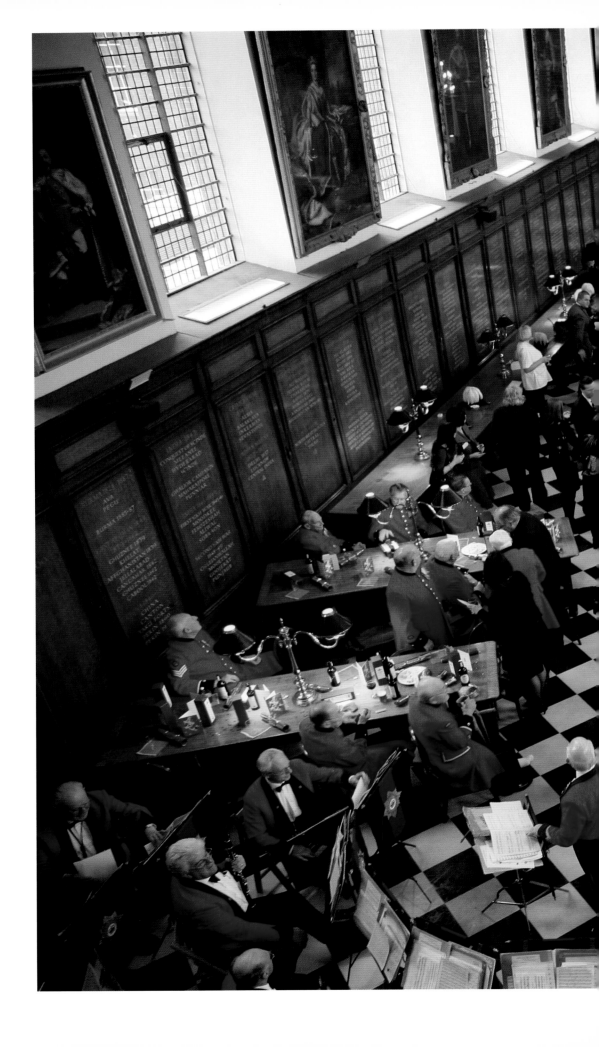

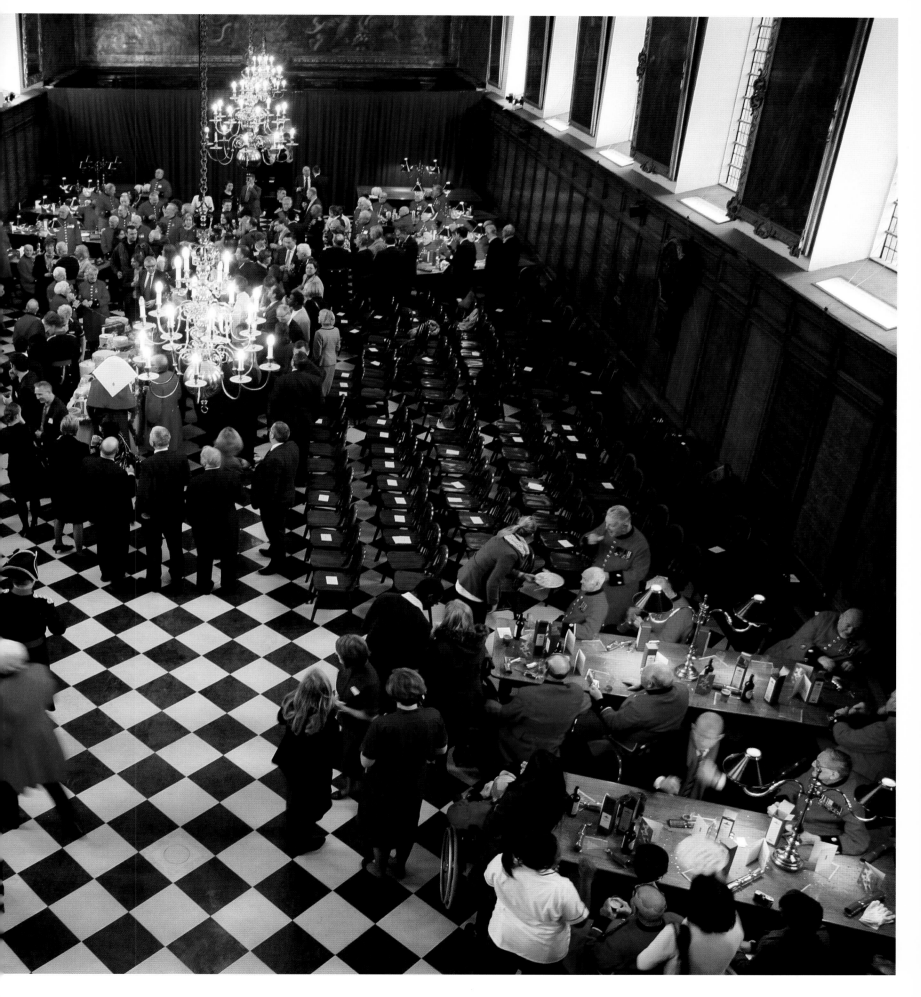

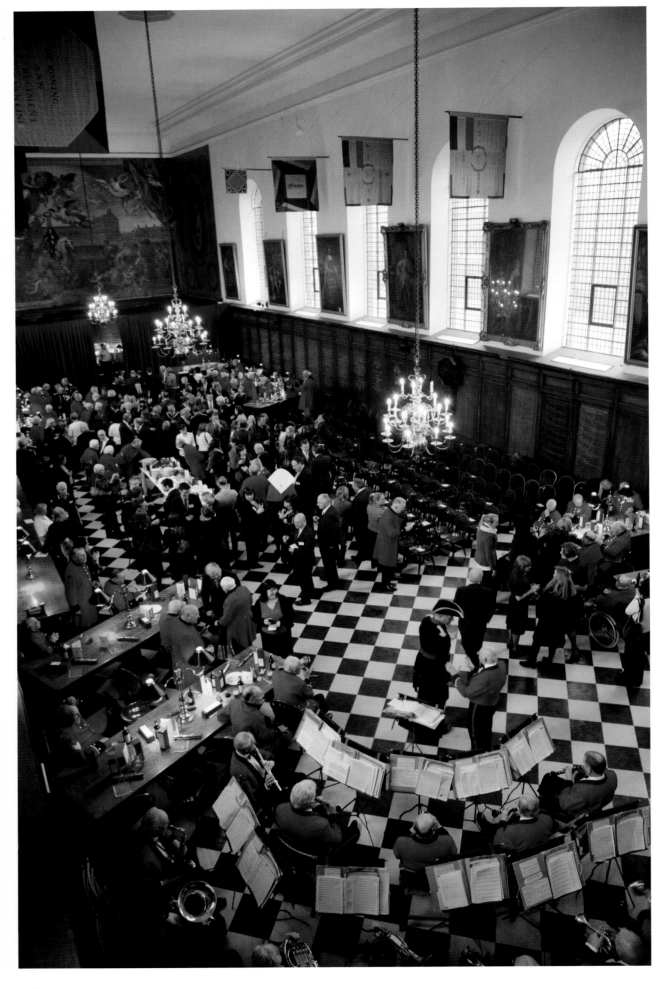

A happy crowd mingles and makes merry at the Cheese Ceremony. All around them in the Great Hall are replicas of old flags taken from the enemy during battles, portraits of British kings and queens and a large mural showing Charles II on horseback with the Royal Hospital buildings in the background, begun by Italian-born painter Antonio Verrio in 1690 but completed by Henry Cooke (1642–1700). The Hall, at 35 metres (115 ft) in length, is very slightly longer than the Chapel, which is built along similar lines, but it is not quite so lofty: 11.3 metres (37 ft) in height, against the Chapel's 12.8 metres (42 ft).

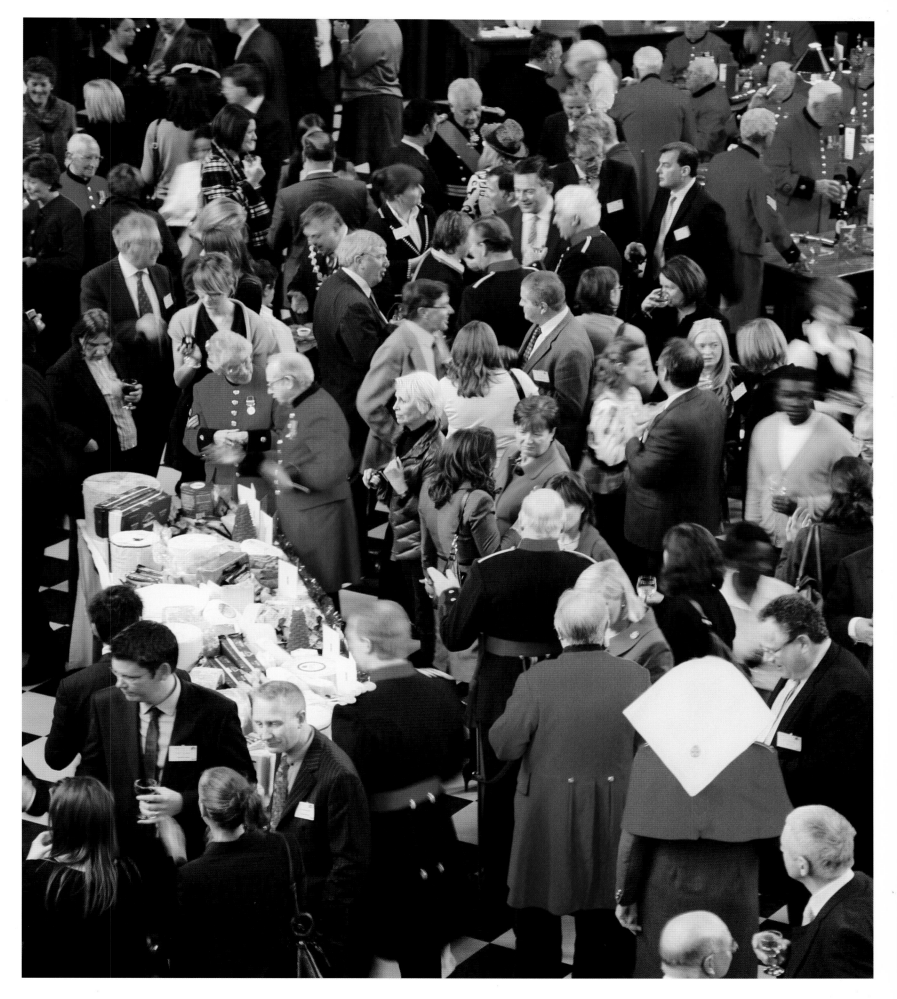

The Royal Hospital is home to a number of retired military musicians, and they have formed a regimental band. At the Cheese Ceremony and other events they are joined by other retired army musicians of various regiments who are not In-Pensioners but offer their time to the Hospital band. The band wears not the scarlet but the short-jacketed mess dress (or mess kit), the military evening dress worn at formal occasions.

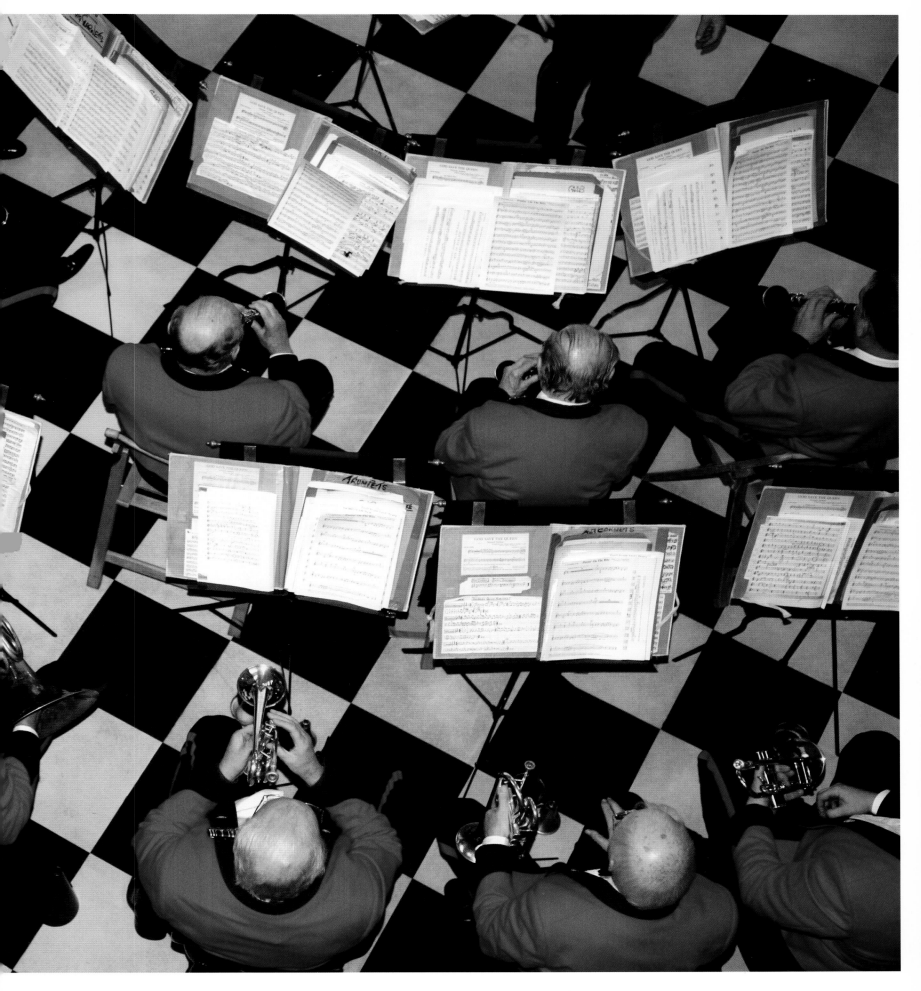

I.P. Mal Smart, MBE

I've been [at the Royal Hospital Chelsea] for two and a half years. I moved to London from the north-west, where I went off to the seaside at Morecambe after my wife's death – nobody told me it doesn't open except in the summertime! I'm the type of person who wouldn't be isolated anywhere, but I got involved in quite a heavy business, and it took more out of me than I expected, and so I thought I'd retire.

I'd been to the Royal Hospital before, on a number of occasions, as a regular soldier, and I thought I'd apply, not knowing that they take only soldiers, not officers – and I was an officer. And so I was turned down, because I

hadn't given the right information. I applied again, and I was accepted this time, because I was a 'ranking officer' [one who has come through the ranks]. It's one of the best things I've done in life – certainly in later life.

After being a soldier for thirty years, I found the Hospital to be like coming home, because we all speak with a common tongue, and we all empathize with one another. Within a matter of twelve hours, it was like I'd never been anywhere else. And I thoroughly enjoy it – apart from the fact we are treated like royalty and looked after like lords! Seriously, though, it's a wonderful place to be, because in this home – and that's what this is, an old

people's home – we're treated with great dignity. It wouldn't be the same, I would have thought, in other establishments.

The other uniqueness about the place is that, within this sheltered accommodation, bolted on to the side of this fine establishment, is an infirmary. Old people in other establishments, when they get to the stage of needing twenty-four-hour medical care, will go to an infirmary probably miles from where they've lived, so they're losing contact. Here, you don't. It's part of the barracks, and all your pals are still with you. So everything about the place is unique, and everything about the place is so reassuring and so gratifying.

I thought to myself when I came here, 'I'm young enough and fit enough to contribute. There will come a time when I won't be able to.' So I became a tour guide at the Hospital, because I've always been interested in history. We also do a few talks outside of the Hospital. And I also enjoy the social aspect of life. The entertainment, the fun, is quite normal here. I get involved in anything that goes; you'd run out of energy before you'd run out of things to do here. And we go out, we socialize outside too. We're invited to attend functions, which is fantastic. I've got a lot of friends outside the Royal Hospital – many of them I've met through tours.

Most people's view is that, when you go to a retirement home, you have to look reality in the face. You're going there to survive, and then die. Not here. You come here to *live*, survive and die. There's a big difference.

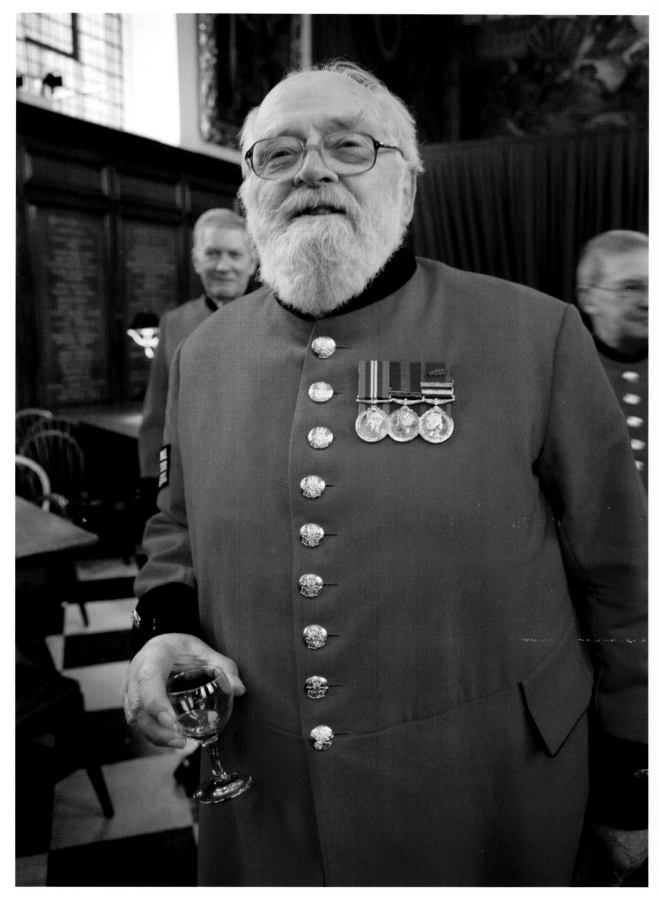

I.P. Busty Peart partakes of a bit of
seasonal cheer at the Cheese Ceremony.

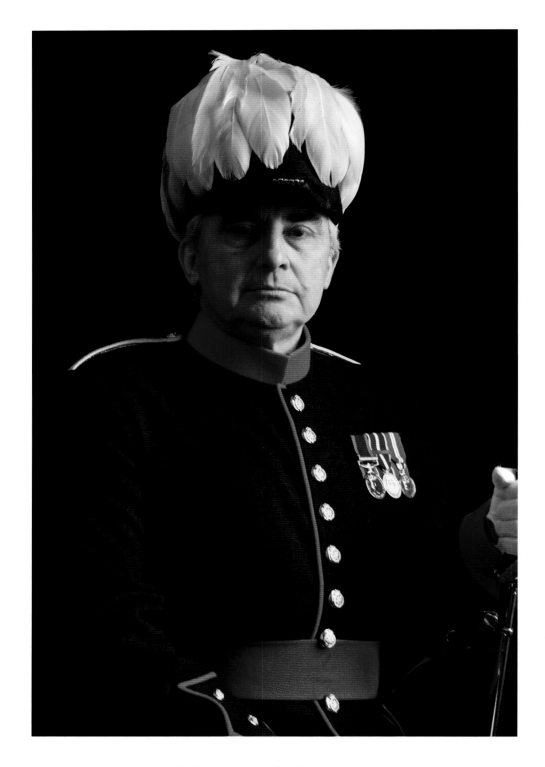

Colonel Mark Baker
Captain of Invalids

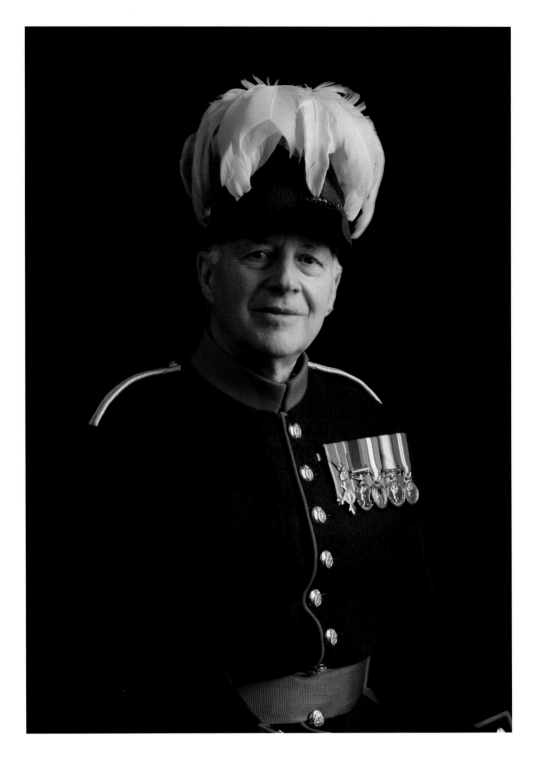

Brigadier David Ratcliffe, MBE
Adjudant

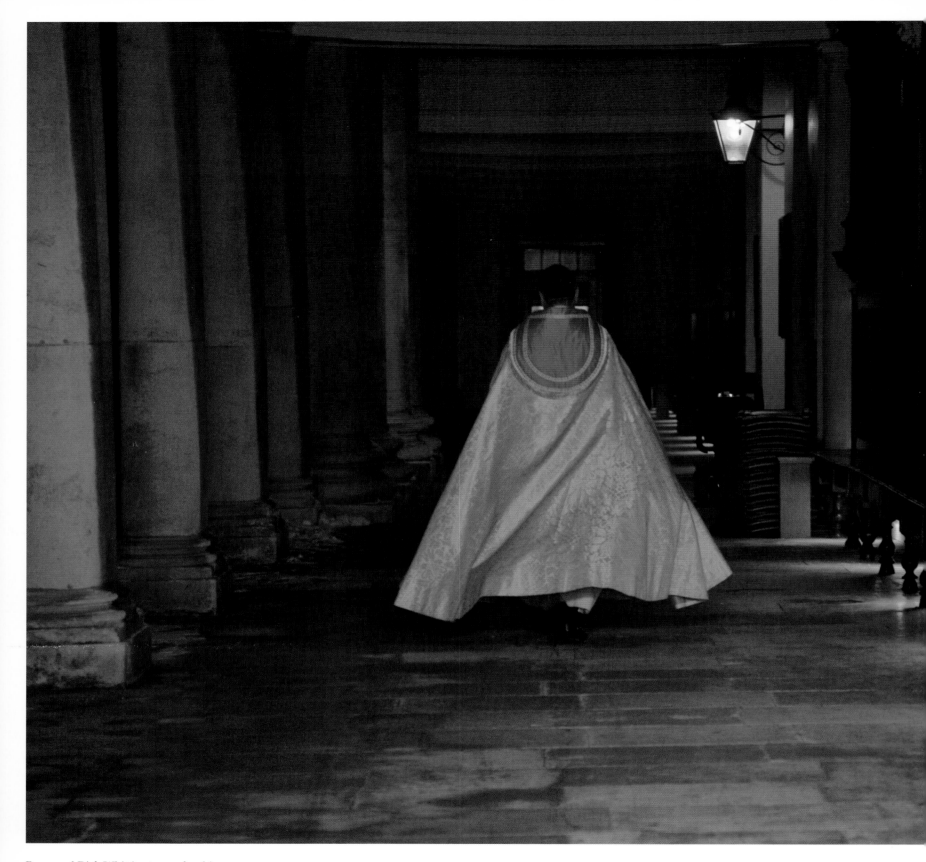

Reverend Dick Whittington makes his
way along the Colonnade to the Chapel
for the start of the carol service.

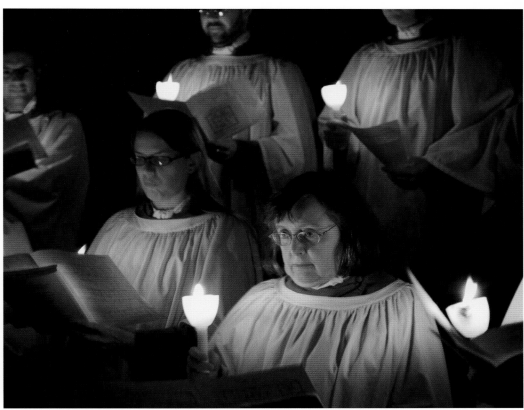

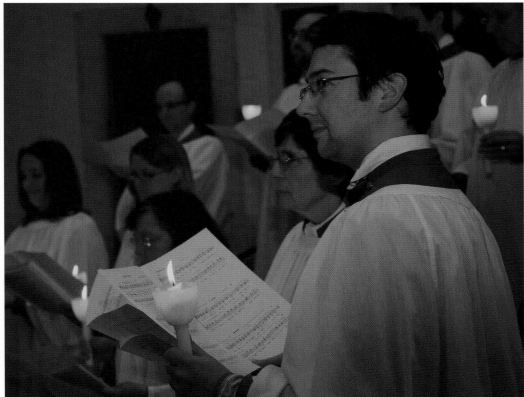

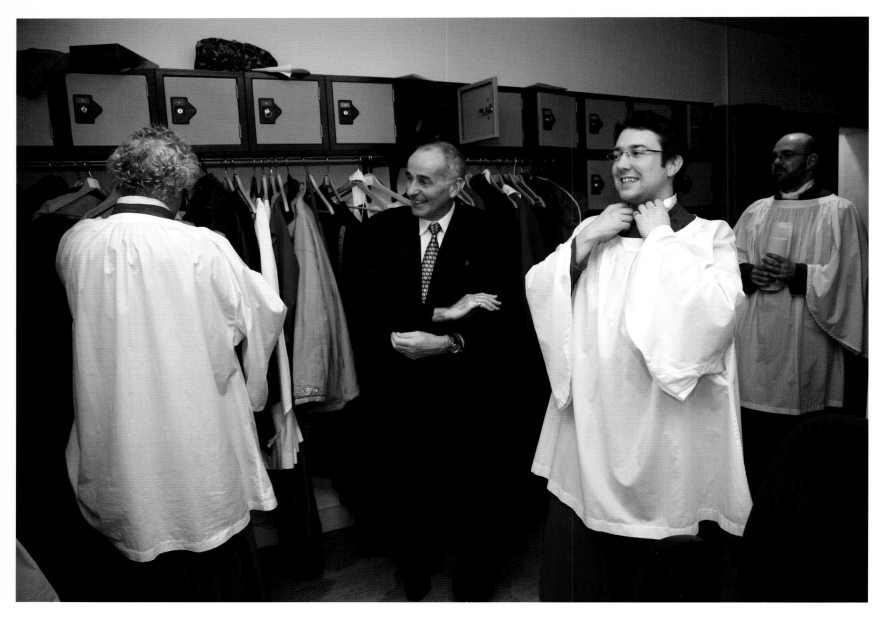

The morning of 25 December, Christmas Day. Ian Curror, the Royal Hospital's Director of Music and organist since 1974 and only the fourteenth to hold the post since 1693, readies for the Chapel's Christmas Day service with his choir of twelve professional mixed voices, who also sing all the Sunday services throughout the year.

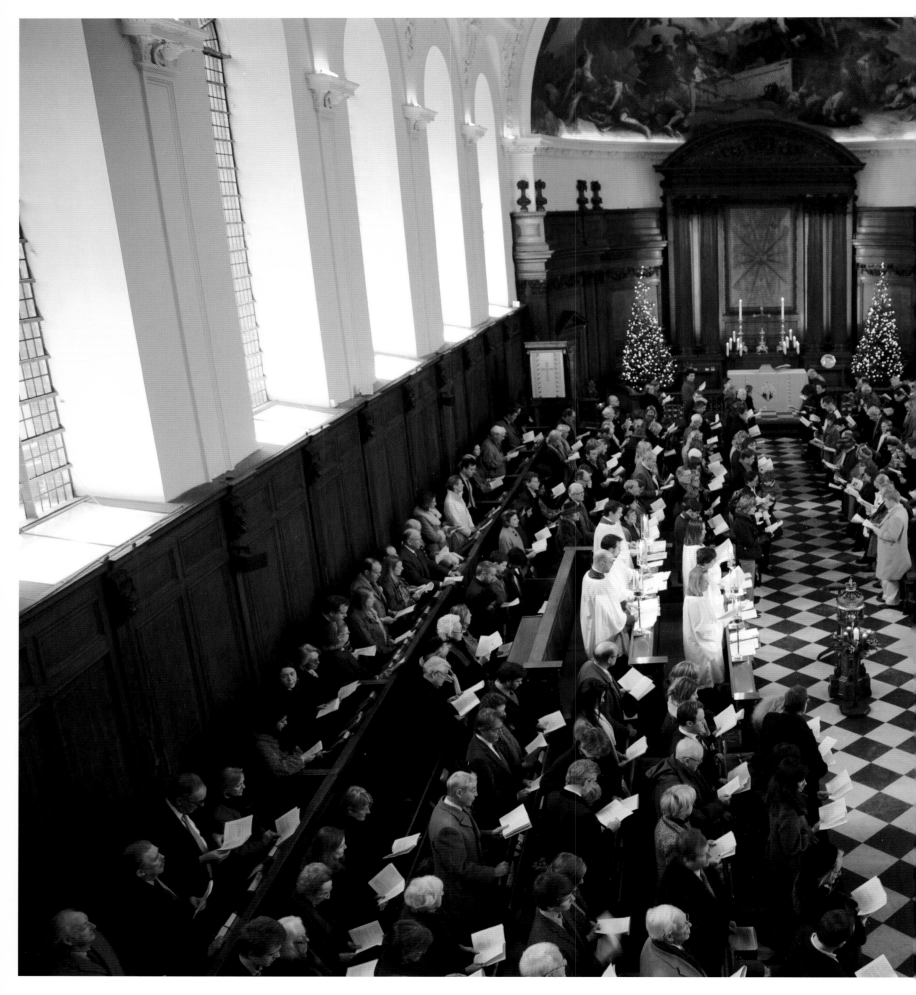

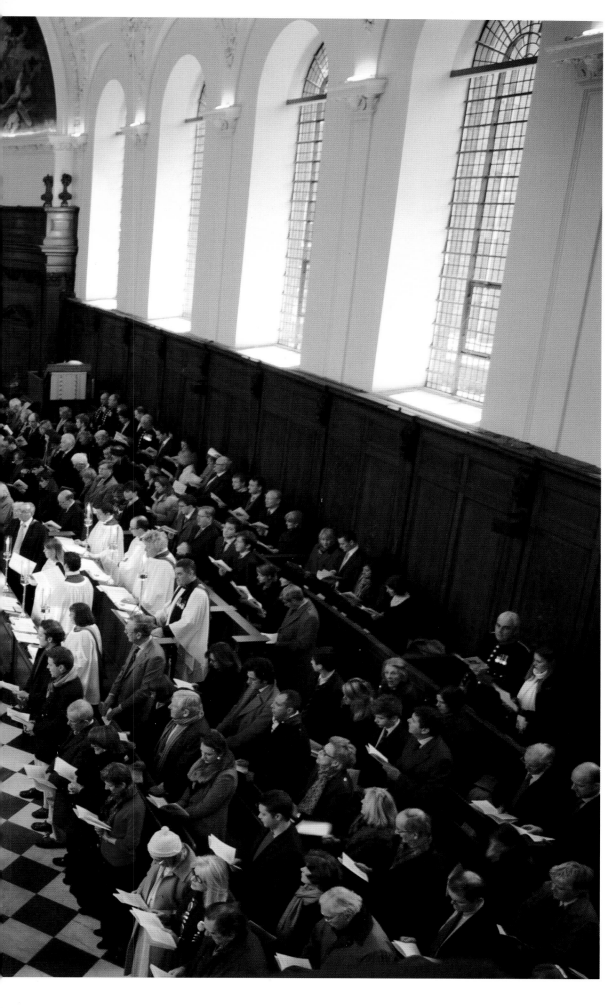

CHRISTMAS DAY SERVICE

Christmas morning brings a crowd of local residents to the Royal Hospital's Chapel, in which two illuminated and decorated pine trees provide the only touch of seasonal adornment. The traditional Christmas service often sees the Chapel reaching its maximum capacity of 500 people.

CHRISTMAS LUNCH

With up to half the In-Pensioners away visiting families and friends – regulations allow Chelsea Pensioners to be away for up to six weeks at any one time – at Christmas lunch the Hall is less busy than at usual mealtimes but no less convivial. Scarlets make way for informal 'blues', and the officers' plumed hats are set aside. Today there are no honoured guests, ceremony or fanfare; just military men, their days of active duty completed, gathering to mark the day, enjoy a seasonal feast and share a moment together.

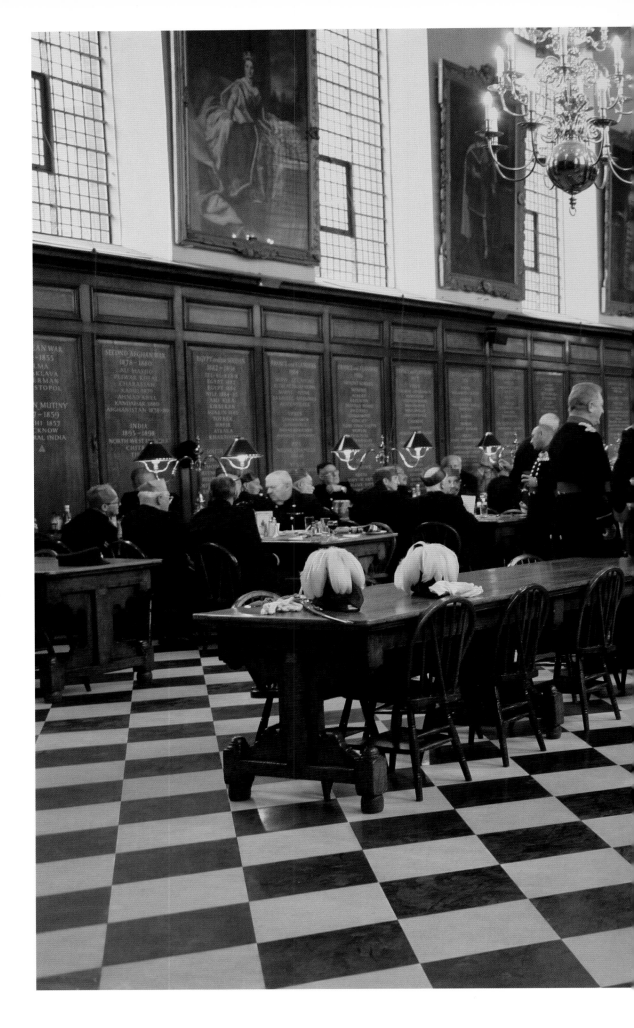

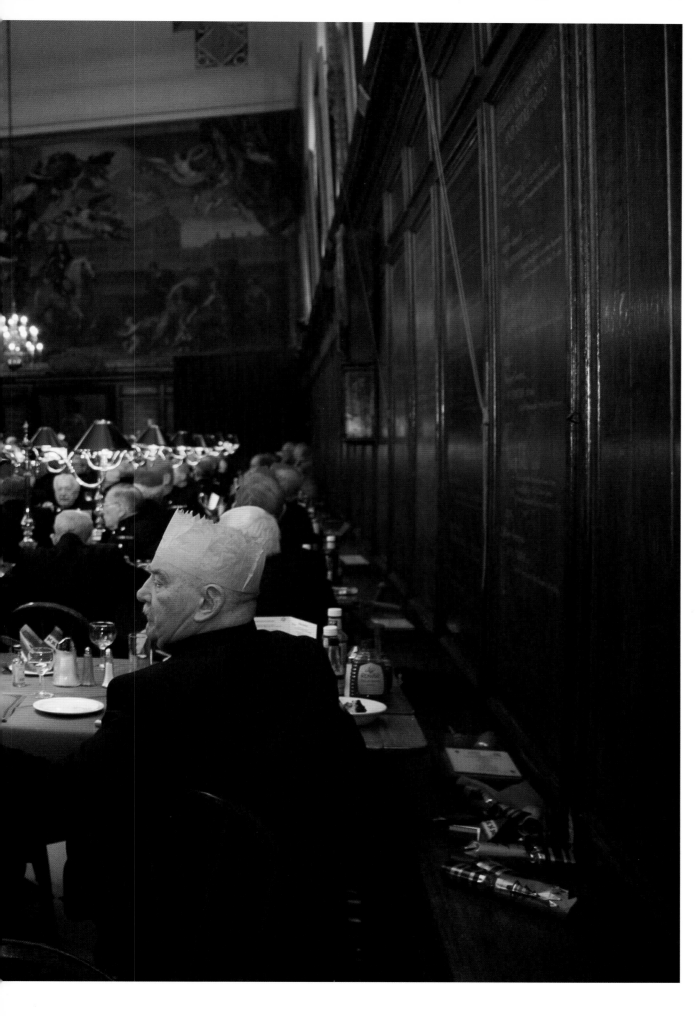

Lieutenant Colonel Archie Mackenzie, Captain of Invalids, tops up an In-Pensioner's glass during Christmas lunch. As is traditional in the British Army, on Christmas Day the officers and the Governor wait on and serve their soldiers.

As Christmas is celebrated and the year draws to a close, the Governor leads In-Pensioners and staff of the Royal Hospital Chelsea in reflection and thoughts of the future. While the day's light slowly fades outside, in his Christmas Day speech (traditionally given while standing on a table), the Governor looks back at the past year and informs the I.P.s and staff of the identity of the distinguished reviewing officer at next summer's Founder's Day.

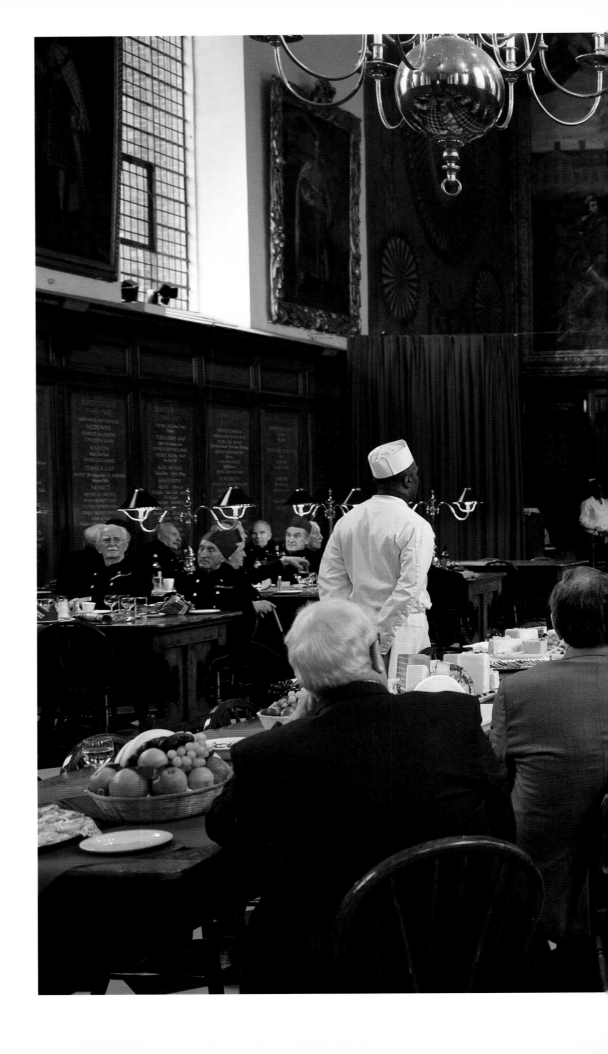

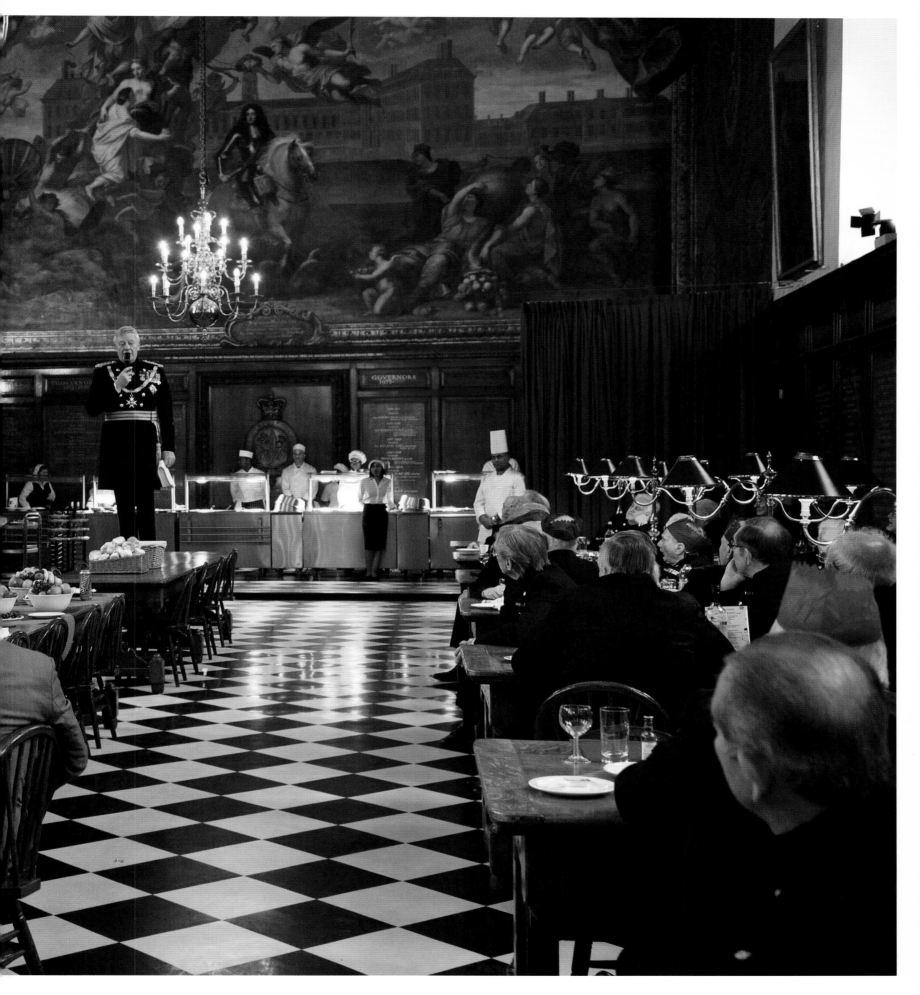

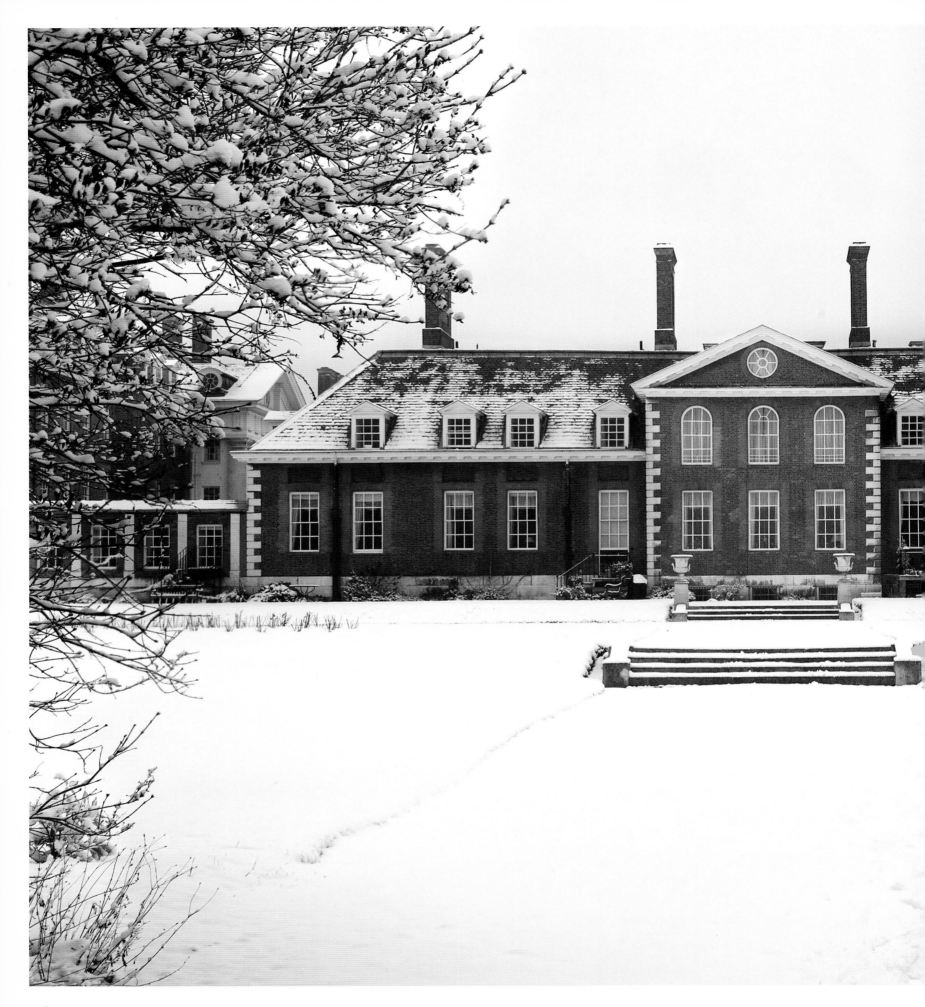

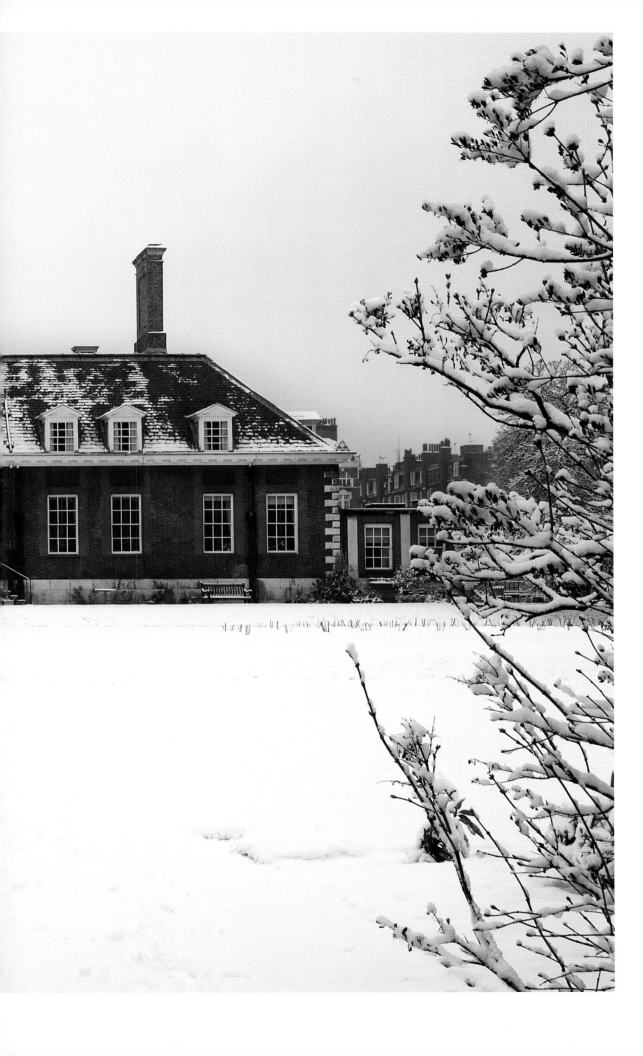

Light Horse Court lies quiet under the snow. The cavalry (Light Horse Guards) after whom Light Horse Court is named were regarded as a junior division of the army and did not figure in the original scheme for the Royal Hospital, but were eventually accommodated in this Wren-designed addition. The building suffered in both world wars (see p. 13) but was fully restored to its original condition in the mid-1960s, and from the outside it is now impossible to tell that it was ever damaged. Inside, the amenities have been fully modernized and the layout transformed.

Who's Who at the Royal Hospital Chelsea

The management of the Royal Hospital is assured by the following:

Governor
Traditionally a retired general. The Governor is the de facto chair of the Royal Hospital Chelsea's Board of Commissioners (trustees) and the titular head of the Royal Hospital.

Lieutenant Governor
Traditionally a retired major general. The Lieutenant Governor is the Royal Hospital's Chief Executive Officer, and is also a Royal Hospital Commissioner.

Secretary
Traditionally a retired senior civil servant. The Secretary is the Royal Hospital's Director of Finance and Head of Administration, and its Accounting Officer.

Adjudant
Traditionally a retired senior officer. The Adjudant is responsible for In-Pensioners' day-to-day welfare and administration.

Quartermaster
Traditionally a retired officer. The Quartermaster is the Hospital's Director of Facilities and also manages capital projects.

Matron
The Matron is responsible for the provision of professional medical care to the In-Pensioners.

Development Director
The Development Director is responsible for all commercial and fundraising activities, as well as for marketing and communications.

Chaplain
The Chaplain is responsible for In-Pensioners' spiritual care and for running what is, in effect, a parish church.

Physician and Surgeon
the Physician and Surgeon is the In-Pensioners' GP and also provides minor surgery.

Captains of Invalids
There are several Captains of Invalids, who are traditionally retired officers. Each is responsible for a cohort of In-Pensioners.

Sergeant Major
Traditionally a retired warrant officer. The Sergeant Major is responsible for the In-Pensioners' day-to-day routine, for 'discipline' and for ceremonial activities.

Acknowledgements

I should like to give special thanks to Colonel Anthony Beattie, National Secretary of The Women's Section, The Royal British Legion for his enthusiasm and support. Many thanks also to all those at the Royal Hospital who have played an enormous part in making the book, especially Lord Walker, Maj. Gen. Peter Currie, Col. Mark Baker, Brig. David Radcliffe, Col. Martin Snow, Lt Col. Andy Hickling, Col. Laura Bale, Revd Dick Whittington, Warrant Officer Bob Appleby, Theresa Ayeche, Tracy Shayler, David Williams, Jon Clark and Jill Morgan; and the In-Pensioners, to whom I owe a huge amount, especially I.P.s Jim Hawtree, Paddy Fox, Bill Moylon, Majorie Cole, Dorothy Hughes, Kenneth Elgenia and Patrick Brady, and all the other In-Pensioners and staff who have been included in the book. Special thanks go to I.P. Mal Smart for his constant friendship, lovely lunches in the Great Hall, glasses of wine in the In-Pensioners' club after a hard day's shoot, and his support and kindness in helping to put this book together; and to my parents, Sue and Andrew Rodwell, for their critical eye. To my husband, James, for allowing me to work on this book long into the night without complaining, I thank you.

My thanks also go to Merrell Publishers, especially Hugh Merrell, Nicola Bailey, Claire Chandler, Amanda Mackie, Marion Moisy and Henry Russell. Thank you very much indeed for your brilliant words, your never-ending patience and your enthusiasm. I have gained more wisdom and experience than I could ever have wished for. You are a wonderful team, and great fun to work with.

I should like to remember those who died throughout my year at the Royal Hospital, especially I.P. Ron Liles, I.P. Don Matthews, I.P. Charlie Boyce and Lieutenant Colonel Archie Mackenzie.

Patricia Rodwell, November 2011

The publisher wishes to thank the officers, In-Pensioners and staff of the Royal Hospital Chelsea for their warm hospitality and invaluable help in producing this book; in particular, Major General Peter Currie, David Hellens, and I.P.s Mal Smart, Jim Hawtree, Paddy Fox, Bill Moylon and Dorothy Hughes.

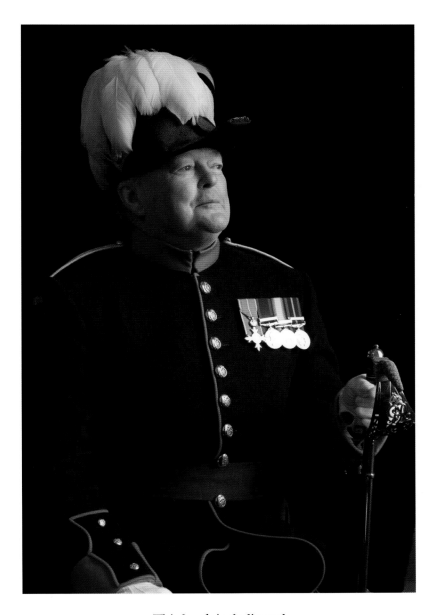

This book is dedicated
to the memory of
Lieutenant Colonel Archie Mackenzie, MBE
Captain of Invalids 2001–2011

The Royal Hospital Chelsea
Home of the Chelsea Pensioners
Royal Hospital Road
London SW3 4SR
020 7881 5200
www.chelsea-pensioners.org.uk

THE CHELSEA PENSIONERS' *Appeal*

Come and visit the Chelsea Pensioners and find out how a donation or a gift in your will can help to maintain their home.

The Royal Hospital Chelsea has been looking after old and infirm veteran soldiers for well over three centuries since it was first occupied in 1692. Our duty today is to make sure it can continue doing so for the next century and beyond, so that it remains as a living testament to the sacrifice of successive generations of soldiers in the service of their nation.

To do this we have embarked on a major development programme to make the Royal Hospital fit for purpose in the twenty-first century and beyond. Already we have raised enough money to have the new Margaret Thatcher Infirmary built, which today stands handsomely alongside the original Wren and Soane buildings. Moreover, it was built to budget and on time, an achievement of which we are very proud. The Infirmary has also enabled us to offer interim accommodation to our first Ladies, who joined us as Chelsea Pensioners in March 2009.

The next step is to modernize the historic Long Wards, in which the majority of Chelsea Pensioners live in conditions Wren would instantly recognize were he to return. Once that has been completed, we intend progressively to build an endowment to guarantee the long-term survival of this important and much loved national institution.

Very appropriately, the government provides us with a considerable grant-in-aid to help with our day-to-day running costs. But the Royal Hospital is not government-owned, and we rely on the generosity of our friends and support from the public to fund capital projects, together with making the best possible use of our own assets.

We believe that military service is unique in the demands that it places on individuals, and that in return the government and the nation have a duty towards those who are prepared to make the ultimate sacrifice. Indeed, this is the basis of the military covenant, that essential and unbreakable bond between those who serve in the armed forces, the government, which employs them, and the people whose freedom they defend.

We are very grateful to you for playing your part in this by giving us your support; and we hope you will remain a friend and supporter of the Royal Hospital in future.

For more information about preparing to leave a legacy or making a gift, please contact:
Development Department
e-mail: appeal@chelsea-pensioners.org.uk
Tel: 020 7881 5463

The Royal Hospital Chelsea likes to acknowledge supporters in the timeless fabric of our unique environment.

The Chelsea Pensioners' Appeal
Registered in England Charity Number: 1076414

This text is reproduced from *A Salute to Cooking* (2009), which contains more than 100 recipes contributed by notable chefs and such celebrities as Joanna Lumley and James Blunt, plus the Duke of Edinburgh. The book was compiled by Angela Currie, wife of the Royal Hospital Chelsea's Lieutenant Governor, Major General Peter Currie. All profits from *A Salute to Cooking* will go towards the Chelsea Pensioners' fundraising campaign to transform the current living accommodation in the Long Wards into modern study bedrooms with en-suite facilities. The book can be ordered from the Royal Hospital Chelsea website (chelsea-pensioners. org.uk), or bought at the Royal Hospital gift shop.

Sponsors

The publisher should like to thank the following sponsors,
whose generosity has made the publication of this book possible:

The Earl Cadogan, DL

Lord Cadogan is pleased to support the book *The Royal Hospital Chelsea: A Year in Pictures.*

SCH (Supplies)

SCH (Supplies) is a British manufacturer of estate and garden machinery, established in 1986. It is extremely proud to be associated with *The Royal Hospital Chelsea: A Year in Pictures.*

Shepherd Neame

Shepherd Neame, established in 1698, is Britain's oldest brewer and remains an independent family business based at Faversham, in the heart of Kent's hop country. It operates 359 pubs across London and the south-east of England, and brews traditional Kentish ales and international lagers, under licence. Shepherd Neame is a proud supporter of veterans' charities, mainly through our flagship beer brand, Spitfire Premium Kentish Ale.

UK Land

UK Land, a specialist in equity release for old established property companies and institutions, is proud to have an opportunity to support *The Royal Hospital Chelsea: A Year in Pictures.*

Index

Page numbers in *italic* refer to the illustrations.

First published 2012 by

Merrell Publishers Limited
81 Southwark Street
London SE1 0HX

merrellpublishers.com

British Library Cataloguing-in-Publication Data:
Rodwell, Patricia.
The Royal Hospital Chelsea: a year in pictures.
1. Royal Hospital (Chelsea, London, England)–
Pictorial works.
2. Soldiers' homes–England–London–Pictorial works.
3. Veterans–England–London–Pictorial works.
I. Title
362.8'685'0942134-dc23

ISBN 978-1-8589-4572-9

Produced by Merrell Publishers Limited
Designed by Dennis Bailey
Project-managed by Marion Moisy
Proof-read by Kirsty Seymour-Ure
Indexed by Hilary Bird

Printed and bound in China

JACKET, FRONT
Founder's Day parade in the Royal Hospital Chelsea's
Figure Court

JACKET, BACK, clockwise from top left
The conclusion of the Founder's Day parade (see
page 91); In-Pensioner Alf Humphries on Founder's
Day in 2011 (see page 73); I.P. Paddy Fox in his
allotment (see page 106); journalist Kate Adie with
I.P. Dorothy Hughes (left) and I.P. Marjorie Cole
(see page 116)

PAGE 1
The Royal Hospital Chelsea crest; the crown and the
inscription in Old French (which appears on all royal
crests) reflect the Royal Hospital's association with
the monarch

PAGE 2
Founder's Day parade

PAGES 4–5
Chelsea Pensioners in their scarlet and tricorne

PAGE 6
The traditional raising of tricorne hats by
In-Pensioners at the conclusion of the Founder's
Day parade

ISBN 978-1-8589-4572-9